P9-CJF-095

Gardner's Art Through the Ages
A Global History

FOURTEENTH EDITION

Volume I

Fred S. Kleiner

WADSWORTH
CENGAGE Learning·

Australia • Brazil • Japan • Korea • Mexico • Singapore • Spain • United Kingdom • United States

ISBN-13: 978-1-111-77186-7
ISBN-10: 1-111-77186-3

Wadsworth
20 Channel Center Street
Boston, MA 02210
USA

Cengage Learning is a leading provider of customized learning solutions with office locations around the globe, including Singapore, the United Kingdom, Australia, Mexico, Brazil, and Japan. Locate your local office at: **www.cengage.com/global**

Cengage Learning products are represented in Canada by Nelson Education, Ltd.

To learn more about Wadsworth, visit
www.cengage.com/wadsworth

Purchase any of our products at your local college store or at our preferred online store
www.cengagebrain.com

Printed in the United States of America
1 2 3 4 5 6 7 15 14 13 12 11

Contents

Chapter 1

Art Before History

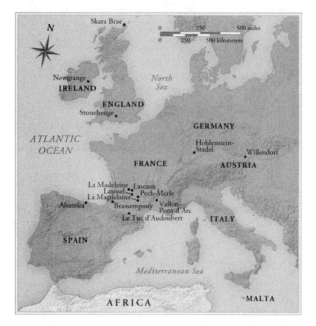

MAP 1-1 Prehistoric sites in Europe.

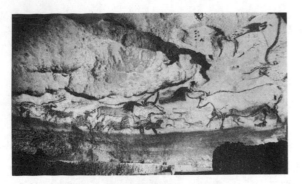

FIG. 01-01 Hall of the Bulls (left wall), in the cave at Lascaux, France, ca. 15,000–13,000 BCE. Largest bull 11′ 6″ long.

FIG. 01-02 Waterworn pebble resembling a human face, from Makapansgat, South Africa, ca. 3,000,000 BCE. Reddish brown jasperite, approx. 2 3/8″ wide. Natural History Museum, London.

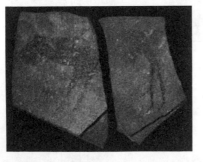

FIG. 01-03 Animal facing left, from the Apollo 11 Cave, Namibia, ca. 23,000 BCE. Charcoal on stone, approx. 5″ × 4 1/4″. State Museum of Namibia, Windhoek.

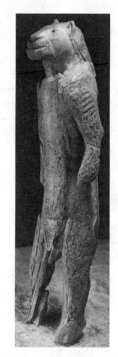

FIG. 01-04 Human with feline head, from Hohlenstein-Stadel, Germany, ca. 30,000–28,000 BCE. Mammoth ivory, 11 5/8″ high. Ulmer Museum, Ulm.

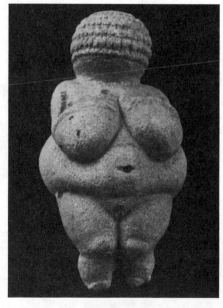

FIG. 01-05 Nude woman *(Venus of Willendorf)*, from Willendorf, Austria, ca. 28,000–25,000 BCE. Limestone, approx. 4 1/4″ high. Naturhistorisches Museum, Vienna.

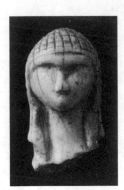

FIG. 01-05A Head of a woman, from the Grotte du Pape, Brassempouy, France, ca. 25,000–20,000 BCE. Ivory, 1 1/2″ high. Musée des Antiquités Nationales, Saint-Germanin-en-Laye.

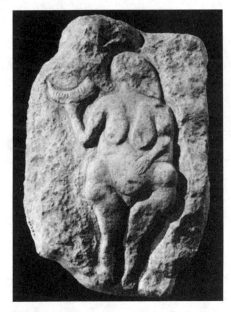

FIG. 01-06 Woman holding a bison horn, from Laussel, France, ca. 25,000–20,000 BCE. Painted limestone, 1′ 6″ high. Musée d'Aquitaine, Bordeaux.

FIG. 01-06A Reclining woman, rock-cut relief on the right wall of the first corridor in the cave at La Magdeleine, France, ca. 12,000 BCE.

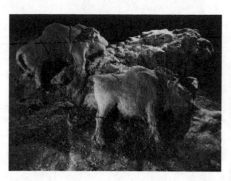

FIG. 01-07 Two bison, reliefs in a cave at Le Tuc d'Audoubert, France, ca. 15,000–10,000 BCE. Clay, right bison 2′ 7/8″ long.

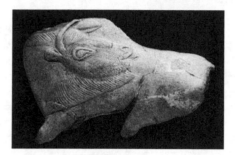

FIG. 01-08 Bison with turned head, fragmentary spearthrower, from La Madeleine, France, ca. 12,000 BCE. Reindeer horn, 4 1/8 long. Musee d'archeologie National, Saint-Germain-en-Laye.

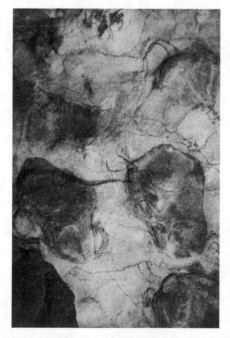

FIG. 01-09 Bison, detail of a painted ceiling in the cave at Altamira, Spain, ca. 12,000–11,000 BCE. Standing bison 5; 2 1/2″ long.

5

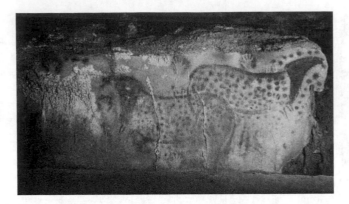

FIG. 01-10 Spotted horses and negative hand imprints, wall painting in the cave at Pech-Merle, France, ca. 23,000–22,000 BCE. 11′ 2″ long.

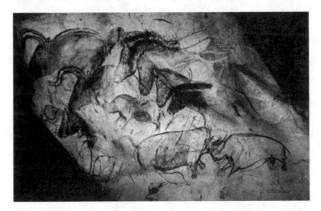

FIG. 01-11 Aurochs, horses, and rhinoceroses, wall painting in the Chauvet Cave, Vallon-Pont-d'Arc, France, ca. 30,000–28,000 or ca. 15,000–13,000 BCE. Right rhinoceros 3′ 4″ long.

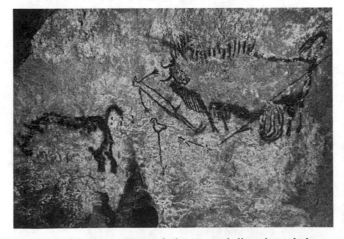

FIG. 01-12 Rhinoceros, wounded man, and disemboweled bison, painting in the well of the cave at Lascaux, France, ca. 16,000–14,000 BCE. Bison 3′ 4 1/2″ long.

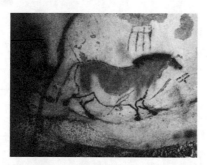

FIG. 01-12A "Chinese horse," Lascaux, ca. 16,000–14,000 BCE.

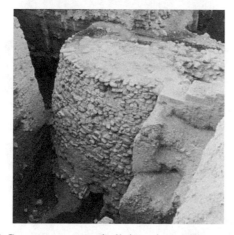

FIG. 01-13 Great stone tower built into the settlement wall, Jericho, ca. 8000–7000 BCE.

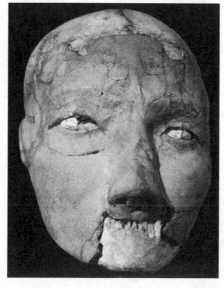

FIG. 01-14 Human skull with restored features, from Jericho, Jordan, ca. 7000–6000 BCE. Features modeled in plaster, painted, and inlaid with seashells. Life size. Archaeological Museum, Amman.

7

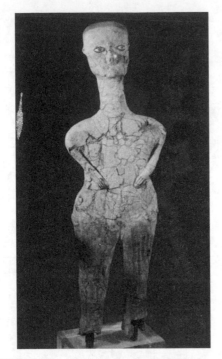

FIG. 01-15 Human figure, from Ain Ghazal, Jordan, ca. 6750–6250 BCE. Plaster, painted and inlaid with bitumen, 3′ 5 3/8″ high. Louvre, Paris.

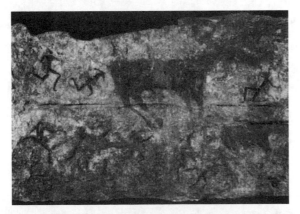

FIG. 01-16 Deer hunt, detail of a wall painting from Level III, Çatal Höyük, Turkey, ca. 5750 BCE. Museum of Anatolian Civilization, Ankara.

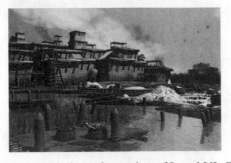

FIG. 01-16A Restored view of a section of Level VI, Çatal Höyük, Turkey, ca. 6000–5900 BCE.

FIG. 01-17 Landscape with volcanic eruption(?), watercolor copy of a wall painting from Level VII, Çatal Höyük, Turkey, ca. 6150 BCE.

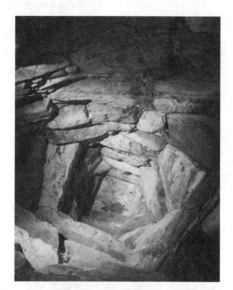

FIG. 01-18 Gallery leading to the main chamber of the passage grave, Newgrange, Ireland ca. 3200–2500 BCE.

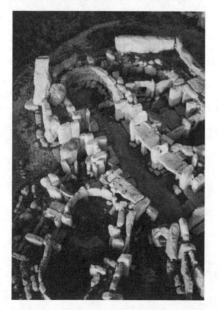

FIG. 01-19 Aerial view of the ruins of Hagar Qim, Malta, ca. 3200–2500 BCE.

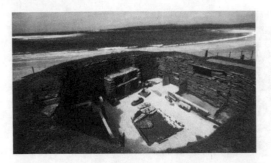

FIG. 01-19A House 1, Skara Brae, Scotland, ca. 3100–2500 BCE.

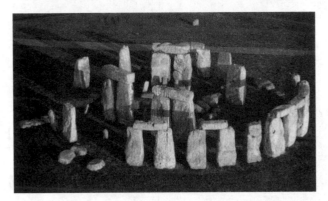

FIG. 01-20 Aerial view of Stonehenge, Salisbury Plain, England, ca. 2550–1600 BCE. Circle is 97′ in diameter; trilithons 24′ high.

Chapter 2

The Ancient Near East

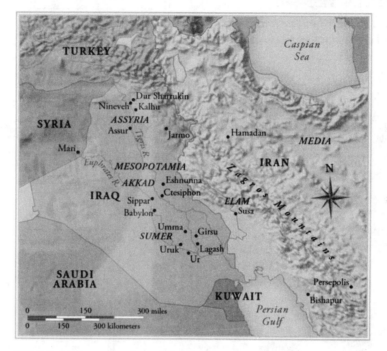

MAP 2-1 Mesopotamia and Persia.

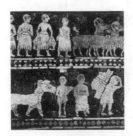

FIG. 02-01 Peace side of Standard of Ur, from tomb 779, Royal Cemetery, Ur (modern Tell Muqayyar), Iraq, ca. 2600–2400 BCE. Wood, lapis lazuli, shell, and red limestone, 8″ × 1′7″. British Museum, London.

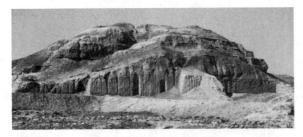

FIG. 02-02 White Temple and ziggurat, Uruk (modern Warka), Iraq, ca. 3200–3000 BCE. (page 33)

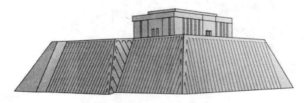

FIG. 02-03 Restored view of the White Temple and ziggurat, Uruk (modern Warka), Iraq, ca. 3200–3000 BCE. (page 33)

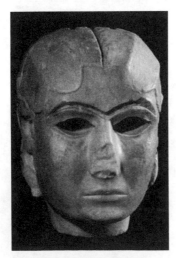

FIG. 02-04 Female head (Inanna?), from Uruk (modern Warka), Iraq, ca. 3200–3000 BCE. Marble, 8″ high. National Museum, of Iraq, Baghdad. (page 34)

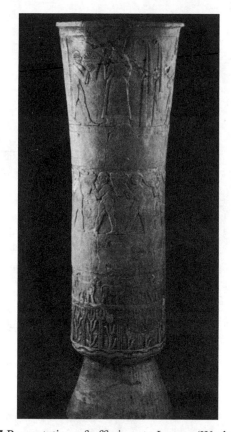

FIG. 02-05 Presentation of offerings to Inanna (Warka Vase), from Uruk (modern Warka), Iraq, ca. 3200–3000 BCE. Alabaster, 3′ 1/4″ high. National Museum, of Iraq, Baghdad. (page 34)

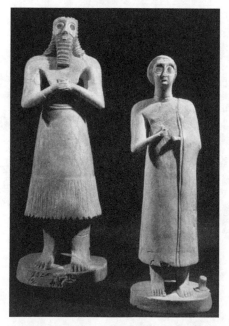

FIG. 02-06 Statuettes of two worshipers, from the Square Temple at Eshnunna (modern Tell Asmar), Iraq, ca. 2700 BCE. Gypsum shell, and black limestone, man 2′ 4 1/4″ high, woman 1′ 11 1/4″ high. National Museum of Iraq, Baghdad. (page 35)

13

FIG. 02-06A Urnashe, from Mari, ca. 200–2500 BCE.

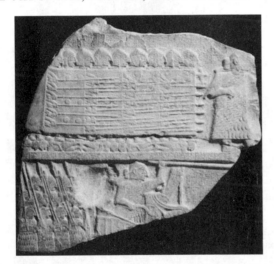

FIG. 02-07 Battle scenes, Fragment of the victory stele of Eannatum *(Stele of the Vultures),* from Girsu (modern Telloh), Iraq, ca. 2600–2500 BCE. Limestone, fragment 2′ 6″ high, full stele 5′ 11″ high. Louvre, Paris. (page 36)

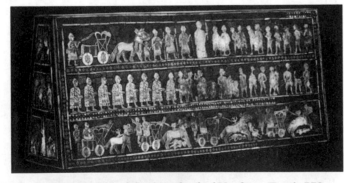

FIG. 02-08 War side of the *Standard of Ur,* from Tomb 779, Royal Cemetery, Ur (modern Tell Muqayyar), Iraq, ca. 2600 BCE. Wood lapis lazuli, and red limestone, 8″ × 1′ 7″. British Museum, London. (page 37)

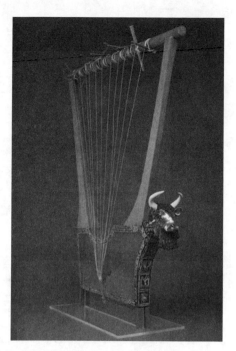

FIG. 02-09 Bull headed harp with inlaid sound box, from the tomb of Pu-abi (tomb 800), Royal Cemetery, Ur (modern Tell Muqayyar), Iraq, ca. 2600–2400 BCE. Wood, gold lapis lazuli, red limestone, and shell, 3′ 8 1/8″ high. British Museum, London.

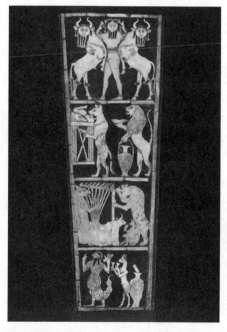

FIG. 02-10 Sound box of the bull headed harp from tomb 789 ("King's Grave"), Royal Cemetery, Ur (modern Tell Muqayyar), Iraq, ca. 2600–2400 BCE. Wood, lapis lazuli, and shell 1′ 7″ high. University of Pennsylvania Museum of Archaeology and Anthropology, Philadelphia.

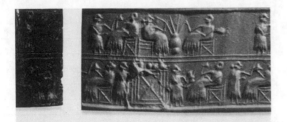

FIG. 02-11 Banquet scene, cylinder seal *(left)* and its modern impression *(right),* from the Tomb of Pu-abi (tomb 800), Royal Cemetery, Ur (modern Tell Muqayyar), Iraq, ca. 2600 BCE. Lapis lazuli, 1 7/8″ high, 1″ diameter high. British Museum, London. (page 39)

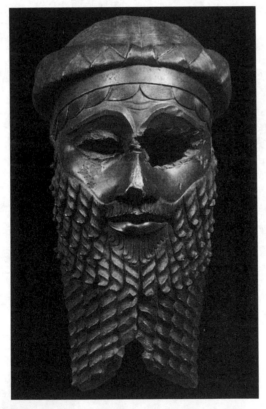

FIG. 02-12 Head of an Akkadian ruler, from Nineveh (modern Kuyunjik), Iraq, ca. 2250–2200 BCE. Copper, 1′ 2 3/8″ high. National Museum of Iraq, Baghdad. (page 40)

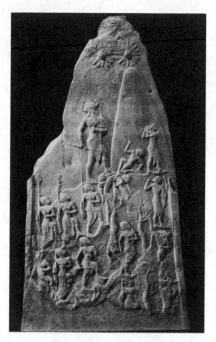

FIG. 02-13 Victory stele of Naram-Sin, from Susa, Iran, 2254–2218 BCE. Pink sandstone, 6′ 7″ high. Musee du Louvre, Paris. (page 40)

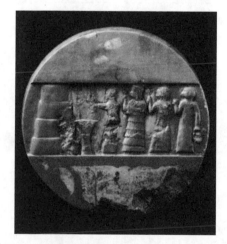

FIG. 02-14 Votive disk of Enheduanna, from Ur (modern Tell Muqayyar), Iraq, ca. 2300–2275 BCE. Alabaster, diameter 10″. University of Pennsylvania Museum of Archaeology and Anthropology, Philadelphia. (page 41)

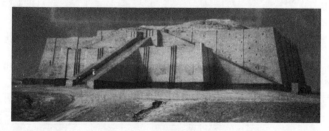

FIG. 02-15 Ziggurat (looking southwest), Ur (modern Tell Muqayyar), Iraq, ca. 2100 BCE.

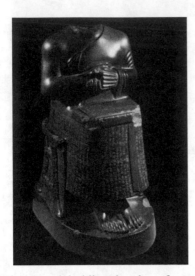

FIG. 02-16 Gudea seated, holding the plan of a temple, from Girsu (modern Telloh), Iraq, ca. 2100 BCE. Diorite, 2′5″ high. Musee du Louvre, Paris.

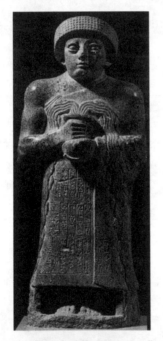

FIG. 02-17 Gudea standing, holding an overflowing water jar, from the Temple of Geshtinanna, Girsu (modern Telloh), Irqu, ca. 2100 BCE. Calcite, 2′ 3/8″ high. Musee du Louvre, Paris.

FIG. 02-17A Investiture of Zimri-Lim, Mari, ca. 1775–1760 BCE.

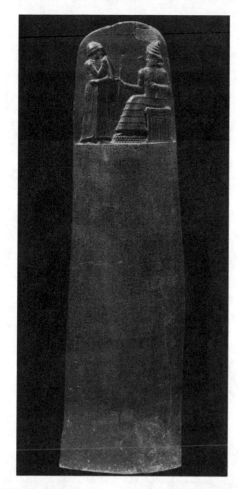

FIG. 02-18 Stele with the laws of Hammurabi, from Susa, Iran, ca. 1780 BCE. Basalt, approx. 7′ 4″ high. Musee du Louvre, Paris. (page 43)

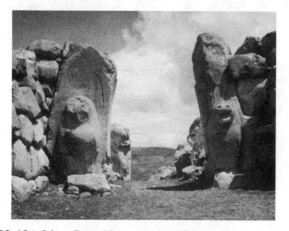

FIG. 02-18A Lion Gate, Hattusa, ca. 1400 BCE.

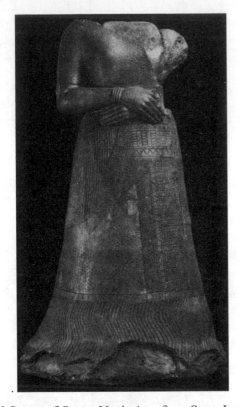

FIG. 02-19 Statue of Queen Napir-Asu, from Susa, Iran, ca. 1350–1300 BCE. Bronze and copper, 4′ 2 3/4″ high. Musee du Louvre, Paris.

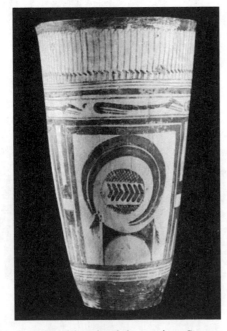

FIG. 02-19A Beaker with animal decoration, Susa, ca. 4000 BCE.

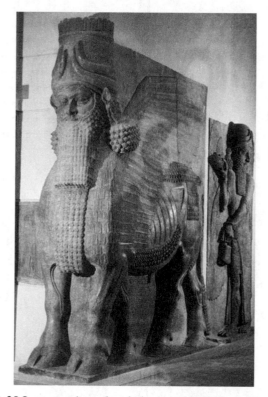

FIG. 02-20 Lamassu (man-headed winged bull) from the citadel of Sargon II, Dur Sharrukin (modern Khorsabad), Iraq, ca. 720–705 BCE. Limestone, 13′ 10″ high. Musee du Louvre, Paris.

FIG. 02-20A Citadel of Sargon II, Dur Sharrukin, ca. 720–705 BCE.

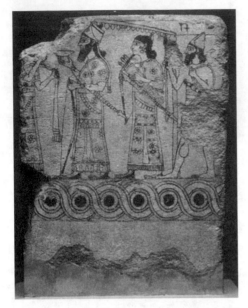

FIG. 02-21 Ashurnasirpal II with attendants and soldier, from the Northwest Palace of Ashurnasirpal II, Kalhu (modern Nimrud), Iraq, ca. 875–860 BCE. Glazed brick, 11 3/4″ high. British Museum, London. (page 46)

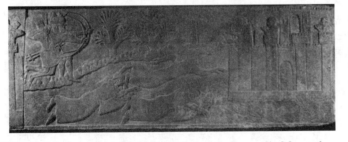

FIG. 02-22 Assyrian archers pursuing enemies, relief from the Northwest Palace of Ashurnasirpal II, Kalhu (modern Nimrud), Iraq, ca. 875–860 BCE. Gypsum, 2′ 10 5/8″ high. British Museum, London. (page 46)

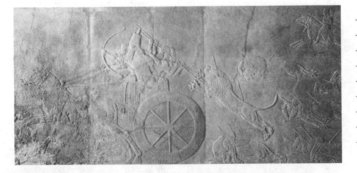

FIG. 02-23 Ashurbanipal hunting lions, relief from the North Palace of Ashurbanipal, Nineveh (modern Kuyunjik), Iraq, ca. 645–640 BCE. Gypsum, 5′ 4″ high. British Museum, London.

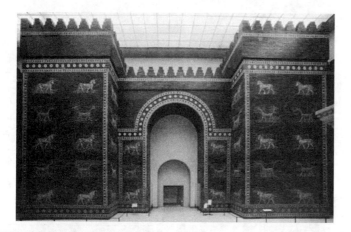

FIG. 02-24 Ishtar Gate (restored), Babylon, Iraq, ca. 575 BCE. Vorderasiatisches Museum, Staatlich Museen zu Berlin, Berlin.

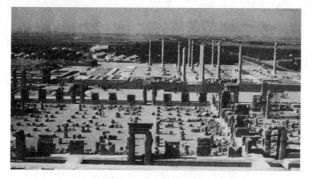

FIG. 02-25 Arial view of Persepolis (apadana in the background), Iran, ca. 521–465 BCE.

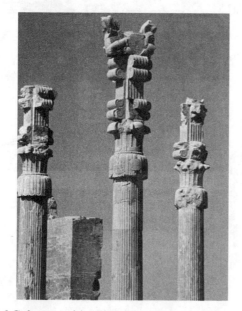

FIG. 02-26 Columns with animal protomes, from the apadana of the palace, Persepolis, Iran, ca. 521–465 BCE.

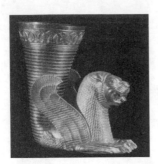

FIG. 02-26A Gold rython, Hamadan, fifth to third century BCE.

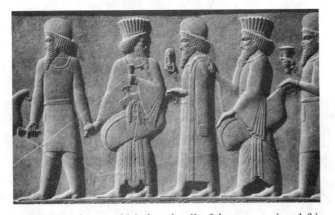

FIG. 02-27 Persians and Medes, detail of the processional frieze on the east side of the terrace of the apadana of the palace FIG. 2–25), Persepolis, Iran, ca. 521–465 BCE. Limestone, 8′4″ high.

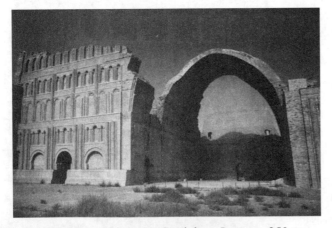

FIG. 02-28 Palace of Shapur I, Ctesiphon, Iraq, ca. 250 CE.

FIG. 02-28A Triumph of Shapur I, Bishapur, Iran, ca. 260 CE.

Chapter 3

Egypt Under the Pharaohs

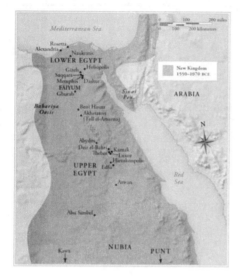

MAP 3-1 Ancient Egypt.

FIG. 03-01 Back of the palette of King Narmer (compare FIG.
3–2), from Hierakonpoli, Egypt, Predynastic, ca. 300–2920 BCE.
Slate, 2′1″ high. Egypt Museum, Cairo.

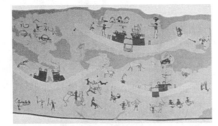

FIG. 03-01A Tomb 100, Hierakonpolis, ca. 3500–3200 BCE.

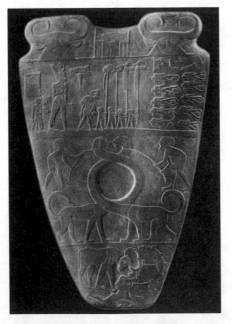

FIG. 03-02 Front of the palette of King Narmer (compare FIG.
3–1), from Hierakonpolis, Egypt, Predynastic, ca. 300–2920 BCE.
Slate, 2′1″ high. Egyptian Museum, Cairo.

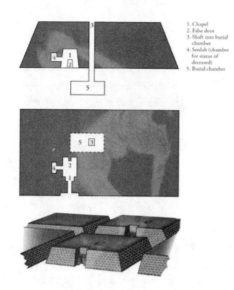

1. Chapel
2. False door
3. Shaft into burial chamber
4. Serdab (chamber for statue of deceased)
5. Burial chamber

FIG. 03-03 Section *(top)*, plan *(center)*, and restored view *(bottom)* of typical Egyptian mastaba tombs.

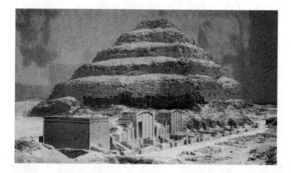

FIG. 03-04 Iмнотер, Stepped Pyramid (looking northeast) of Djoser, Saqqara, Egypt, Third Dynasty, ca. 2630–2611 BCE.

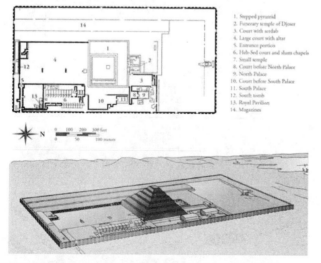

1. Stepped pyramid
2. Funerary temple of Djoser
3. Court with serdab
4. Large court with altar
5. Entrance portico
6. Heb-Sed court and sham chapels
7. Small temple
8. Court before North Palace
9. North Palace
10. Court before South Palace
11. South Palace
12. South tomb
13. Royal Pavilion
14. Magazines

FIG. 03-05 Restored view (top) and plan (bottom) of the mortuary precinct of Djoser, Saqqara, Egypt, third Dynasty, ca. 2630–2611 BCE.

27

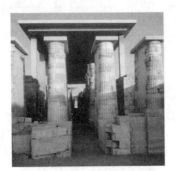

FIG. 03-05A Entrance hall, Djoser precinct, Saqqara, ca. 2630–2611 BCE.

FIG. 03-06 Detail of the facade of the north palace of the mortuary precinct of Djoser (FIG. 3–5), Saqqara, Eqypt, Third Dynasty, ca. 230–2611 BCE.

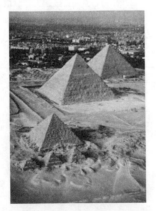

FIG. 03-07 Great Pyramids, Gizeh, Egypt, Fourth Dynasty. *From bottom:* pyramids of Menkaure, ca. 2490–2472 BCE; Khafre, ca. 2520–2494 BCE; and Khufu, ca. 2551–2528 BCE.

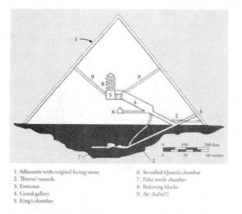

1. Silhouette with original facing stone
2. Thieves' tunnels
3. Entrance
4. Grand gallery
5. King's chamber
6. So-called Queen's chamber
7. False tomb chamber
8. Relieving blocks
9. Air shafts(?)

FIG. 03-08 Section of the Pyramid of Khufu, Gizeh, Egypt, Fourth Dynasty, ca. 2551–2528 BCE.

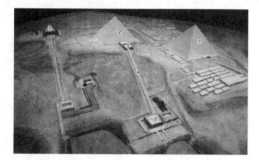

FIG. 03-09 Model of the pyramid complex, Gizeh, Egypt. Harvard University Semitic Museum, Cambridge. (1) pyramid of Menkaure, (2) pyramid of Khafre, (3) mortuary temple of Khafre, (4) causeway, (5) Great Sphinx, (6) valley temple of Khafre, (7) pyramid of Khufu, (8) pyramids of the royal family and mastabas of nobles

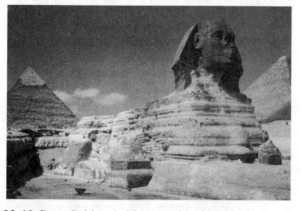

FIG. 03-10 Great Sphinx (with pyramid of Khafre in the background at left), Gizeh, Egypt, Fourth Dynasty, ca. 2520–2494 BCE. Sandstone, 65′ × 240′.

29

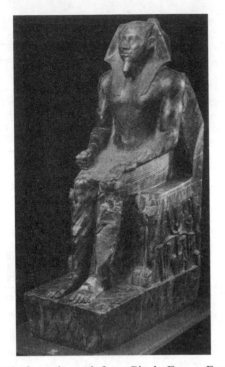

FIG. 03-11 Khafre enthroned, from Gizeh, Egypt, Fourth Dynasty, ca. 2520–2494 BCE. Diorite, 5′ 6″ high. Egyptian Museum, Cairo.

FIG. 03-11A Rahotep and Nofret, Maidum, ca. 2575–2550 BCE.

FIG. 03-11B Sculptors at work, Thebes, ca. 1425 BCE.

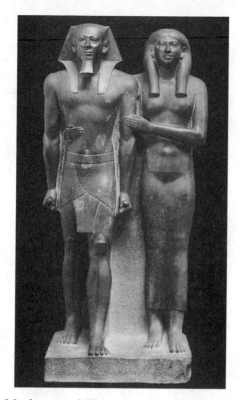

FIG 03-12 Menkaure and Khamerernebty(?), from Gizeh, Egypt, Fourth Dynasty, ca. 2490–2472 BCE. Graywacke, approx. 4′ 6 1/2″ high. Museum of Fine Arts, Boston.

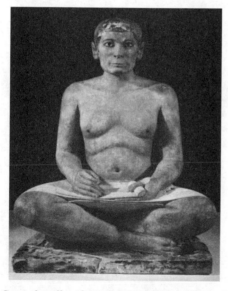

FIG. 03-13 Seated scribe, from Saqqara, Egypt, Fourth Dynasty, ca. 2500 BCE. Painted limestone, 1′ 9″ high. Musee du Louvre, Paris.

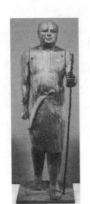

FIG. 03-13A Ka-Aper, Saqqara, ca. 2450–2350 BCE.

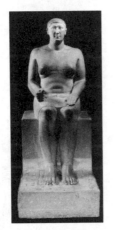

FIG. 03-13B Hemiunu Gizeh, ca. 2550–2530 BCE.

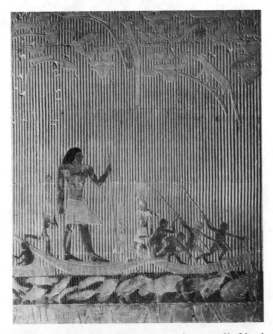

FIG. 03-14 Ti watching a hippopotamus hunt, relief in the mastaba of Ti, Saqqara, Egypt, Fifth Dynasty, ca. 2450–2350 BCE. Painted limestone, 4′ high.

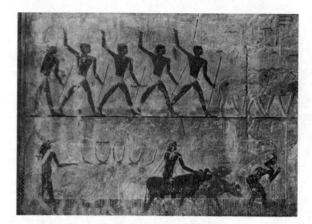

FIG. 03-15 Goats treading seed and cattle fording a canal, reliefs in the mastaba of Ti, Saqqara, Egypt, Fifth Dynasty, ca. 2450–2350 BCE. Painted limestone. (page 65)

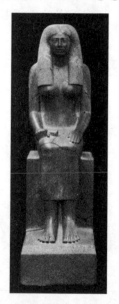

FIG. 03-15A Lady Sennuwy, Kerma, 1960–1916 BCE.

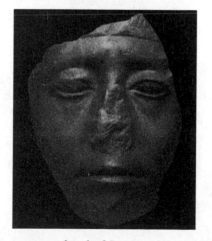

FIG. 03-16 Fragmentary head of Senusret III, 12th Dynasty, ca. 1860 BCE. Red quartzite, 6 1/2″ high. Metropolitan Museum of Art, New York.

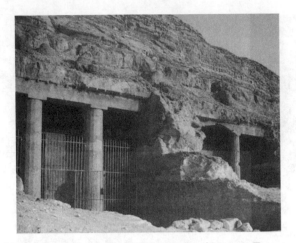

FIG. 03-17 Rock-cut tombs BH 3 to 5, Beni Hasan, Egypt, 12th Dynasty, ca. 1950–1900 BCE. (page 66)

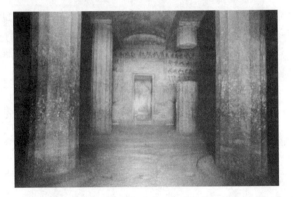

FIG. 03-18 Interior hall of the rock-cut tomb of Amenemhet (tomb BH 2), Beni Hasan, Egypt, 12th Dynasty, ca. 1950–1900 BCE.

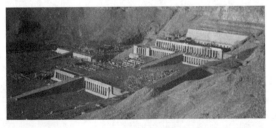

FIG. 03-19 Mortuary temple of Hatshepsut (looking southwest), Deir el-Bahri, Egypt, 18th Dynasty, ca. 1473–1458 BCE.

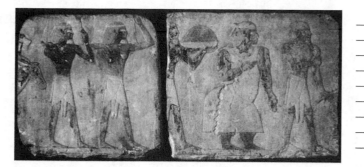

FIG. 03-20 King and queen of Punt and attendants, relief from the mortuary temple of Hatshepsut, Deir el-Bahri, Egypt, 18th Dynasty, ca. 1473–1458 BCE. Painted limestone, 1′ 3″ high. Egyptian Museum, Cairo.

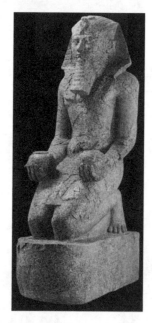

FIG. 03-21 Hatshepsut with offering jars, from the upper court of her mortuary temple, Deir el-Bahri, Egypt, 18th Dynasty, ca. 1473–1458 BCE. Red granite, 8′ 6″ high. Metropolitan Museum of Art, New York.

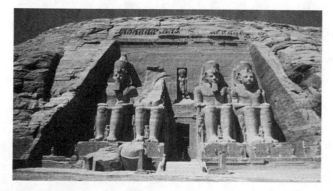

FIG. 03-22 Facade of the temple of Ramses II, Abu Simbel, Egypt, 19th Dynasty, ca. 1290–1224 BCE. Sandstone, colossi 65′ high.

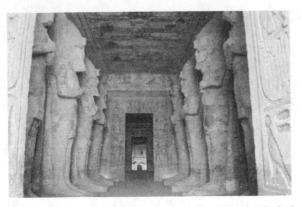

FIG. 03-23 Interior of the temple of Ramses II, Abu Simbel, Egypt, 19th Dynasty, ca. 1290–1224 BCE. Sandstone, pillar statues 32′ high.

FIG. 03-24 Aerial view of the temple of Amen-Re (looking north) Karnak, Egypt, begun 15th century BCE.

FIG. 03-24A Temple of Amen-Re, Luxor, begun early 14th century BCE.

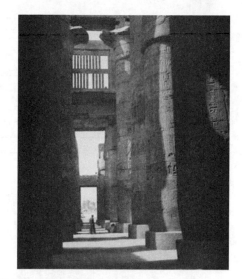

FIG. 03-25 Hypostyle hall of the temple of Amen-Re, Karnak, Egypt, 19th Dynasty, ca. 1290–1224 BCE.

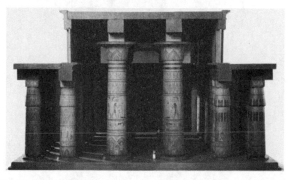

FIG. 03-26 Model of the hypostyle hall, temple of Amen-Re, Karnak, Egypt, 19th Dynasty, ca. 1290–1224 BCE. Metropolitan Museum of Art, New York.

37

FIG. 03-27 Senmut with Princess Nefrura, from Thebes, Egypt, 18th Dynasty, ca. 1470–1460 BCE. Granite, 3′ 1/2″ high. Ägyptisches Museum, Berlin.

FIG. 03-28 Nebamun hunting fowl, from the tomb of Nebamun, Thebes, Egypt, 18th Dynasty, ca. 1400–1350 BCE. Fresco on dry plaster, 2′ 8″ high. British Museum, London.

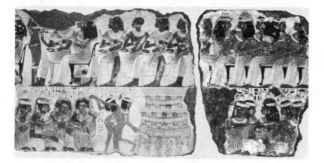

FIG. 03-29 Funerary banquet from the tomb of Nebamun, Thebes, Egypt, 18th Dynasty, ca. 1400–1350 BCE. Fresco secco, 2′10 5/8″ × 3; 10 7/8.″ British Museum, London.

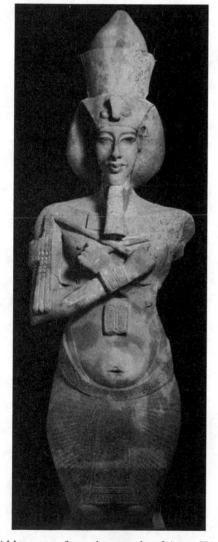

FIG. 03-30 Akhenaton, from the temple of Aton, Karnak, Egypt, 18th Dynasty, ca. 1353–1335 BCE. Sandstone, 13′ high. Egyptian Museum, Cairo.

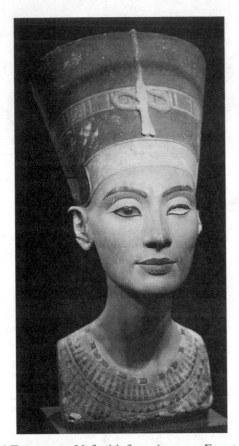

FIG. 03-31 Thutmose, Nefertiti, from Amarna, Egypt, 18th Dynasty, ca. 1353–1335 BCE. Painted limestone, 1′ 8″ high. Ägyptisches Museum, Berlin.

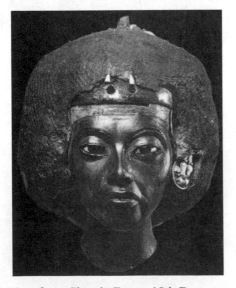

FIG. 03-32 Tiye, from Ghurab, Egypt, 18th Dynasty, ca. 1353–1335 BCE. Wood, with gold, silver, alabaster, and lapis lazuli, 3 3/4″ high. Ägyptisches Museum, Berlin.

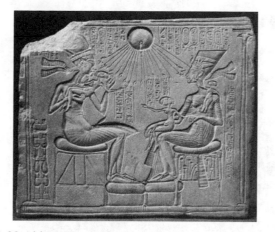

FIG. 03-33 Akhenaton, Nefertiti, and three daughters, from Amarna, Egypt, 18th Dynasty, ca. 1353–1335 BCE. Limestone, 1′ 1/4″ high. Ägyptisches Museum, Berlin.

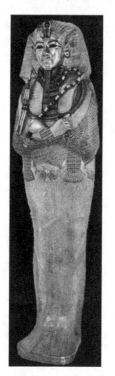

FIG. 03-34 Innermost coffin of Tutankhamen, from his tomb at Thebes, Egypt, 18th Dynasty, ca. 1323 BCE. Gold with inlay of enamel and semiprecious stones, 6′ 1″ long. Egyptian Museum, Cairo.

41

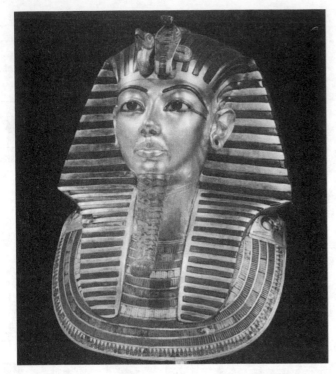

FIG. 03-35 Death mask of Tutankhamen, from the innermost coffin in his tomb at Thebes, Egypt, 18th Dynasty, ca. 1323 BCE. Gold with inlay of semiprecious stones, 1′9 1/4″ high. Egyptian Museum, Cairo.

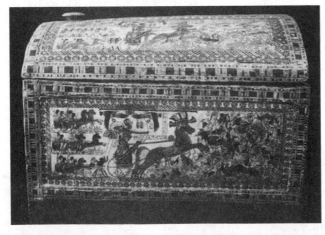

FIG. 03–36 Painted chest, from the tomb of Tutankhamen, Thebes, Egypt, 18th Dynasty, ca. 1333–1323 BCE. Wood, 1′ 8″ long. Egyptian Museum, Cairo.

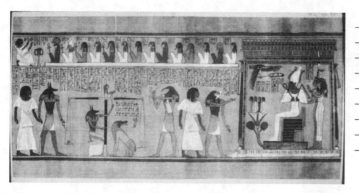

FIG. 03-37 Last judgment of Hunefer, from his tomb at Thebes, Egypt, 19th Dynasty, ca. 1290–1280 BCE. Painted papyrus scroll, 1′ 6″ high. British Museum, London.

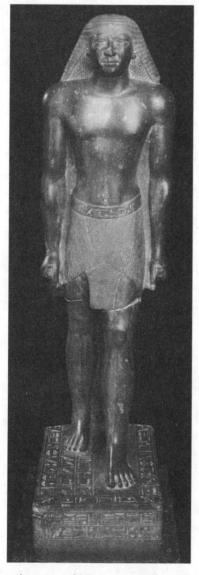

FIG. 03-38 Portrait statue of Mentuemhet, from Karnak, Egypt, 26th Dynasty, ca. 660–650 BCE. Granite, 4′ 5″ high. Egyptian Museum, Cairo.

FIG. 03-39 Taharqo as a sphinx, from temple T, Kawa, Sudan, 25th Dynasty, ca. 680 BCE. Granite, 1′ 4″ × 2′ 4 3/4″. British Museum, London.

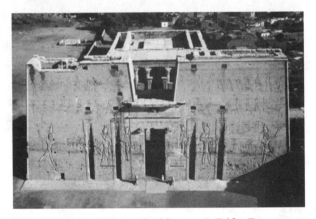

FIG. 03-40 Temple of Horus (looking east) Edfu, Egypt, ca. 237–47 BCE.

Chapter 4

The Prehistoric Aegean

MAP 4-1 The prehistoric Aegean.

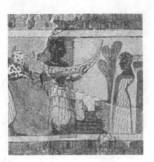

FIG. 04-01 Sacrophagus, from Hagia Triada (Crete), Greece, ca. 1450–1400 BCE. Painted limestone, 4'6" long. Archeological Museum, Herakleion

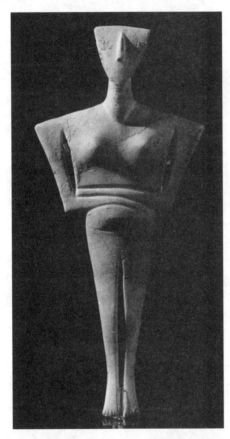

FIG. 04-02 Figurine of a woman, from Syros (Cyclades), Greece, ca. 2500–2300 BCE. Marble, 1' 6" high. National Archaeological Museum, Athens.

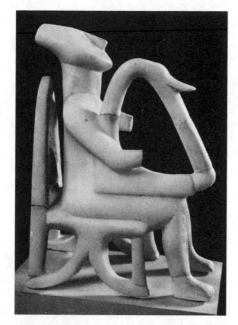

FIG. 04-03 Male lyre player, from Keros (Cyclades), Greece, ca. 2700–2500 BCE. Marble, 9″ high. National Archaeological Museum, Athens.

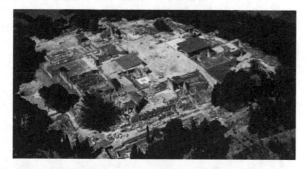

FIG. 04-04 Aerial view of the palace (looking northeast), Knossos (Crete) Greece, ca. 1700–1400 BCE.

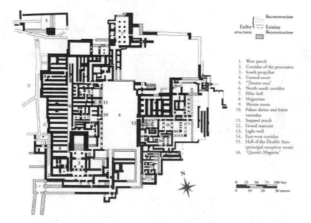

FIG. 04-05 Plan of the palace, Knossos (Crete), Greece, ca. 1700–1400 BCE.

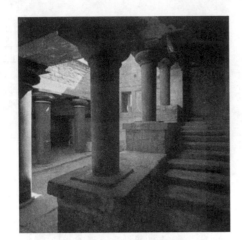

FIG. 04-06 Stairwell in the residential quarter of the palace, Knossos (Crete), Greece, ca. 1700–1370 BCE.

FIG. 04-07 Minoan woman or goddess *(La Parisienne),* from the palace, Knossos (Crete), Greece, ca. 1400–1370 BCE. Fragment of a fresco, 10″ high. Archaeological Museum, Herakleion.

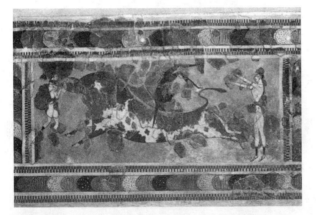

FIG. 04-08 Bull-leaping, from the palace, Knossos (Crete), Greece, ca. 1400–1370 BCE. Fresco, 2′ 8″ high, including border. Archaeological Museum, Herakleion.

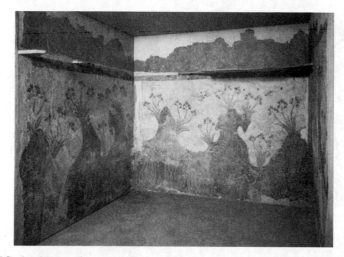

FIG. 04-09 Landscape with swallows *(Spring Fresco),* from room Delta 2, Akrotiri, Thera (Cyclades), Greece, ca. 1650 BCE. Fresco, 7′ 6″ high. National Archaeological Museum, Athens.

FIG. 04-09A Miniature Ships, Fresco, Akrotiri, ca. 1650–1625 BCE.

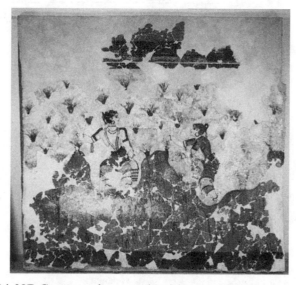

FIG. 04-09B Crocus gatherers, Akrotiri, ca. 1650–1625 BCE.

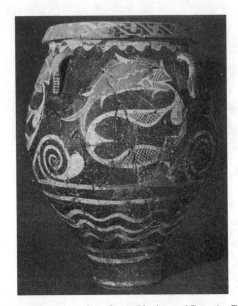

FIG. 04-10 Kamares-ware jar, from Phaistos (Crete), Greece, ca. 1800–1700 BCE. 1′ 8″ high. Archaeological Museum, Herakleion.

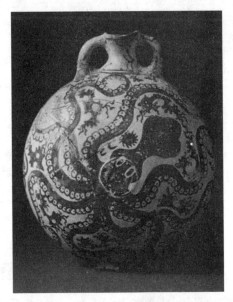

FIG. 04-11 Marine Style octopus flask from Palaikastro (Crete), Greece, ca. 1500 BCE. 11″ high. Archaeological Museum, Herakleion.

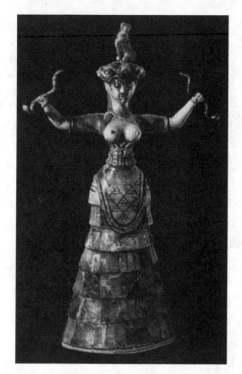

FIG. 04-12 *Snake Goddess,* from the palace at Knossos (Crete), Greece, ca. 1600 BCE. Faience, 1′ 1 1/2″ high. Archaeological Museum, Herakleion.

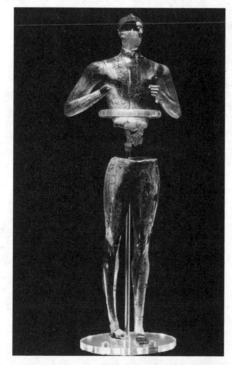

FIG. 04-13 Young god(?), from Palaikastro (Crete), Greece, ca. 1500–1450 BCE. Ivory, gold, serpentine, and rock crystal, restored height 1′7 1/2″. Archaeological Museum, Siteia. (page 89)

51

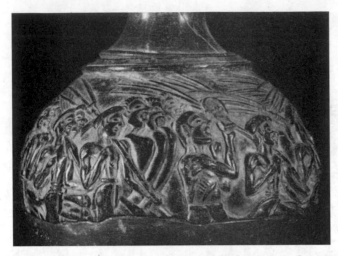

FIG. 04-14 *Harvesters Vase,* from Hagia Triada (Crete), Greece, ca. 1500–1450 BCE. Steatite, originally with gold leaf, greatest diameter approx. 5″. Archaeological Museum, Herakleion.

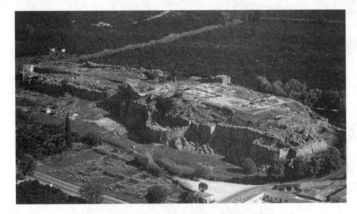

FIG. 04-15 Aerial view of the citadel (looking east), Tiryns, Greece, ca. 1400–1200 BCE.

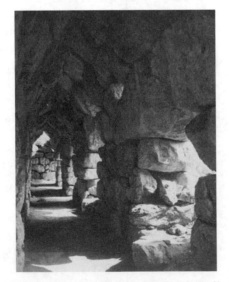

FIG. 04-16 Corbel-vaulted gallery in the circuit wall of the citadel, Tiryns, Greece, ca. 1400–1200 BCE.

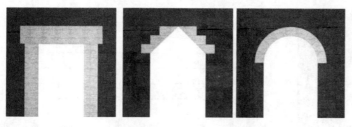

FIG. 04-17 Three methods of spanning a passageway: (John Burge) (a) post and lintel, (b) corbeled arch, (c) arch.

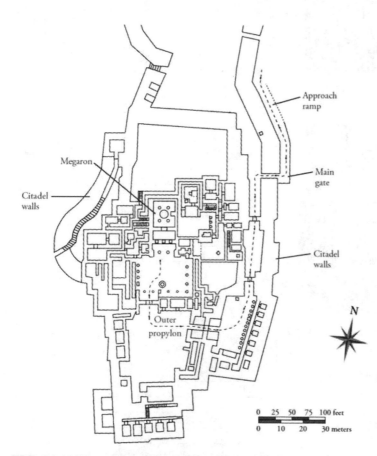

FIG. 04-18 Plan of the palace and southern part of the citadel, Tiryns, Greece, ca. 1400–1200 BCE.

FIG. 04-18A Megaron, Palace of Nestor, Pylos, ca. 1300 BCE (watercolor by Piet de Jong).

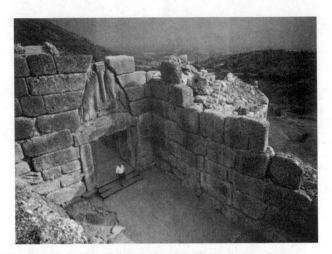

FIG. 04-19 Lion Gate (looking southeast) Mycenae, Greece, ca. 1300–1250 BCE. Limestone, relief panel 9′ 6″ high.

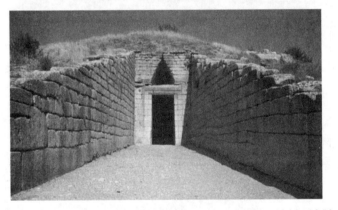

FIG. 04-20 Treasury of Atreus, Mycenae, Greece, ca. 1300–1250 BCE.

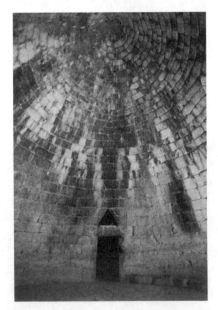

FIG. 04-21 Interior of the Treasury of Atreus Mycenae, Greece, ca. 1300–1250 BCE.

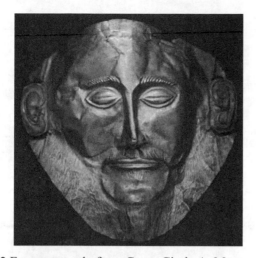

FIG. 04-22 Funerary mask, from Grave Circle A, Mycenae, Greece, ca. 1600–1500 BCE. Beaten gold, 1′ high. National Archaeological Museum, Athens.

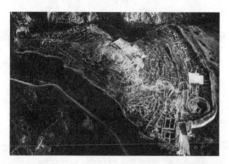

FIG. 04-22A Grave Circle A, Mycenae, ca. 1600 BCE.

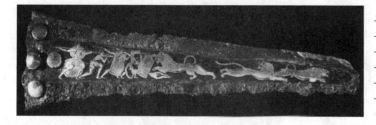

FIG. 04-23 Inlaid dagger blade with lion hunt, from Grave Circle A, Mycenae, Greece, ca. 1600–1500 BCE. Bronze, inlaid with gold silver, and niello, 9″ long. National Archaeological Museum, Athens.

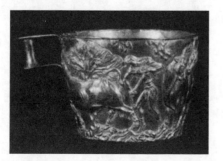

FIG. 04-23A Gold drinking cup, Vapheio, ca. 1600–1500 BCE.

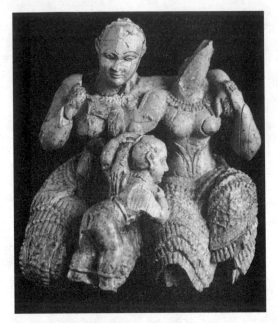

FIG. 04-24 Two goddesses(?) and a child from Mycenae, Greece, ca. 1400–1250 BCE. Ivory, 2 3/4″ high. National Archaeological Museum, Athens.

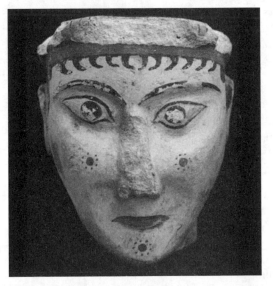

FIG. 04-25 Female head, from Mycenae, Greece, ca. 1300–1250 BCE. Painted plaster, 6 1/2″ high. National Archaeological Museum, Athens.

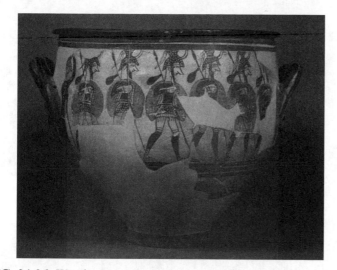

FIG. 04-26 Warrior Vase (krater) from Mycenae, Greece, ca. 1200 BCE. 1′ 4″ high. National Archaeological Museum, Athens.

Chapter 5

Ancient Greece

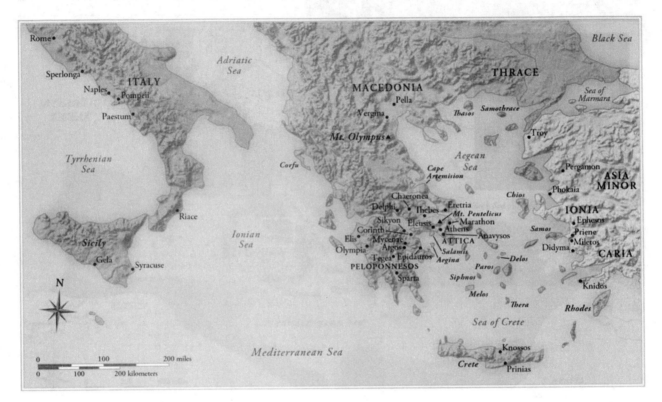

MAP 5-1 The Greek world.

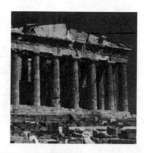

FIG. 05-01 Iktinos and Kallikrates, Parthenon (Temple of Athena Parthenos: looking southeast), Acropolis, Athens, Greece, 447–438 BCE.

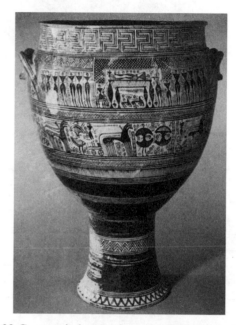

FIG. 05-02 Geometric krater, from the Dipylon cemetery, Athens, Greece, ca. 740 BCE. 3′ 4 1/2″ high. Metropolitan Museum of Art, New York.

FIG. 05-02A Diplon Painter, Geometric funerary amphora, ca. 750 BCE.

59

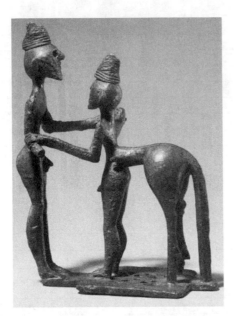

FIG. 05-03 Hero and centaur (Herakles and Nessos?), from Olympia, Greece, ca. 750–730 BCE. Bronze, 4 1/2″ high. Metropolitan Museum of Art, New York (gift of J. Pierpont).

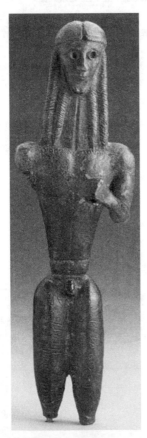

FIG. 05-04 *Mantiklos Apollo,* statuette of a youth dedicated by Mantiklos to Apollo, from Thebes, Greece, ca. 700–680 BCE. Bronze, 8″ high. Museum of Fine Arts, Boston.

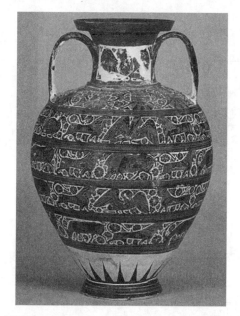

FIG. 05-05 Corinthian black-figure amphora with animal friezes, from Rhodes, Greece, ca. 625–600 BCE. 1′ 2″ high. British Museum, London.

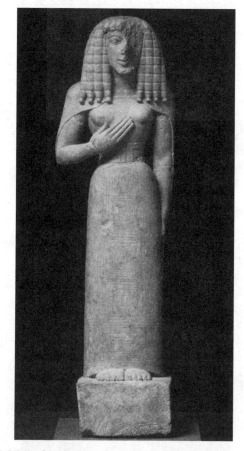

FIG. 05-06 *Lady of Auxerre,* ca. 650–625 BCE. Limestone, 2′ 1 1/2″ high. Musee du Louvre, Paris.

FIG. 05-06A Plan of Temple A, Prinias, Greece, ca. 625 BCE. (page 105)

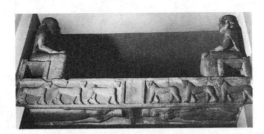

FIG. 05-06B Lintel of Temple A, Prinias, ca. 625 BCE.

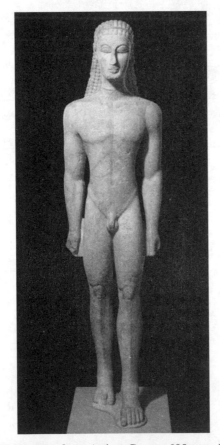

FIG. 05-07 Kouros, from Attica, Greece 600 BCE. Marble, 6′ 1/2″ high. Metropolitan Museum of Art, New York.

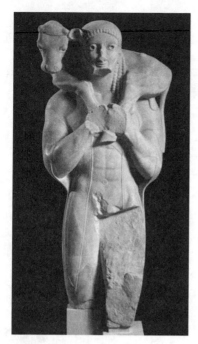

FIG. 05-08 Calf bearer, dedicated by Rhonbos on the
Acropolis, Athens, Greece, ca. 560 BCE. Marble, restored
height 5′ 5″; fragment 3′ 11 1/2″ high. Acropolis Museum,
Athens.

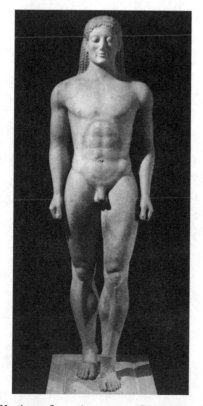

FIG. 05-09 Kroisos, from Anavysos, Greece, ca. 530 BCE.
Marble, 6′ 4″ high. National Archaeological Museum,
Athens.

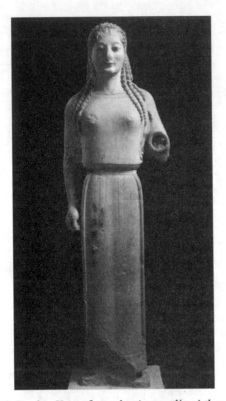

FIG. 05-10 *Peplos Kore,* from the Acropolis, Athens, Greece, ca. 530 BCE. Marble, 4′ high. Acropolis Museum, Athens.

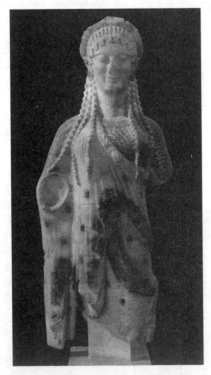

FIG. 05-11 Kore in Ionian dress, from the Acropolis, Athens, Greece, ca. 520–510 BCE. Marble, 1′ 9″ high. Acropolis Museum, Athens.

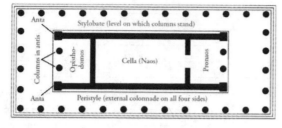

FIG. 05-12 Plan of a typical Greek peripteral temple.

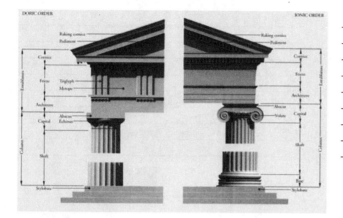

FIG. 05-13 Elevations of the Doric and Ionic orders.
(John Burge)

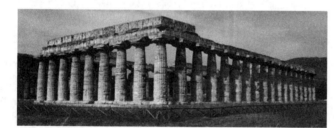

FIG. 05-14 Temple of Hera I ("Basilica"), Paestum, Italy,
ca. 550 BCE.

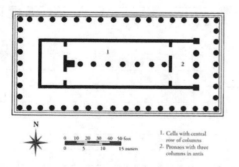

FIG. 05-15 Plan of the Temple of Hera I, Paestum, Italy,
ca. 550 BCE.

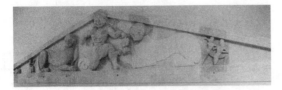

FIG. 05-16 West pediment Temple of Artemis, Corfu, Greece, ca. 600–580 BCE. Limestone, greatest height 9′ 4″. Archaeological Museum, Corfu.

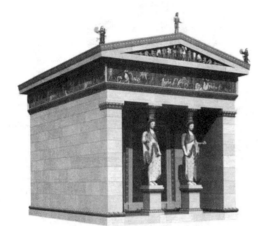

FIG. 05-17 Restored view of the Siphnian Treasury, Delphi, Greece, ca. 530 BCE (John Burge).

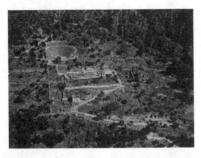

FIG. 05-17A Sanctuary of Apollo, Delphi (looking north).

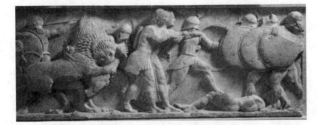

FIG. 05-18 Gigantomachy, detail of the north frieze of the Siphnian Treasury, Delphi, Greece, ca. 530 BCE. Marble, 2′ 1″ high. Archaeological Museum, Delphi.

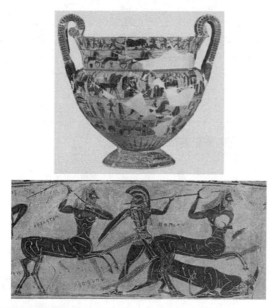

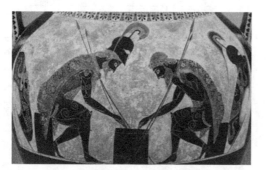

FIG. 05-19 KLEITIAS and ERGOTIMOS, *François Vase* (Athenian black-figure volute krater), from Chiusi, Italy, ca. 570 BCE. General view *(top)* and detail of centauromachy on other side of vase *(bottom)*. 2′ 2″ high. Museo Archeologico, Florence.

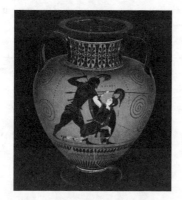

FIG. 05-20 Exekias, Achilles and Ajax playing a dice game (detail of an Athenian black-figure amphora), from Vulci, Italy, ca. 540–530 BCE. Amphora 2′ high; detail 8 1/2″ high. Musei Vaticani, Rome.

FIG. 05-20A EXEKIAS, Achilles killing Penthesilea ca. 540–530 BCE.

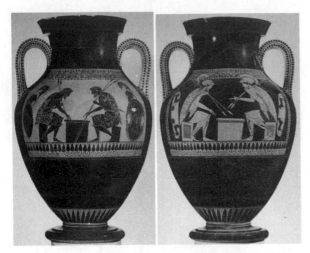

FIG. 05-21 ANDOKIDES PAINTER, Achilles and Ajax playing a dice game (Athenian bilingual amphora), from Orvieto, Italy, ca. 525–520 BCE. Black-figure side *(left)* and red-figure side *(right)*. 1′ 9″ high. Museum of Fine Arts, Boston.

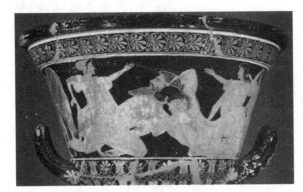

FIG. 05-22 EUPHRONIOS, Herakles wrestling Antaios (detail of an Athenian red-figure calyx krater), from Cerveteri, Italy, ca. 510 BCE. Whole vessel 1′ 7″ high. Detail 7 3/4″ high. Louvre, Paris.

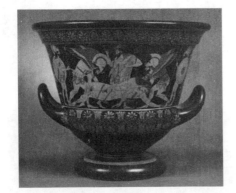

FIG. 05-22A Euphronios, Death of Sarpedon, ca. 515 BCE.

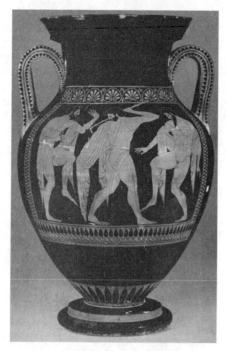

FIG. 05-23 EUTHYMIDES, Three revelers (Athenian red-figure amphora), from Vulci, Italy, ca. 510 BCE. 2′ high. Staatliche Antikensammlungen, Munich.

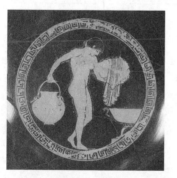

FIG. 05-23A Onesimos, Girl preparing to bathe, ca. 490 BCE.

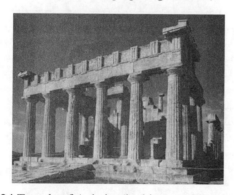

FIG. 05-24 Temple of Aphaia, (looking southwest) Aegina, Greece, ca. 500–490 BCE.

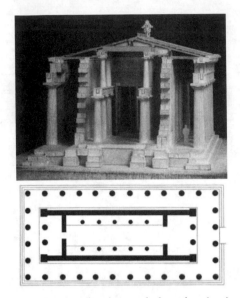

FIG. 05-25 Model showing internal elevation (top) and plan (bottom) of the Temple of Aphaia, Aegina, Greece, ca. 500–490 BCE. Model: Glyptothek, Munich.

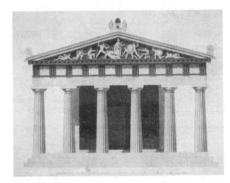

FIG. 05-26 Gullaume-Abel Blout, restored view of the facade of the Temple of Aphaia, Aegina, Greece, ca. 500–490 BCE.

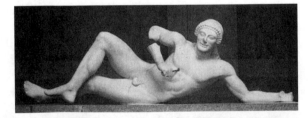

FIG. 05-27 Dying warrior, from the west pediment of the Temple of Aphaia, Aegina, Greece, ca. 490 BCE. Marble, 5′ 2 1/2″ long. Glyptothek, Munich.

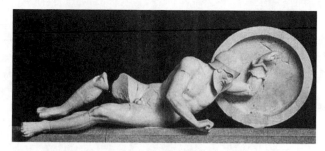

FIG. 05-28 Dying warrior, from the east pediment of the Temple of Aphaia, Aegina, Greece, ca. 480 BCE. Marble, 6′ 1″ long. Glyptothek, Munich.

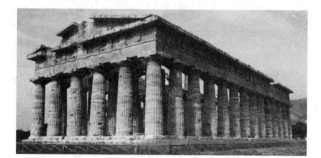

FIG. 05-29 Temple of Hera II or Apollo (looking northeast) Paestum, Italy, ca. 460 BCE.

FIG. 05.30 Chariot race of Pelops and Oinomaos East pediment from the Temple of Zeus, Olympia, Greece, ca. 470–456 BCE. Marble, 87′ wide. Archaeological Museum, Olympia. (page 119)

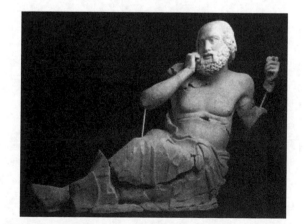

FIG. 05-31 Seer, from the east pediment (FIG. 5–30) of the Temple of Zeus, Olympia, Greece, ca. 470–456 BCE. Marble, 4′6″ high. Archaeological Museum, Olympia.

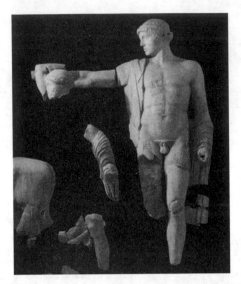

FIG. 05-32 Apollo, from the west pediment (FIG. 5–32A of the Temple of Zeus, Olympia, Greece, ca. 470–456 BCE. Marble, restored height 10′8″. Archaeological Museum, Olympia.

FIG. 05-32A West pediment, Temple of Zeus, Olympia, ca. 470–456 BCE.

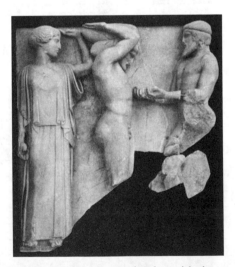

FIG. 05-33 Athena, Herakles, and Atlas with the apples of the Hesperides, metope from the Temple of Zeus, Olympia, Greece, ca. 470–456 BCE. Marble, 5′ 3″ high. Archaeological Museum, Olympia.

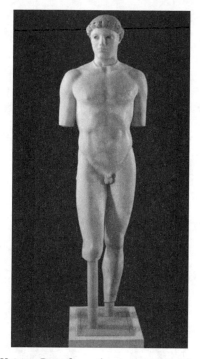

FIG. 05-34 *Kritios Boy,* from the Acropolis, Athens, Greece, ca. 480 BCE. Marble, 2′ 10″ high. Acropolis Museum, Athens.

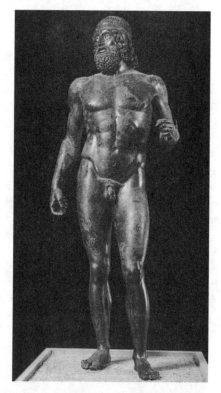

FIG. 05-35 Warrior, from the sea off Riace, Italy, ca. 460–450 BCE. Bronze, 6′ 6″ high. Museo Archeo-logico Nazionale, Reggio Calabria.

FIG. 05-36 Two stages of the lost-wax method of bronze casting (after Sean A. Hemingway).

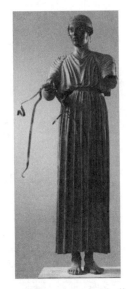

FIG. 05-37 Charioteer, from a group dedicated by Polyzalos of Gela in the sanctuary of Apollo, Delphi, Greece, ca. 470 BCE. Bronze, 5′ 11″ high. Archaeological Museum, Delphi.

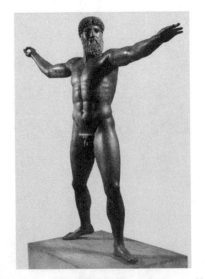

FIG. 05-38 Zeus (or Poseidon?), from the sea off Cape Artemision, Greece, ca. 460–450 BCE. Bronze, 6′ 10″ high. National Archaeological Museum, Athens.

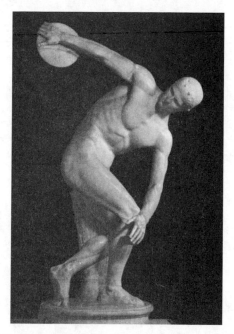

FIG. 05-39 MYRON, *Diskobolos (Discus Thrower).* Roman marble copy of a bronze original of ca. 450 BCE, 5′ 1″ high. Museo Nazionale Romano—Palazzo Massimo alle Terme.

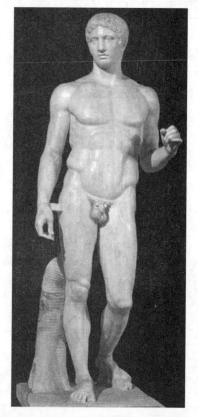

FIG. 05-40 POLYKLEITOS, *Doryphoros (Spear Bearer).* Roman copy from the palaestra, Pompeii, Italy of a bronze original of ca. 450–440 BCE, 6′ 11″ high. Museo Archeologico Nazionale, Naples.

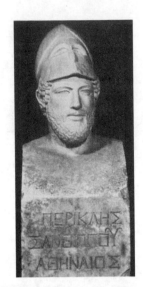

FIG. 05-41 Kresilas, Pericles. Roman herm copy of the head of a bronze statute of ca. 429 BCE. Marble, full herm 6′ high; detail 4′ 6 1/2″ high, Musei Vaticani, Rome

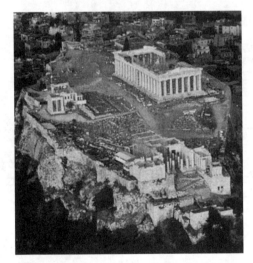

FIG. 05-42 Aerial view of the Acropolis (looking southeast), Athens, Greece.

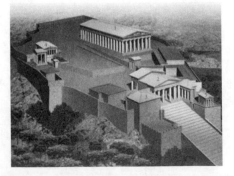

FIG. 05-43 Restored view of the Acropolis, Athens, Greece (John Burge). (1) Parthenon, (2) Propylaia, (3) pinakotheke, (4) Erechtheion, (5) Temple of Athena Nike.

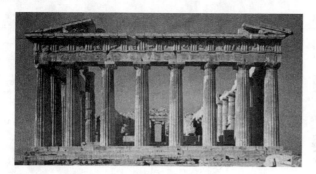

FIG. 05-44 Iktinos and Kallikrates, east facade of the Parthenon, Acropolis Athens, Greece, 447–438 BCE.

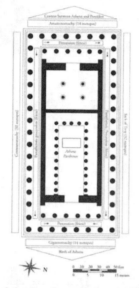

FIG. 05-45 Plan of the Parthenon, Acropolis, Athens, Greece, with diagram of the sculptural program (after Andrew Stewart), 447–432 BCE.

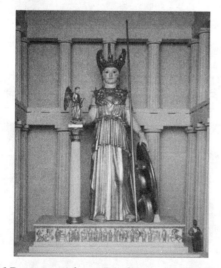

FIG. 05-46 PHIDIAS, _Athena Parthenos,_ in the cella of the Parthenon, Acropolis, Athens, Greece, ca. 438 BCE. Model of the lost chryselephantine statue. Royal Ontario Museum, Toronto.

77

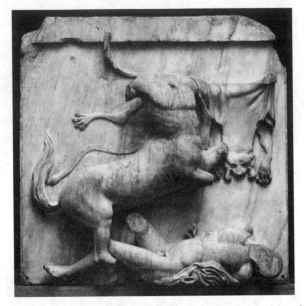

FIG. 05-47 Centauromachy metope from the south side of the Parthenon, Acropolis, Athens, Greece, ca. 447–438 BCE. Marble, 4′ 8″ high. British Museum, London.

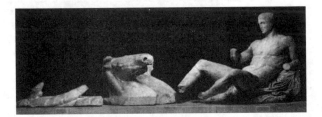

FIG. 05-48 Helios and his horses, and Dionysos (Herakles?), from the east pediment of the Parthenon, Acropolis, Athens, Greece, ca. 438–432 BCE. Marble, greatest height 4′ 3″. British Museum, London.

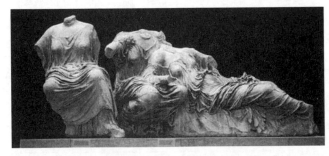

FIG. 05-49 Three goddesses (Hestia, Dione, and Aphrodite?), from the east pediment of the Parthenon, Acropolis, Athens, Greece, ca. 438–432 BCE. Marble, greatest height 4′ 5″. British Museum, London.

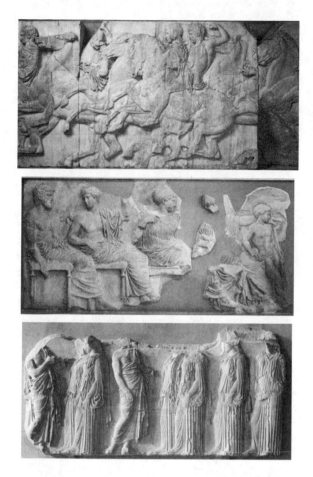

FIG. 05-50 Three details of the Panathenaic Festival procession frieze, from the Parthenon, Acropolis, Athens, Greece, ca. 447–438 BCE. Marble, 3′ 6″ high. Horsemen of north frieze *(top),* British Museum, London; seated gods and goddesses (Poseidon, Apollo, and Artemis) of east frieze *(center),* Acropolis Museum, Athens; and elders and maidens of east frieze *(bottom),* Louvre, Paris.

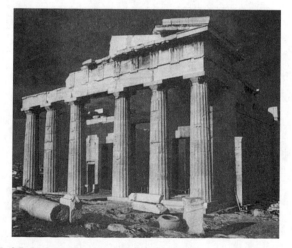

FIG. 05-51 MNESIKLES, Propylaia (looking southwest), Acropolis, Athens, Greece, 437–432 BCE.

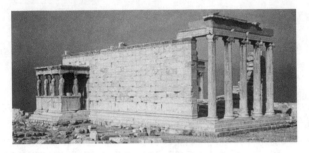

FIG. 05-52 Erechtheion (looking northwest), Acropolis, Athens, Greece, ca. 421–405 BCE.

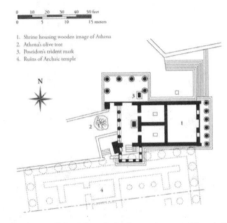

FIG. 05-53 Plan of the Erechtheion, Acropolis, Athens, Greece, ca. 421–405 BCE.

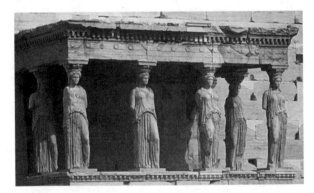

FIG. 05-54 Caryatids of the south porch of the Erechtheion, Acropolis, Athens, Greece, ca. 421–405 BCE. Marble, 7′7″ high.

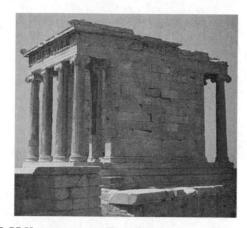

FIG. 05-55 KALLIKRATES, Temple of Athena Nike (looking southwest), Acropolis, Athens, Greece, ca. 427–424 BCE.

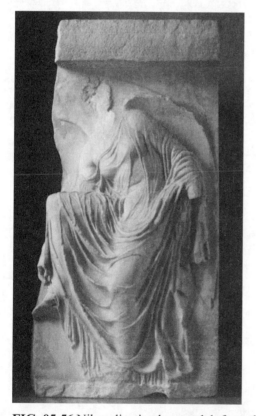

FIG. 05-56 Nike adjusting her sandal, from the south side of the parapet of the Temple of Athena Nike, Acropolis, Athens, Greece, ca. 410 BCE. Marble, 3′ 6″ high. Acropolis Museum, Athens.

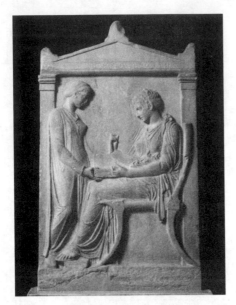

FIG. 05-57 Grave stele of Hegeso, from the Dipylon cemetery, Athens, Greece, ca. 400 BCE. Marble, 5′ 2″ high. National Archaeological Museum, Athens.

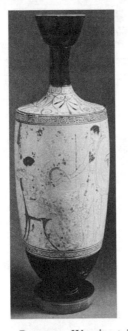

FIG. 05-58 ACHILLES PAINTER, Warrior taking leave of his wife (Athenian white-ground lekythos), from Eretria, Greece, ca. 440 BCE. 1′ 5″ high. National Archaeological Museum, Athens.

FIG. 05-58A Reed Painter, warrior seated at his tomb, ca. 410–400 BCE.

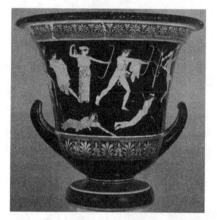

FIG. 05-59 NIOBID PAINTER, Artemis and Apollo slaying the children of Niobe (Athenian red–figure calyx krater), from Orvieto, Italy, ca. 450 BCE. 1′ 9″ high. Louvre, Paris.

FIG. 05-60 PHIALE PAINTER, Hermes bringing the infant Dionysos to Papposilenos (Athenian white–ground calyx krater), from Vulci, Italy, ca. 440–435 BCE. 1′ 2″high. Musei Vaticani, Rome.

83

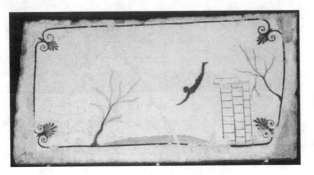

FIG. 05-61 Youth diving, cover slab of the Tomb of the Diver, Tempe del Prete necropolis, Paestum, Italy, ca. 480–470 BCE. Fresco, 3′4″ high. Museo Archeologico Nazionale, Paestum.

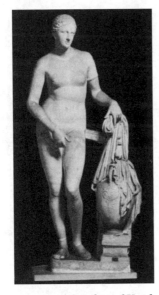

FIG. 05-62 PRAXITELES, *Aphrodite of Knidos.* Roman copy of a marble statute of ca. 350–340 BCE. 6′ 8″ high. Musei Vaticani, Rome.

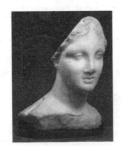

FIG. 05-62A Head of a woman, from Chios, Greece, ca. 320–300 BCE.

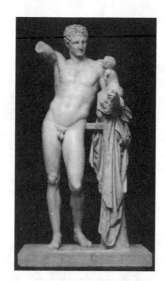

FIG. 05-63 PRAXITELES(?), Hermes and the infant
Dionysos, from the Temple of Hera, Olympia, Greece.
Copy of a statue by Praxiteles of ca. 340 BCE or an original
work of ca. 330–270 BCE by a son or grandson. Marble,
7′ 1″ high. Archaeological Museum, Olympia.

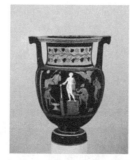

FIG. 05-63A Artist painting a marble statue of Herakles,
ca. 350–320 BCE.

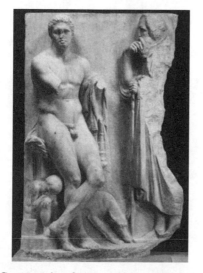

FIG. 05-64 Grave stele of a young hunter, found near the
Ilissos River, Athens, Greece, ca. 340–330 BCE. Marble,
5′ 6″ high. National Archaeological Museum, Athens.

FIG. 05-64A Herakles, Temple of Athena Alea, Tegea, ca. 340 BCE.

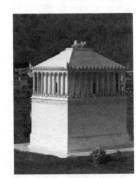

FIG. 05-64B Mausoleum, Halikarnassos, ca. 353–340 BCE.

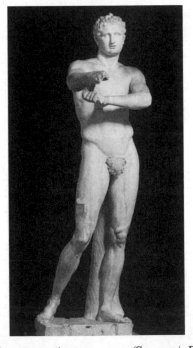

FIG. 05-65 LYSIPPOS, *Apoxyomenos (Scraper)*. Roman copy of a bronze statute of ca. 330 BCE, 6′ 9″ high. Musei Vaticani, Rome.

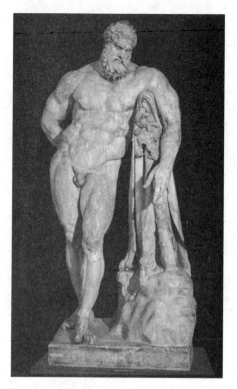

FIG. 05-66 LYSIPPOS, Weary Herakles *(Farnese Herakles)*. Roman statue from the Baths of Caracalla (FIG. 7–66), Rome, Italy, signed by GLYKON OF ATHENS, of a bronze original of ca. 320 BCE. 10′ 5″ high. Museo Archeologico Nazionale, Naples.

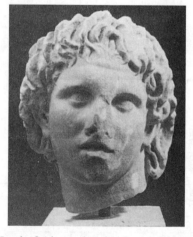

FIG. 05-67 Head of Alexander the Great, from Pella, Greece, third century BCE. Marble, 1′ high. Archaeological Museum, Pella.

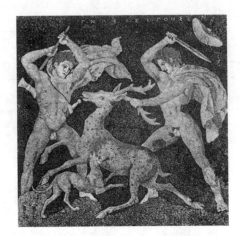

FIG. 05-68 GNOSIS, Stag hunt, from Pella, Greece, ca. 300 BCE. Pebble mosaic, figural panel 10′ 2″ high. Archaeological Museum, Pella.

FIG. 05-69 Hades abducting Persephone, detail of a wall painting in tomb 1, Vergina, Greece, mid-fourth century BCE. 3′ 3 1/2″ high.

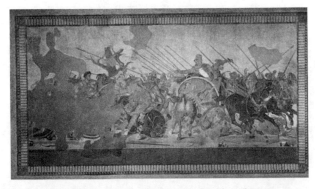

FIG. 05-70 PHILOXENOS OF ERETRIA, *Battle of Issus,* ca. 310 BCE. Roman copy *(Alexander Mosaic)* from the House of the Faun, Pompeii, Italy, late second or early first century BCE. Tessera mosaic, 8′ 10″ × 16′ 9″. Museo Archeologico Nazionale, Naples.

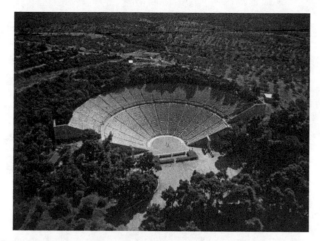

FIG. 05-71 POLYKLEITOS THE YOUNGER, aerial view of the theater (looking northeast), Epidauros, Greece ca. 350 BCE.

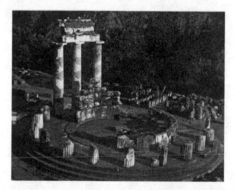

FIG. 05-72 THEODOROS OF PHOKAIA, Tholos, Delphi, Greece, ca. 375 BCE.

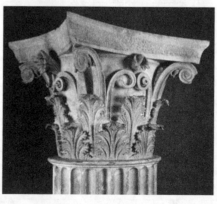

FIG. 05-73 POLYKLEITOS THE YOUNGER, Corinthian capital, from the tholos, Epidauros, Greece, ca. 350 BCE. Archaeological Museum, Epidauros.

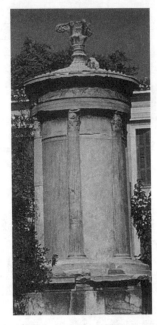

FIG. 05-74 Choragic Monument of Lysikrates, Athens, Greece, 334 BCE.

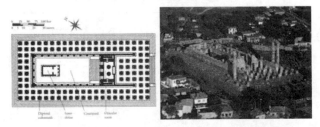

FIG. 05-75 Paionios of Ephesos and Daphnis of Miletos, aerial view looking east (left) and plan (right) of the Temple of Apollo, Didyma, Turkey, begun 313 BCE.

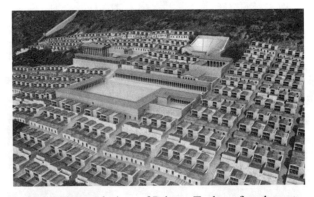

FIG. 05-76 Restored view of Priene, Turkey, fourth century BCE and later (John Burge).

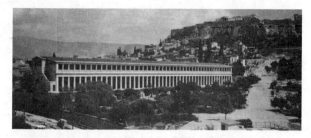

FIG. 05-77 Stoa of Attalos II, Agora, Athens, Greece, ca. 150 BCE (looking southeast with Acropolis in the background).

FIG. 05-78 Reconstructed west front of the Altar of Zeus, Pergamon, Turkey, ca. 175 BCE. Staatliche Museen, Berlin.

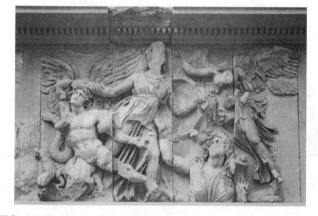

FIG. 05-79 Athena battling Alkyoneos, detail of the gigantomachy frieze, from the Altar of Zeus, Pergamon, Turkey, ca. 175 BCE. Marble, 7′ 6″ high. Staatliche Museen, Berlin.

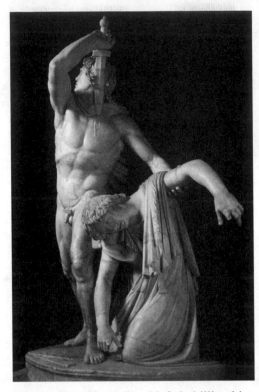

FIG. 05-80 Epigonos(?), Gallic chieftain killing himself and his wife. Roman copy of a bronze statute from Pergamon, Turkey, of ca. 230–220 BCE, 6′ 11″ high. Museo Nazionale Romano—Palazzo Altemps, Rome.

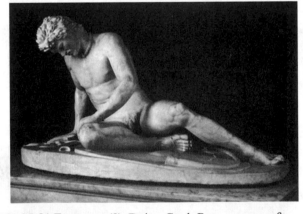

FIG. 05-81 Epigonos(?), Dying Gaul. Roman copy of a bronze statue from Peramon, Turkey of ca. 230–220 BCE, 3′ 1/2″ high. Museo Capitolino, Rome.

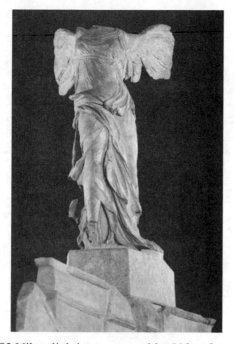

FIG. 05-82 Nike alighting on a warship *(Nike of Samothrace),* from Samothrace, Greece, ca. 190 BCE. Marble, figure 8′ 1″ high. Musee du Louvre, Paris.

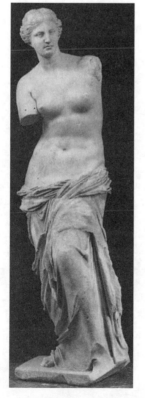

FIG. 05-83 ALEXANDROS OF ANTIOCH-ON-THE-MEANDER, Aphrodite *(Venus de Milo),* from Melos, Greece, ca. 150–125 BCE. Marble, 6′ 7″ high. Musee du Louvre, Paris.

FIG. 05-83A Aphrodite, Eros, and Pan, Delos, ca. 100 BCE.

FIG. 05-84 Sleeping satyr *(Barberini Faun),* from Rome, Italy, ca. 230–200 BCE. Marble, 7′ 1″ high. Glyptothek, Munich.

FIG. 05-85 Sleeping Eros, from Rhodes, ca. 150–100 BCE. Bronze, 2′ 9 1/2″ long. Metropolitan Museum of Art, New York (Rogers Fund, 1943).

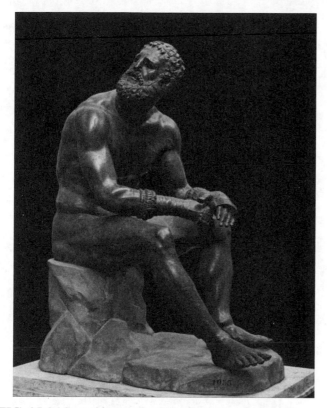

FIG. 05-86 Seated boxer, from Rome, Italy, ca. 100–50 BCE. Bronze, 4′ 2″ high. Museo Nazionale Romano–Palazzo Massimo alle Terme, Rome.

FIG. 05-87 Old market woman, ca. 150–100 BCE. Marble, 4′ 1/2″ high. Metropolitan Museum of Art, New York.

95

FIG. 05-88 POLYEUKTOS, Demosthenes. Roman marble copy of a bronze original of ca. 280 BCE. 6′ 7 1/2″ high. Ny Carlsberg Glyptotek, Copenhagen.

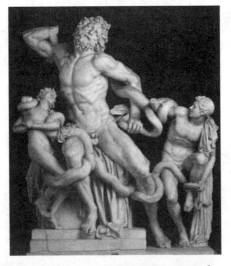

FIG. 05-89 ATHANADOROS, HAGESANDROS, and POLYDOROS OF RHODES, Laocoön and his sons, from Rome, Italy, early first century CE. Marble, 7′ 10 1/2″ high. Musei Vaticani, Rome.

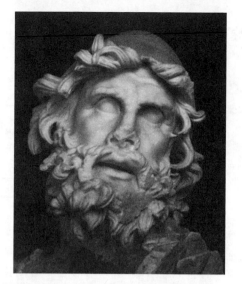

FIG. 05-90 ATHANADOROS, HAGESANDROS, and POLYDOROS OF RHODES, head of Odysseus, from the villa of Tiberius, Sperlonga, Italy, early first century CE. Marble, 2′ 1 1/4″ high. Museo Archeologico, Sperlonga.

Chapter 6

The Etruscans

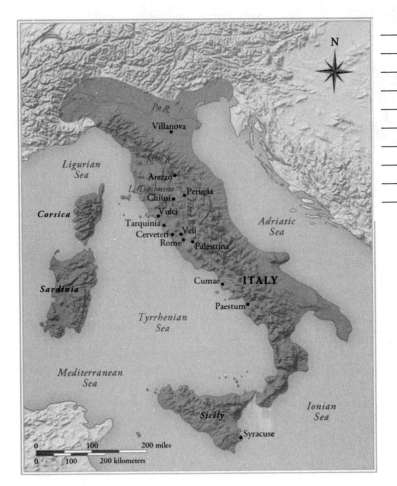

MAP 6-1 Italy in Etruscan times.

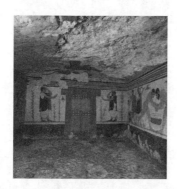

FIG. 06-01 Interior of the tomb of the Augurs, Monterozzi necropolis, Tarquinia, ca. 520 BCE.

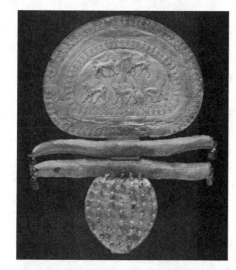

FIG. 06-02 Fibula with Orientalizing lions, from the Regolini-Galassi Tomb, Cerveteri, Italy, ca. 650–640 BCE. Gold 1′ 1/2″ high. Musei Vaticani, Rome.

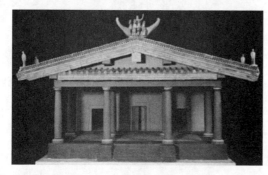

FIG. 06-03 Model of a typical sixth-century BCE Etruscan temple as described by Vitruvius. Istituto di Etruscologia e di Antichità Italiche, Università di Roma, Rome.

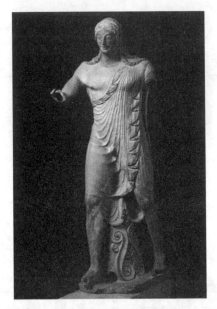

FIG. 06-04 Apulu (Apollo of Veli), from the roof of the Portonaccio temple, Veii, Italy, ca. 510–500 BCE. Painted terracotta, 5′ 11″ high. Museo Nazionale di Villa Giulia, Rome.

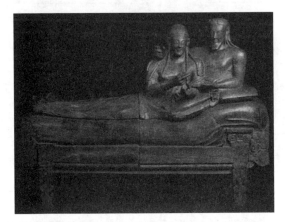

FIG. 06-05 Sarcophagus with reclining couple, from Cerveteri, Italy, ca. 520 BCE. Painted terracotta 3′ 9 1/2″ × 6′ 7″. Museo Nazionale di Villa Giulia, Rome.

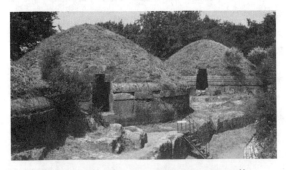

FIG. 06-06 Tumuli in the Banditaccia necropolis, Cerveteri, Italy, seventh to second centuries BCE.

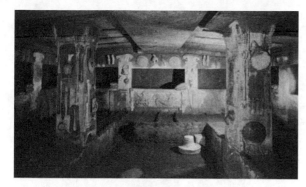

FIG. 06-07 Interior of the Tomb of the Shields and Chairs, Banditaccia necropolis, Cerveteri, Italy, ca. 550–500 BCE.

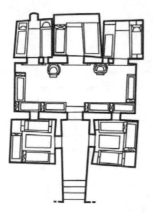

FIG. 06-07A Plan of the Tomb of the Shields and Chairs, Cerveteri, 550–500 BCE.

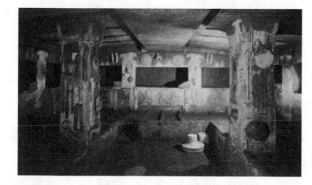

FIG. 06-08 Interior of the Tomb of the Reliefs, Banditaccia necropolis, Cerveteri, Italy, late fourth or early third century BCE.

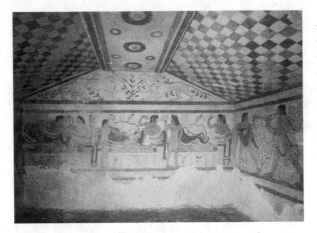

FIG. 06-09 Interior of the Tomb of the Leopards, Tarquinia, Italy, ca. 480–470 BCE.

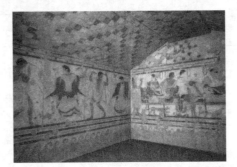

FIG. 06-09A Interior of the Tomb of the Triclinium, Tarquinia, ca. 480–470 BCE.

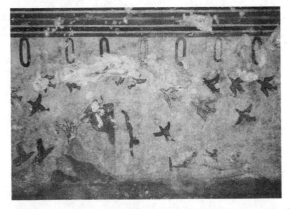

FIG. 06-10 Diving and fishing, detail of the left wall of the Tomb of Hunting and Fishing, Monterozzi necropolis, Tarquinia, Italy, ca. 530–520 BCE. Fresco, detail 5′ 6 1/2″ high.

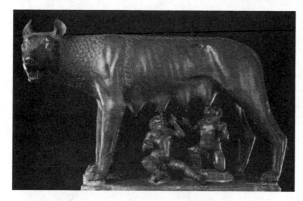

FIG. 06-11 *Capitoline Wolf,* from Rome, Italy, ca. 500–480 BCE. Bronze, 2′ 7 1/2″ high. Musei Capitolini, Rome.

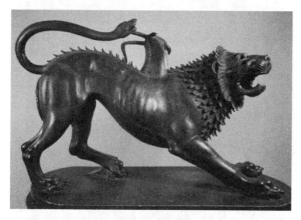

FIG. 06-12 *Chimera of Arezzo,* from Arezzo, Italy, first half of fourth century BCE. Bronze, 2′ 7 1/2″ high. Museo Archeologico Nazionale, Florence.

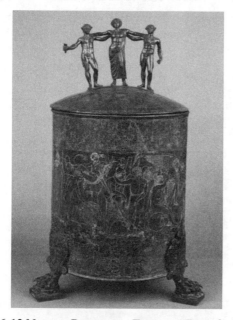

FIG. 06-13 NOVIOS PLAUTIOS, *Ficoroni Cista,* from Palestrina, Italy, late fourth century BCE. Bronze 2′ 6″ high. Museo Nazionale di Villa Giulia, Rome.

FIG. 06-13A Chalchas examining a liver, ca. 400–375 BCE.

FIG. 06-14 Porta Marzia, Perugia, Italy, second century BCE. (page 233)

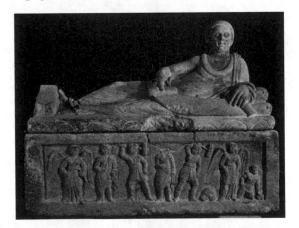

FIG. 06-15 Sarcophagus of Lars Pulena, from Tarquinia, Italy, late third or early second century BCE. Tufa, 6′ 6″ long. Museo Archeologico Nazionale, Tarquinia.

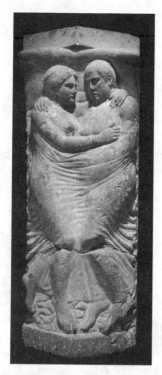

FIG. 06-15A Sarcophagus of Ramtha Visnai and Arnth
Tetnies, ca. 350–300 BCE.

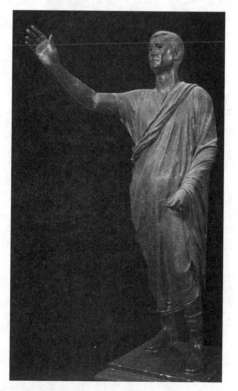

FIG. 06-16 Aule Metele *(Arringatore),* from Cortona,
Italy, early first century BCE. Bronze, 5′ 7″ high. Museo
Archeologico Nazionale, Florence.

Chapter 7

The Roman Empire

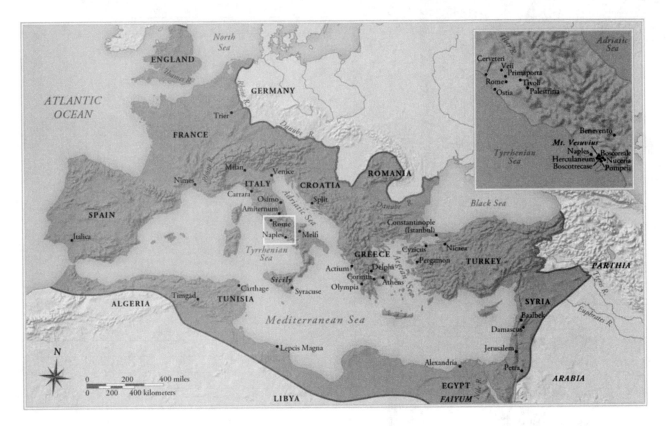

MAP 7-1 The Roman Empire at the death of Trajan in 117 CE.

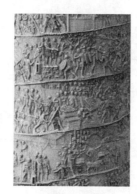

FIG. 07-01 Detail of the three bands of the spiral frieze of the Column of Trajan (fig. 7–45), Forum of Trajan, Rome, Italy, dedicated 112 CE.

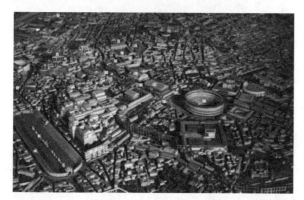

FIG. 07-02 Model of the city of Rome during the early fourth century CE. Museo della Civiltà Romana, Rome. (1) Temple of Portunus, (2) Circus Maximus, (3) Palatine Hill, (4) Temple of Jupiter Capitolinus, (5) Pantheon, (6) Column of Trajan, (7) Forum of Trajan, (8) Markets of Trajan, (9) Forum of Julius Caesar, (10) Forum of Augustus, (11) Forum Romanum, (12) Basilica Nova, (13) Arch of Titus, (14) Temple of Venus and Roma, (15) Arch of Constantine, (16) Colossus of Nero, (17) Colosseum.

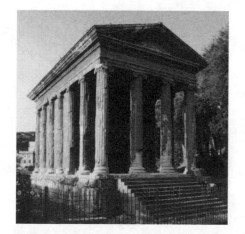

FIG. 07-03 Temple of Portunus (Temple of Fortuna Virilis), Rome, Italy, ca. 75 BCE.

FIG. 07-04 Temple of Vesta(?), Tivoli, Italy, early first century BCE.

FIG. 07-05 Restored view of the Sanctuary of Fortuna Primigenia, Palestrina, Italy, late second century, BCE (John Burge).

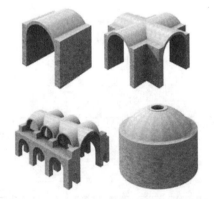

FIG. 07-06 Roman concrete construction. (a) barrel vault, (b) groin vault, (c) fenestrated sequence of groin vaults, (d) hemispherical dome with oculus (John Burge).

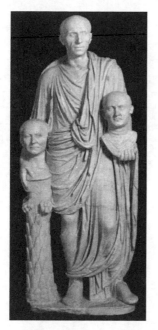

FIG. 07-07 Man with portrait busts of his ancestors, from Rome, late first century BCE. Marble, 5′ 5″ high. Musei-Capitolini-Centro Montemartini, Rome.

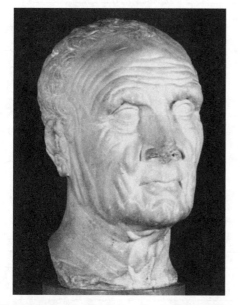

FIG. 07-08 Head of an old man, from Osimo, mid-first century BCE. Marble, life-size. Palazzo del Municipio, Osimo.

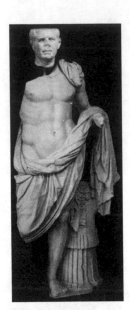

FIG. 07-09 Portrait of a Roman general, from the
Sanctuary of Hercules, Tivoli, Italy, ca. 75–50 BCE.
Marble, 6′ 2″ high. Museo Nazionale Romano–Palazzo
Massimo alle Terme, Rome.

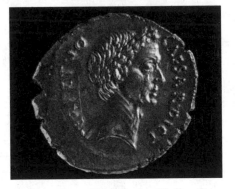

FIG. 07–10 Denarius with portrait of Julius Caesar
44 BCE. Silver, diameter 3/4″. American Numismatic
Society, New York.

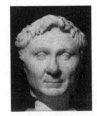

FIG. 07-10A Pompey the Great, ca. 55–50 BCE.

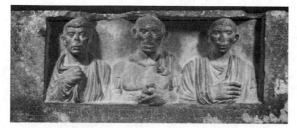

FIG. 07-11 Funerary relief with portraits of the Gessii, from Rome(?), Italy, ca. 30 BCE. Marble, 2′ 1 1/2″ high. Museum of Fine Arts, Boston.

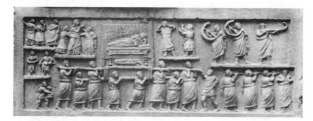

FIG. 07-11A Funerary procession, Amitemum, ca. 50–1 BCE.

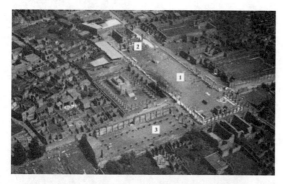

FIG. 07-12 Aerial view of the forum (looking northeast), Pompeii, Italy, second century BCE and later. (1) forum, (2) Temple of Jupiter (Capitolium), (3) basilica.

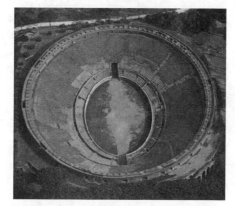

FIG. 07-13 Aerial view of the amphitheater, (looking southeast), Pompeii, Italy, ca. 70 BCE.

FIG. 07-14 Brawl in the Pompeii amphitheater, wall painting from House I,3,23, Pompeii, Italy, ca. 60–79 CE. Fresco, 5′ 7″ × 6′ 1″. Museo Archeologico Nazionale, Naples.

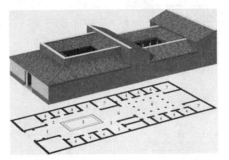

FIG. 07-15 Restored view and plan of a typical Roman house of the Late Republic and Early Empire (John Burge). (1) fauces, (2) atrium, (3) impluvium, (4) cubiculum, (5) ala, (6) tablinum, (7) triclinium, (8) peristyle.

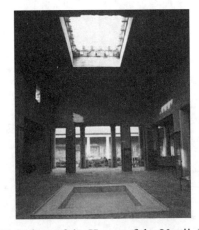

FIG. 07-16 Atrium of the House of the Vettii, Pompeii, Italy, second century, BCE, rebuilt 62–79 CE.

112

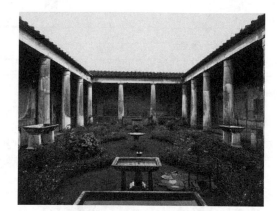

FIG. 07-16A Peristyle, House of the Vettii, second century BCE.

FIG. 07-17 First Style wall painting in the fauces of the Samnite House, Herculaneum, Italy, late second century BCE.

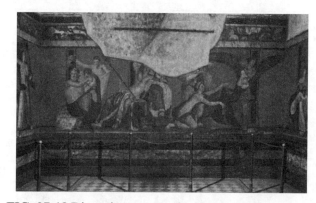

FIG. 07-18 Dionysiac mystery frieze, Second Style wall paintings in room 5 of the Villa of the Mysteries, Pompeii, Italy, ca. 60–50 BCE. Fresco, frieze 5′ 4″ high.

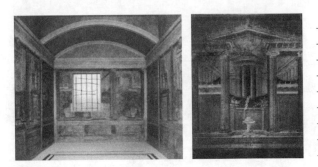

FIG. 07-19 Second Style wall paintings (general view, *left,* and detail of tholos, *right)* from cubiculum M of the Villa of Publius Fannius Synistor, Boscoreale, Italy, ca. 50–40 BCE. Fresco, 8′ 9″ high. Metropolitan Museum of Art, New York.

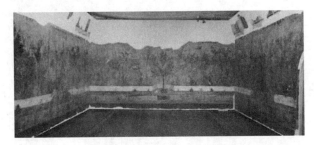

FIG. 07-20 Gardenscape, Second Style wall paintings, from the Villa of Livia, Primaporta, Italy, ca. 30–20 BCE. Fresco, 6′ 7″ high. Museo Nazionale Romano-Palazzo Massimo alle Terme, Rome.

FIG. 07-21 Detail of a Third Style wall painting, from cubiculum 15 of the Villa of Agrippa Postumus, Boscotrecase, Italy, ca. 10 BCE, Fresco, 7′ 8″ high. Metropolitan Museum of Art, New York.

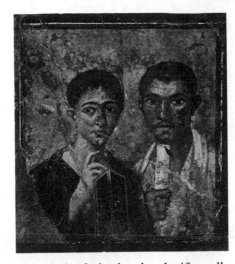

FIG. 07-25 Portrait of a husband and wife, wall painting from House VII,2,6, Pompeii, Italy, ca. 70–79 CE. Fresco, 1′ 11″ × 1′ 8 1/2″. Museo Archeologico Nazionale, Naples.

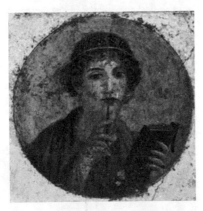

FIG. 07-25A Woman with stylus, Pompeii, ca. 55–70 CE.

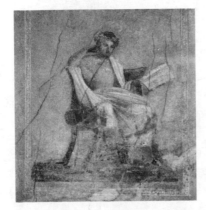

FIG. 07-25B Menander, Pompeii, ca. 62–79 CE.

116

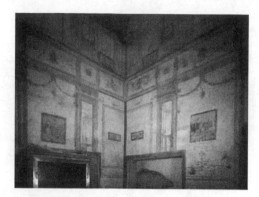

FIG. 07-22 Fourth Style wall paintings in room 78 of the Domus Aurea (Golden House, Fig. 7-35) of Nero, Rome, Italy, 64–68 CE.

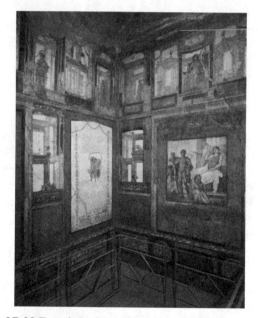

FIG. 07-23 Fourth Style wall paintings in the Ixion Room (triclinium P) of the House of the Vettii, Pompeii, Italy, ca. 70–79 CE.

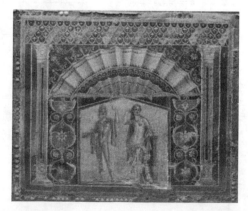

FIG. 07-24 Neptune and Amphitrite, wall mosaic in the summer triclinium of the House of Neptune and Amphitrite, Herculaneum, Italy, ca. 62–79 CE.

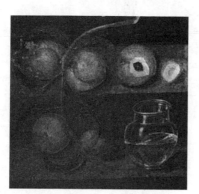

FIG. 07-26 Still life with peaches, detail of a Fourth Style wall painting, from Herculaneum, Italy, ca. 62–79 CE. Fresco, 1′ 2″ × 1′ 1 1/2″. Museo Archeologico Nazionale, Naples.

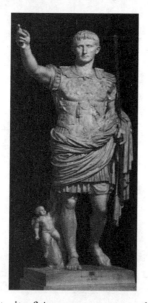

FIG. 07-27 Portrait of Augustus as general, from Primaporta, Italy, early-first-century CE copy of a bronze original of ca. 20 BCE. Marble 6′ 8″ high. Musei Vaticani, Rome.

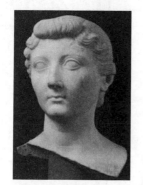

FIG. 07-28 Portait bust of Livia, from Arsinoe, Egypt, early first century CE. Marble, 1′ 1 1/2″ high. Ny Carlsberg Glyptotek, Copenhagen.

117

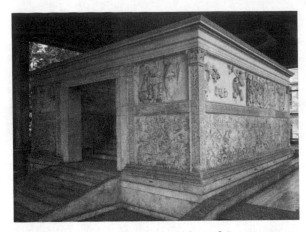

FIG. 07-29 Ara Pacis Augustae (Altar of Augustan Peace; looking northeast), Rome, Italy, 13–9 BCE.

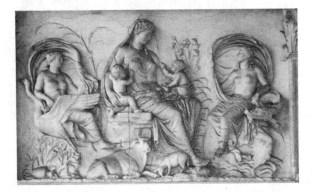

FIG. 07-30 Female personification (Tellus?), panel from the east facade of the Ara Pacis Augustae, Rome, Italy, 13–9 BCE. Marble, 5′ 3″ high.

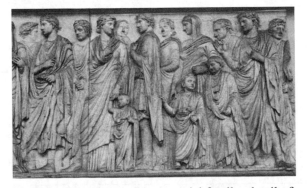

FIG. 07-31 Procession of the imperial family, detail of the south frieze of the Ara Pacis Augustae, Rome, Italy, 13–9 BCE. Marble 5′ 3″ high.

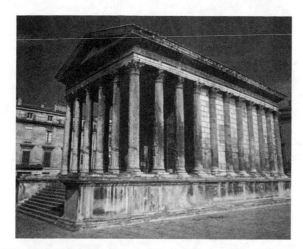

FIG. 07-32 Maison Carrée, Nîmes, France, ca. 1–10 CE.

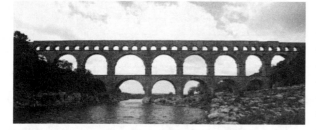

FIG. 07-33 Pont-du-Gard, Nîmes, France, ca. 16 BCE.

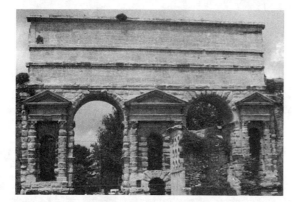

FIG. 07-34 Porta Maggiore, Rome, Italy, ca. 50 CE.

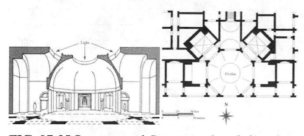

FIG. 07-35 SEVERUS and CELER, section *(left)* and plan *(right)* of the octagonal hall of the Domus Aurea (Golden House) of Nero, Rome, Italy, 64–68 CE.

119

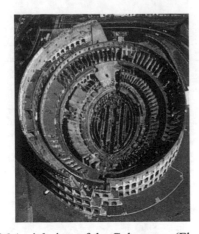

FIG. 07-36 Aerial view of the Colosseum (Flavian Amphitheater), Rome, Italy, ca. 70–80 CE.

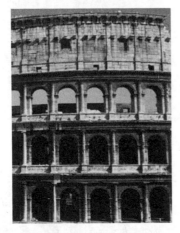

FIG. 07-37 Detail of the facade of the Colosseum (Flavian Amphitheater), Rome, Italy, ca. 70–80 BCE.

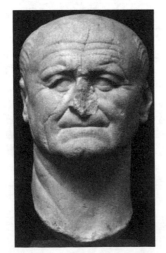

FIG. 07-38 Portrait of Vespasian, ca. 75–79 CE. Marble, 1′ 4″ high. Ny Carlsberg Glyptotek, Copenhagen.

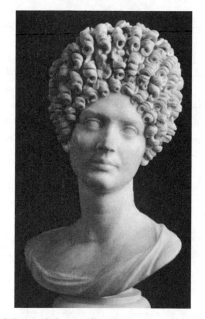

FIG. 07-39 Portrait bust of a Flavian woman, from Rome, Italy, ca. 90 CE. Marble, 2′ 1″ high. Musei Capitolini, Rome.

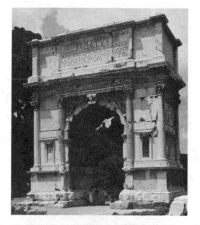

FIG. 07-40 West Facade of the Arch of Titus, Rome, Italy, after 81 CE.

FIG. 07-40A Apotheosis of Titus, after 81 CE.

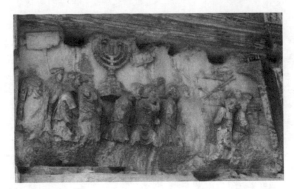

FIG. 07-41 Spoils of Jerusalem, relief panel from the Arch of Titus, Rome, Italy, after 81 CE. Marble, 7′ 10″ high.

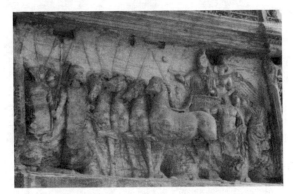

FIG. 07-42 Triumph of Titus, relief panel from the Arch of Titus, Rome, Italy, after 81 CE. Marble, 7′ 10″ high.

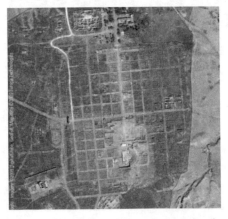

FIG. 07-43 Satellite view of Timgad, Algeria, founded 100 CE.

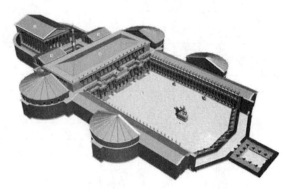

FIG. 07-44 APOLLODORUS OF DAMASCUS, Forum of Trajan, Rome, Italy, dedicated 112 CE (James E. Packer and John Burge). (1) Temple of Trajan, (2) Column of Trajan, (3) libraries, (4) Basilica Ulpia, (5) forum, (6) equestrian statue of Trajan.

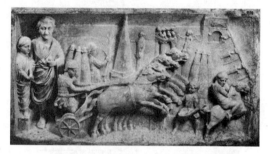

FIG. 07-44A Funerary relief of a circus official, ca. 110–130 CE.

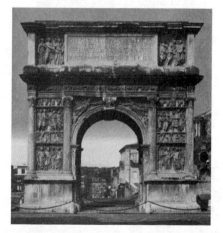

FIG. 07-44B Arch of Trahan, Benevento, ca. 114–118 CE.

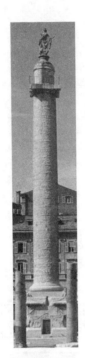

FIG. 07-45 Column of Trajan, Forum of Trajan, Rome, Italy dedicated 112 CE.

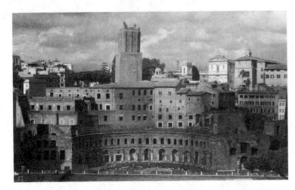

FIG. 07-46 APOLLODORUS OF DAMASCUS, aerial view of the Markets of Trajan, Rome, Italy, ca. 100–112 CE.

FIG. 07-47 APOLLODORUS OF DAMASCUS, interior of the great hall, Markets of Trajan, Rome, Italy, ca. 100–112 CE.

FIG. 07-48 Portrait bust of Hadrian, from Rome, ca. 117–120 CE. Marble, 1′ 4 3/4″ high. Museo Nazionale Romano–Palazzo Massimo alle Terme, Rome.

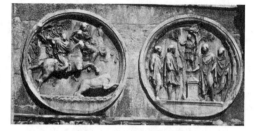

FIG. 07-48A Hadrianic hunting tondi, ca. 130–138 CE.

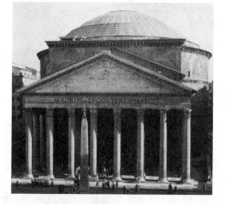

FIG. 07-49 Pantheon (looking south), Rome, Italy, 118–125 CE.

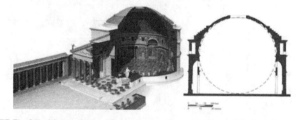

FIG. 07-50 Restored cutaway view *(left)* and lateral section *(right)* of the Pantheon, Rome, Italy, 118–125 CE. (John Burge).

125

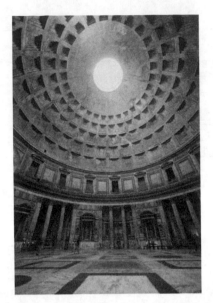

FIG. 07–51 Interior of the Pantheon, Rome, Italy, 118–125 CE.

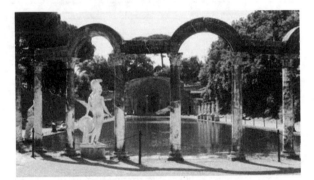

FIG. 07–52 Canopus and Serapeum, Hadrian's Villa, Tivoli, Italy, ca. 125–128 CE.

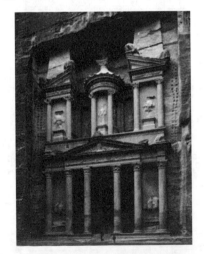

FIG. 07-53 Al-Khazneh ("Treasury"), Petra, Jordan, second century CE.

FIG. 07-54 Model of an insula, Ostia, Italy, second century CE. Museo della Civiltà Romana, Rome.

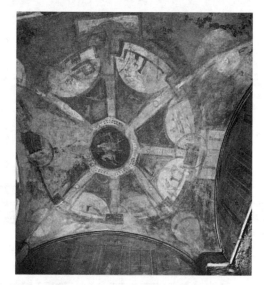

FIG. 07-54A Insula of Painted Vaults, Ostia, ca. 200–220 CE.

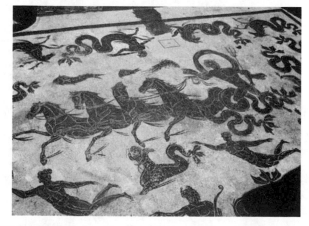

FIG. 07-55 Neptune and creatures of the sea, detail of a floor mosaic in the Baths of Neptune, Ostia, Italy, ca. 140 CE.

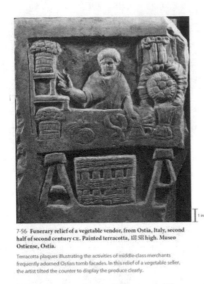

7-56 Funerary relief of a vegetable vendor, from Ostia, Italy, second half of second century CE. Painted terracotta, 1′ 5″ high. Museo Ostiense, Ostia.

Terracotta plaques illustrating the activities of middle-class merchants frequently adorned Ostian tomb facades. In this relief of a vegetable seller, the artist tilted the counter to display the produce clearly.

FIG. 07-56 Funerary relief of a vegetable vendor, from Ostia, Italy, second half of second century CE. Painted terracotta, 1′ 5″ high. Museo Ostiense, Ostia.

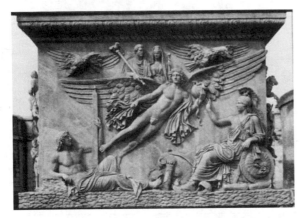

FIG. 07-57 Apotheosis of Antoninus Pius and Faustina, pedestal of the Column of Antoninus Pius, Rome, Italy, ca. 161 CE. Marble, 8′ 1 1/2″ high. Musei Vaticani, Rome.

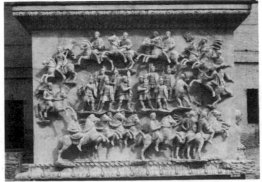

FIG. 07-58 Decursio, pedestal of the Column of Antoninus Pius, Rome, Italy, ca. 161 CE. Marble, 8′ 1 1/2″ high. Musei Vaticani, Rome.

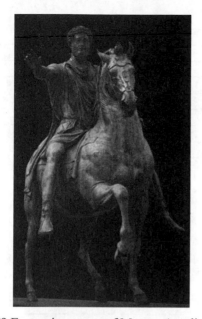

FIG. 07-59 Equestrian statue of Marcus Aurelius, from Rome, Italy, ca. 175 CE. Bronze, 11′ 6″ high. Musei Capitolini, Rome.

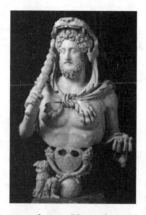

FIG. 07-59A Commodus as Hercules, ca. 190–192 CE.

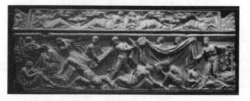

FIG. 07-60 Sarcophagus with the myth of Orestes, ca. 140–150 CE. Marble, 2′ 7 1/2″ high. Cleveland Museum of Art, Cleveland.

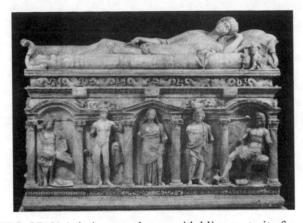

FIG. 07-61 Asiatic sarcophagus with kline portrait of a woman, from Rapolla, near Melfi, Italy, ca. 165–170 CE. Marble, 5′ 7″ high. Museo Nazionale Archeologico del Melfese, Melfi.

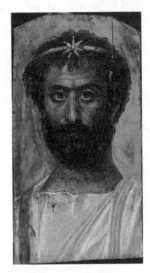

FIG. 07-62 Mummy portrait of a priest of Serapis, from Hawara (Faiyum), Egypt, ca. 140–160 CE. Encaustic on wood 1′ 4 3/4″ × 8 3/4″. British Museum, London.

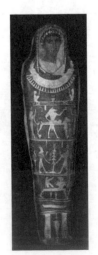

FIG. 07-62A Mummy of Artemidorus, ca. 100–120 CE.

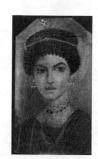

FIG. 07-62B Young woman, Haware, ca. 110–120

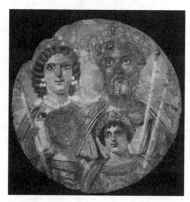

FIG. 07-63 Painted portrait of Septimius Severus and his family, from Egypt, ca. 200 CE. Tempera on wood 1′ 2″ diameter. Staatliche Museen, Berlin.

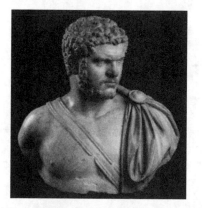

FIG. 07-64 Bust of Caracalla, ca. 211–217. Marbl. 1′10 3/4″ high. Saatiche Museen, Antikensammiung, Berlin.

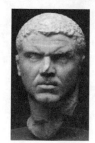

FIG. 07-64 A Portait of Caracalla, ca. 211–217 CE.

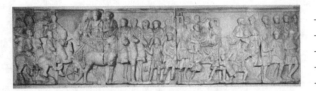

FIG. 07-65 Chariot procession of Septimius Severus, relief from the attic of the Arch of Septimius Severus, Lepcis Magna, Libya, 203 CE. Marble, 5′ 6″ high. Castle Museum, Tripoli.

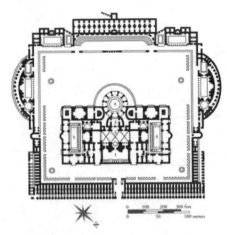

FIG. 07-66 Plan of the Baths of Caracalla, Rome, Italy, 212–216 CE. (1) natatio, (2) frigidarium, (3) tep-idarium, (4) caldarium, (5) palaestra.

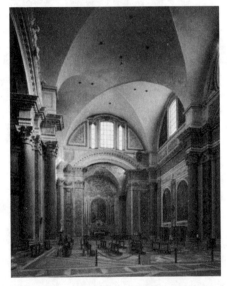

FIG. 07-67 Frigidarium, Baths of Diocletian, Rome, ca. 298–306 CE (remodeled by MICHELANGELO as the nave of Santa Maria degli Angeli, 1563).

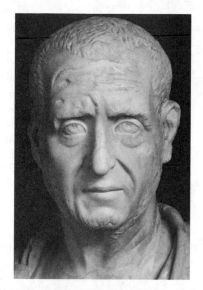

FIG. 07-68 Portrait bust of Trajan Decius, 249–251 CE. Marble, full bust 2′ 7″ high, Musei Capitolini, Rome.

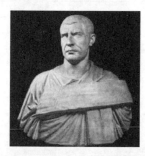

FIG. 07-68A Philip the Arabian, 244–249 CE.

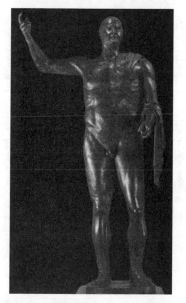

FIG. 07-69 Heroic portrait of Trebonianus Gallus, from Rome, Italy, 251–253 CE. Bronze, 7′ 11″ high. Metropolitan Museum of Art, New York.

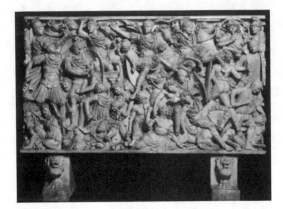

FIG. 07-70 Battle of Romans and barbarians *(Ludovisi Battle Sarcophagus),* from Rome, Italy, ca. 250–260 CE. Marble, 5′ high. Museo Nazionale Romano–Palazzo Altemps, Rome.

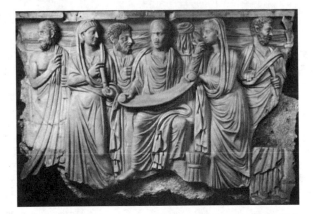

FIG. 07-71 Sarcophagus of a philosopher, ca. 270–280 CE. Marble, 4′ 11″ high. Musei Vaticani, Rome.

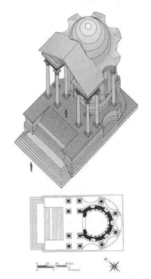

FIG. 07-72 Restored view *(top)* and plan *(bottom)* of the Temple of Venus, Baalbek, Lebanon, third century CE.

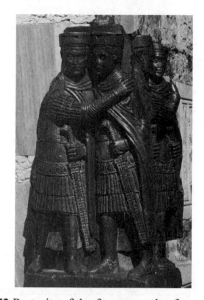

FIG. 07-73 Portraits of the four tetrarchs, from Constantinople, ca. 305 CE. Porphyry, 4′ 3″ high. Saint Mark's, Venice.

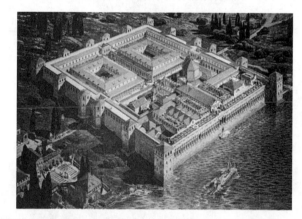

FIG. 07-74 Restored view of the palace of Diocletian, Split, Croatia, ca. 298–306.

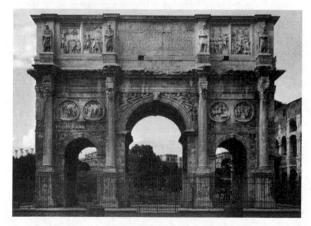

FIG. 07-75 South facade of the Arch of Constantine, Rome, Italy, 312–315 CE.

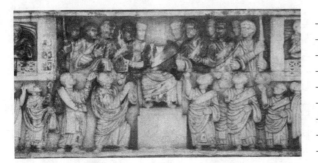

FIG. 07-76 Distribution of largesse, detail of the north frieze of the Arch of Constantine, Rome, Italy, 312–315 CE. Marble, 3′ 4″ high.

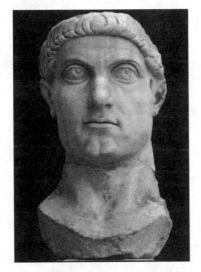

FIG. 07-77 Colossal head of Constantine, from the Basilica Nova, Rome, Italy, ca. 315–330 CE. Marble, 8′ 6″ high. Musei Capitolini, Rome.

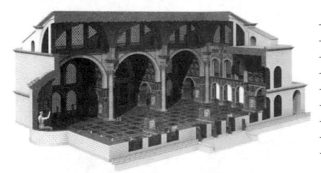

FIG. 07-78 Restored cutaway view of the Basilica Nova, Rome, Italy, ca. 306–312 CE. (John Burge).

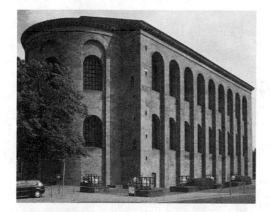

FIG. 07-79 Exterior of the Aula Palatina (looking southeast), Trier, Germany, early fourth century CE.

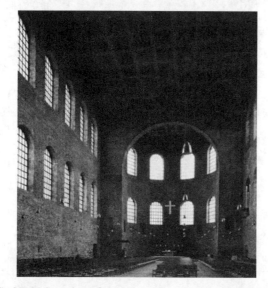

FIG. 07-80 Interior of the Aula Palatina (looking north), trier, germany, early fourth century

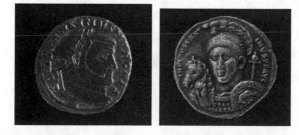

FIG. 07-81 Two coins with portraits of Constantine. Left: nummus, 307 CE. Billion, diameter 1″. American Numismatic Society, New York. Right: medallion, ca. 315 CE. Silver, diameter 1″. Staaliche Munzammlung, Munich.

Chapter 8

Late Antiquity

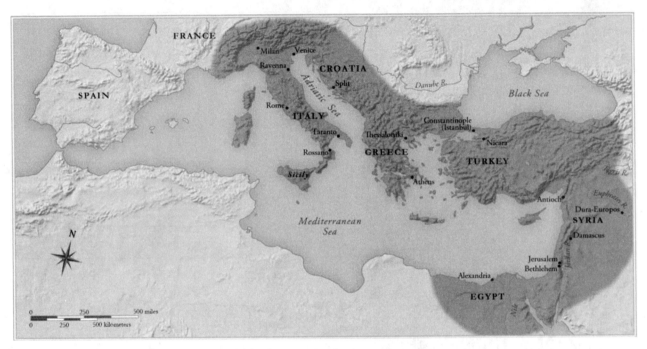

MAP 8-1 The Meditterranean world in late antiquity.

FIG. 08-01 Sarcophagus of Juninus Bassus, from rome, Italy, ca. 359. Marble 3′ 10 1/4″ × 8′. Museo Storico del Tesoro della Basilica di san Pietro, Rome.

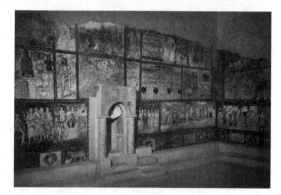

FIG. 08-02 Interior of the synagogue, Dura-Europos, Syria, with wall paintings of Old Testament themes, ca. 245–256. Tempera on plaster. Reconstruction in National Museum, Damascus.

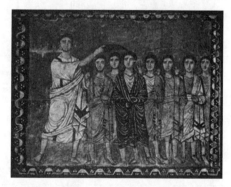

FIG. 08-03 Samuel Anoints David, detail of a main interior wall of the synagogue Dura-Europos, Syria, ca. 245–256. Tempera on plaster, 4′ 7″ high.

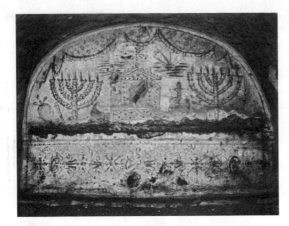

FIG. 08-04 Ark of the Covenant and two menorahs, painted wall in a Jewish catacomb, Villa Torionia, Rome, Italy, third century. Fresco, 3′11″ high.

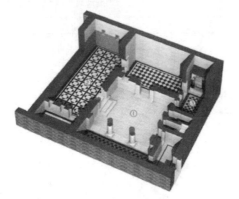

FIG. 08-05 Restored cutaway view of the Christian community house, Dura-Europos, Syria, ca. 240–256 (John Burge). (1) former courtyard of private house, (2) meeting hall, (3) baptistery.

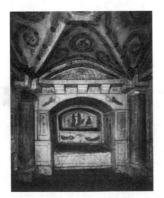

FIG. 08-05A Via Dino Compagni Catacomb, Rome, ca. 320–360.

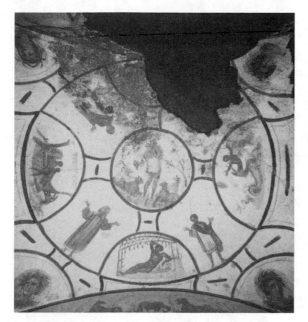

FIG. 08-06 The Good Shepherd, the story of Jonah, and orants, painted ceiling of a cubiculum in the Catacomb of Saints Peter and Marcellinus, Rome, Italy, early fourth century.

FIG. 08-06A Catacomb of Commodilla, Rome, ca. 370–385.

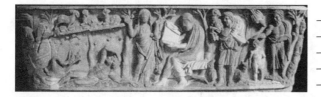

FIG. 08-07 11-06 Sarcophagus with philosopher, orant, and Old and New Testament scenes, ca. 270. Marble, 1′ 11 1/4″ × 7′ 2″. Santa Maria Antiqua, Rome.

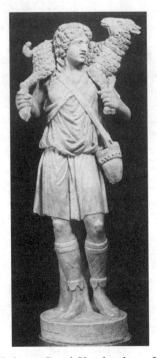

FIG. 08-08 Christ as Good Shepherd, ca. 300–350. Marble, 3′ 1/4″ high. Musei Vaticani, Rome.

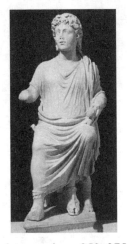

FIG. 08-08A Christ seated, ca. 350–375.

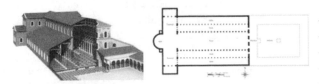

FIG. 08-09 Restored cutaway view *(top)* and plan *(bottom)* of Old Saint Peter's, Rome, Italy, begun ca. 319 (John Burge).

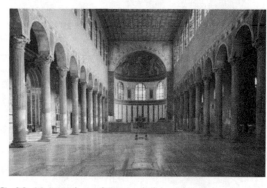

FIG. 08-10 Interior of Santa Sabina, (looking northeast) Rome, Italy, 422–432.

FIG. 08-10A West doors, Santa Sabina, Rome, ca. 432.

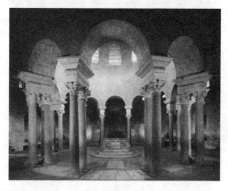

FIG. 08-11 Interior of Santa Costanza, (looking northeast) Rome, Italy, ca. 337–351.

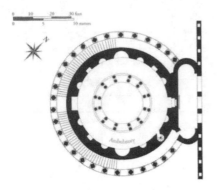

FIG. 08-12 Plan of Santa Costanza, Rome, Italy, ca. 337–351.

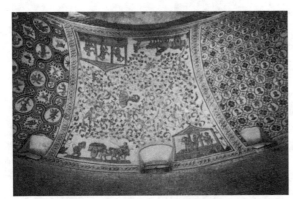

FIG. 08-13 Detail of vault mosaic in the ambulatory of Santa Costanza, Rome, Italy, ca. 337–351.

FIG. 08-13A Christ as Sol Invictus, late third century.

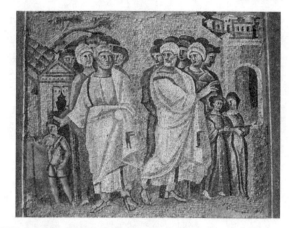

FIG. 08-14 The parting of Abraham and Lot, nave of Santa Maria Maggiore, Rome, Italy, 432–440.

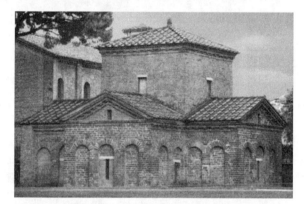

FIG. 08-15 Mausoleum of Galla Placidia, Ravenna, Italy. ca. 425.

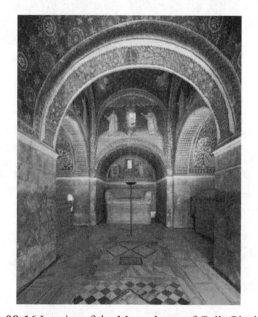

FIG. 08-16 Interior of the Mausoleum of Galla Placidia, Ravenna, Italy, ca. 425.

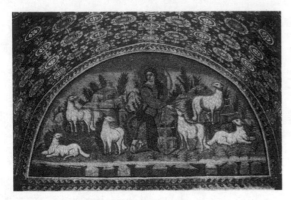

FIG. 08-17 Christ as the Good Shepherd, mosaic from the entrance wall of the Mausoleum of Galla Placidia, Ravenna, Italy, ca. 425.

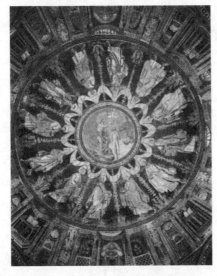

FIG. 08-17A Orthodox Baptistery, Ravenna, ca. 458.

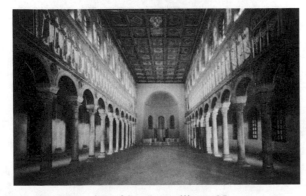

FIG. 08-18 Interior of Sant' Apollinare Nuovo, Ravenna, Italy, dedicated 504.

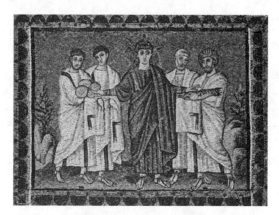

FIG. 08-19 Miracle of the loaves and fishes, mosaic from the top register of the nave wall (above the clerestory windows in FIG. 08-17) of Sant'Apollinare Nuovo, Ravenna, Italy, ca. 504.

FIG. 08-19A Hagios Georgios, Thessaloniki, ca. 390–450.

FIG. 08-20 *Old Farmer of Corycus,* folio 7 verso of the *Vatican Vergil,* ca. 400–420. Tempera on parchment, 1′ 1/2″ ×1′. Biblioteca Apostolica Vaticana, Rome.

147

FIG. 08-21 Rebecca and Eliezer at the well, folio 7 recto of the *Vienna Genesis,* early sixth century. Tempera, gold, and silver on purple vellum, 1′ 1/4″ × 9 1/4″. Österreichische Nationalbibliothek, Vienna.

FIG. 08-21A Story of Jacob, Vienna Genesis, early sixth century.

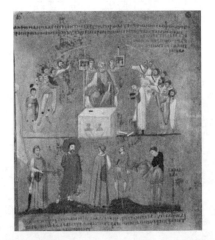

FIG. 08-22 Christ before Pilate, folio 8 verso of the *Rossano Gospels,* early sixth century. Tempera on purple vellum, 11″ × 10 1/4″. Museo Diocesano d'Arte Sacra, Rossano.

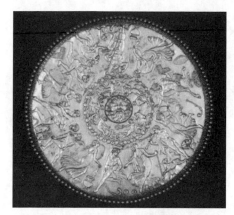

FIG. 08-23 Oceanus and Nereids, and drinking
contest between Bacchus and Hercules, "great Dish,"
from Mildenhall, England, mid-fourth century ce.
Silver, 1' 11 ¾‴ diameter. British Museum, London.

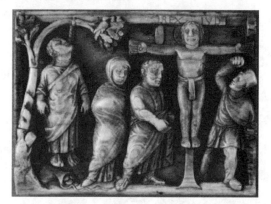

FIG. 08-24 Suicide of Judas and Crucifixion, plaque
from a box, ca 420. Ivory, 3″ × 3 7/8″. British Museum,
London.

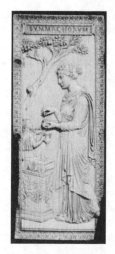

FIG. 08-25 Woman sacrificing at an altar, right leaf of
the diptych of the Nicomachi and the Symmachi, ca.
400. Ivory, 11 3/4″ × 5 1/2″. Victoria & Albert Museum,
London.

Chapter 9

Byzantium

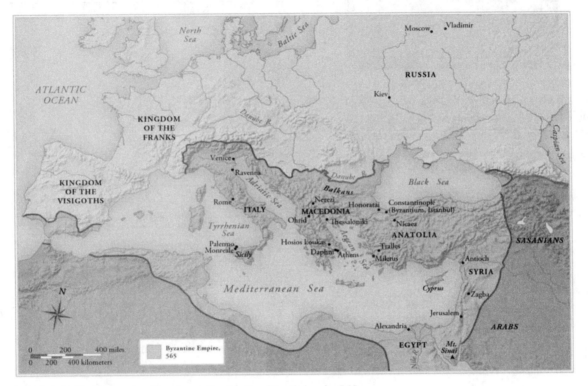

MAP 9-1 The Byzantine Empire at the death of Justinian in 565.

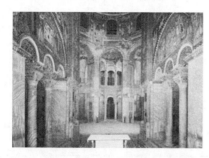

FIG. 09-01 Interior of San Vitale (looking from the apse into the choir), ravenna, Italy, 526–547.

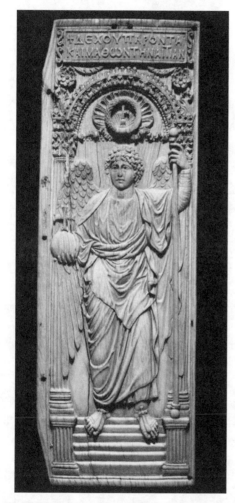

FIG. 09-02 Saint Michael the Archangel, right leaf of diptych, early sixth century. Ivory, 1′5″ × 5 1/2″. British Museum, London.

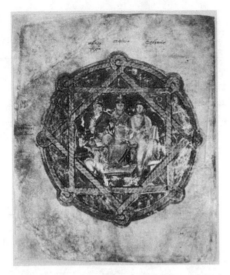

FIG. 09-03 Anicia Juliana between Magnanimity and
Prudence, folio 6 verso of the Vienna Dioskorides,
from Honoratai, near Constantinople (Istanbul),
Turkey, ca. 512. tempera on vellum, 1′3″ × 1′11″.
Osterreichische Nationalbibliothek, Vienna.

Fig 09-03A Blackberry bush, Vienna Dioskorides, 512.

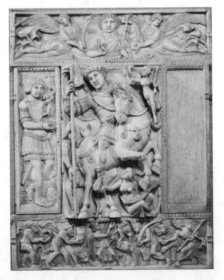

FIG. 09-04 Justinian as world conqueror (Barberini
Ivory), mid-sixth century. Ivory, 1′1 1/2″ × 10 1/2″.
Musee du Louvre, Paris.

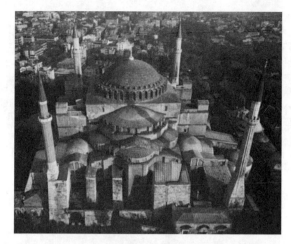

FIG. 09-05 ANTHEMIUS OF TRALLES AND ISIDORUS OF MILETUS, aerial view of Hagia Sophia (looking north), Constantinople (Istanbul), Turkey, 532–537.

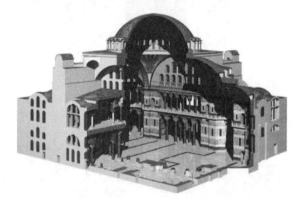

FIG. 09-06 Anthemius of Tralles and Isidorus of Miletus, restored cutaway view of Hagia Sophia, Constantinople (Istanbul), Turkey, 532–537 (John Burge).

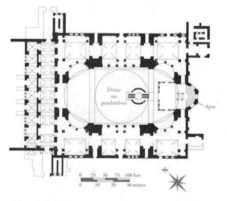

FIG. 09-07 Anthemius of Tralles and Isidorus of Miletus, plan of Hagia Sophia, Constantinople (Istanbul), Turkey, 532–537 (John Burge).

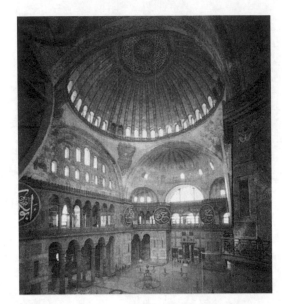

FIG. 09-08 ANTHEMIUS OF TRALLES and ISIDORUS OF MILETUS, interior of Hagia Sophia (looking southwest), Constantinople (Istanbul), Turkey, 532–537.

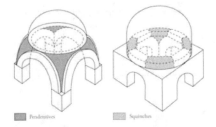

FIG. 09-09 Dome on pendentives (*left*) and on squinches (*right*).

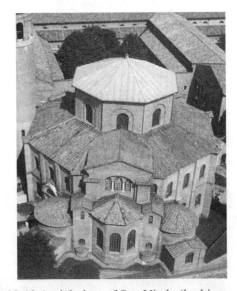

FIG. 09-10 Aerial view of San Vitale (looking northwest), Ravenna, Italy, 526–547. (page 316)

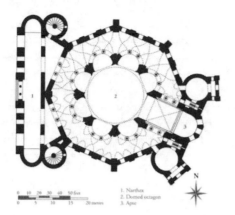

FIG. 09-11 Plan of San Vitale, Ravenna, Italy, 526–547.

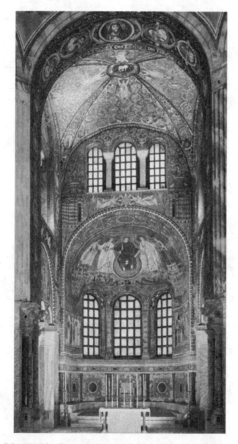

FIG. 09-12 Choir and apse of San Vitale with mosaic of Christ between two angels, Saint Vitalis, and Bishop Ecclesius, Ravenna, Italy, 526–547.

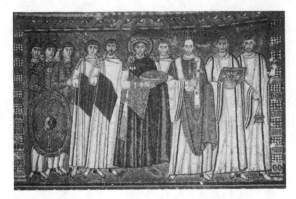

FIG. 09-13 Justinian, Bishop Maximianus, and attendants, mosaic on the north wall of the apse, San Vitale, Ravenna, Italy, ca. 547.

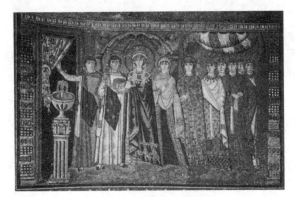

FIG. 09-14 Theodora and attendants, mosaic on the south wall of the apse, San Vitale, Ravenna, Italy, ca. 547.

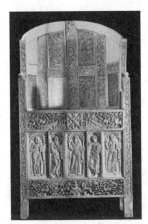

FIG. 09-14A Throne of Maximianus, ca. 546–556. Ivory and wood, 4′ 11″ × 1′ 11 1/2″. Museo Arcivescovile, Ravenna.

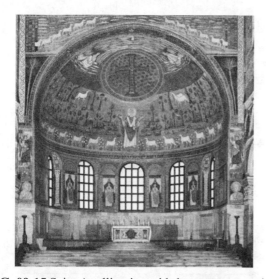

FIG. 09-15 Saint Apollinaris amid sheep, apse mosaic, Sant' Apollinare in Classe, Ravenna, Italy, ca. 533–549.

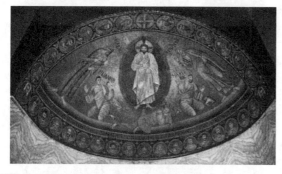

FIG. 09-16 *Transfiguration of Jesus*, apse mosaic, Church of the Virgin, monastery of Saint Catherine, Mount Sinai, Egypt, ca. 548–565.

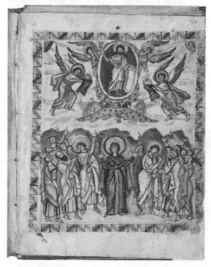
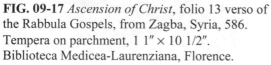

FIG. 09-17 *Ascension of Christ*, folio 13 verso of the Rabbula Gospels, from Zagba, Syria, 586. Tempera on parchment, 1 1″ × 10 1/2″. Biblioteca Medicea-Laurenziana, Florence.

FIG. 09-17A Crucifixion znd Resurrection, Rabbula Gospels, 586.

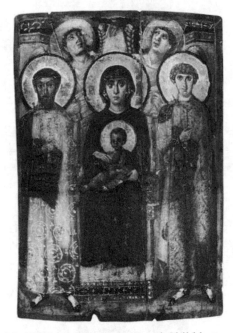

FIG. 09-18 Virgin (Theotokos) and Child between Saints Theodore and George, icon, sixth or early seventh century. Encaustic on wood 2′ 3″ × 1′ 7 3/8″. Monastery of Saint Catherine, Mount Sinai, Egypt.

FIG. 09-18A Christ blessing, Mount Sinai, sixth century.

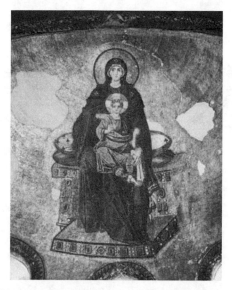

FIG. 09-19 Virgin (Theotokos) and Child enthroned apse mosaic, Hagia Sophia, Constantinople (Istanbul), Turkey, dedicated 867.

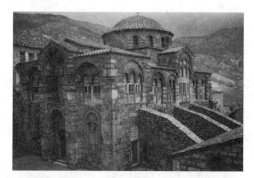

FIG. 09-20 Katholikon (looking northeast), Hosios Loukas, Greece, first quarter of 11th century.

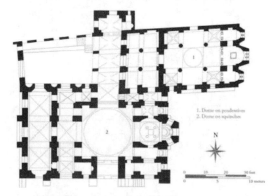

FIG. 09-21 Plan of the Church of the Theotokos *(top)* and the Katholikon *(bottom),* Hosios Loukas, Greece, second half of 10th and first quarter of 11th centuries.

159

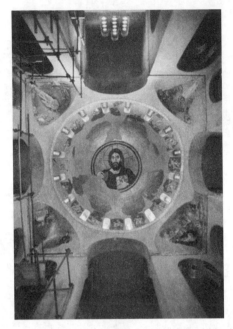

FIG. 09-22. Interior of the Katholikon (looking into the dome), Hosios Loukas, Greece, Daphni, Greece, ca. 1090–1100.

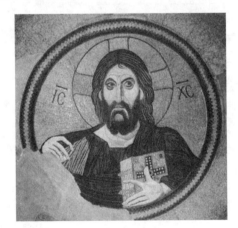

FIG. 09-23 Christ as Pantokrator, dome mosaic in the Church of the Dormition, Daphni, Greece, ca. 1090–1100.

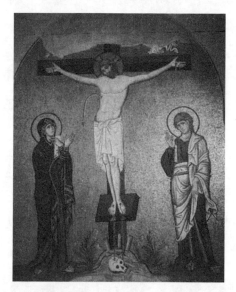

FIG. 09-24 Crucifixion, mosaic in the Church of the Dormition, Daphni, Greece, ca. 1090–1100.

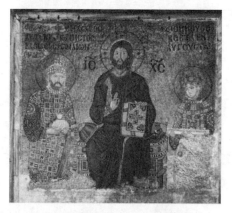

FIG. 09-25 Christ between Constantine IX Monomachus and the empress Zoe, mosaic on the east wall of the south gallery, Hagia Sophia, Constantinople (Istanbul), Turkey, ca. 1028–1035.

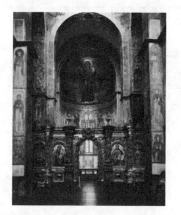

FIG. 09-25A Saint Sophia, Kiev, begun 1037.

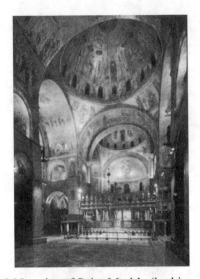

FIG. 09-26 Interior of Saint Mark's (looking east), Venice, Italy, begun 1063.

FIG. 09-26A Pala d'Oro Saint Mark's, Venice, ca. 1150.

FIG. 09-26B Archangel Michael icon, Venice, ca. 1100.

162

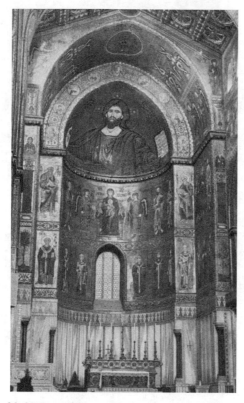

FIG. 09-27 Pantokrator, Theotokos and Child, angels and saints, apse mosaic in the cathedral at Monreale, Italy, ca. 1180–1190.

FIG. 09-27A Cappella Palatina, Palermo, begun 1142.

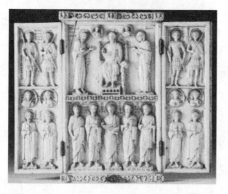

FIG. 09-28 Christ enthroned with saints (*Harbaville Triptych*), ca. 950. Ivory, central panel 9 1/2″ × 5 1/2″. Musee du Louvre, Paris.

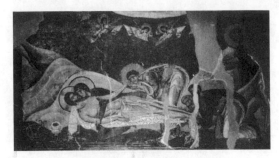

FIG. 09-29 Lamentation, wall painting, Saint Pantaleimon, Nerezi, macedonia, 1164.

FIG. 09-30 David composing the Psalms, folio 1 verso of the *Paris Psalter*, ca. 950–970. Tempera on vellum, 1′ 2 1/8″ × 10 1/4″. Bibliothèque Nationale, Paris.

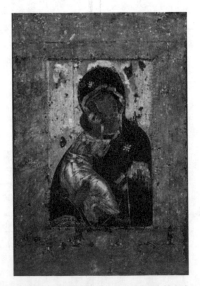

FIG. 09-31 Virgin (Theotokos) and Child, icon (*Vladimir Virgin*), late 11th to early 12th centuries. Tempera on wood, original panel 2′ 6 1/2″ × 1′ 9″. Tretyakov Gallery, Moscow.

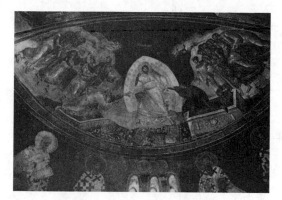

FIG. 09-32 Anastasis, fresco in the apse of the parkkleston of the Church of Christ in Chora (now the Kariye Museum), Constantinople (Istanbul), Turkey, ca. 1310–1320.

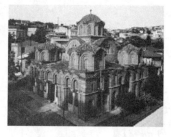

FIG. 09-32A Saint Catherine, Thessaloniki, ca. 1280.

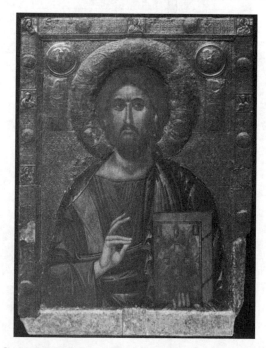

FIG. 09-33 Christ as Savior of Souls, icon from Saint Clement, Ohrid Macedonia, early 14th century. Tempera, linen, and silver on wood, 3′ 1/4″ × 2′ 2 1/2″. Icon Gallery of Saint C;ement, Ohrid.

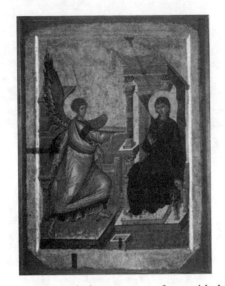

FIG. 09-34 Annunciation, reverse of two-sided icon from Saint Clement, Ohrid, Macedonia, early 14th century. Tempera and linen on wood 3′ 1/4″ × 2′ 2 3/4″. Icon Gallery of Saint Clement, Ohrid.

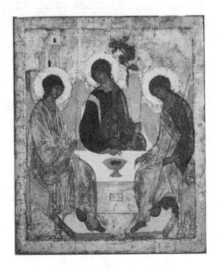

FIG. 09-35 ANDREI RUBLYEV, Three angels (Old Testament Trinity), ca. 1410. Tempera on wood 4′ 8″ × 3′ 9″. Tretyakov Gallery, Moscow.

FIG. 09-35A Large sakkos of Photius, ca. 1417.

Chapter 10

The Islamic World

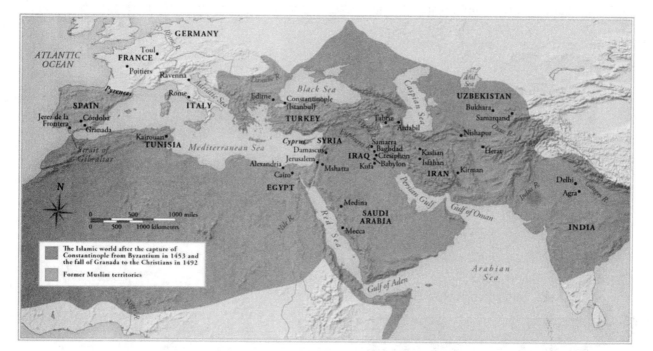

MAP 10-1 The Islamic world around 1500.

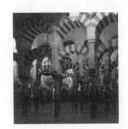

FIG. 10-01 Aerial view of the Mezquita (Great Mosque), Cordoba, Spain, 8th to 10th centuries; rededicated as the Cathedral of Saint Mary, 1236.

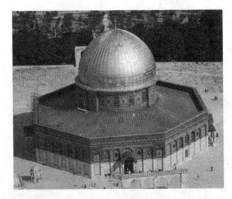

FIG. 10-02 Aerial view (looking southwest) of the Dome of the Rock, Jerusalem, 687–692.

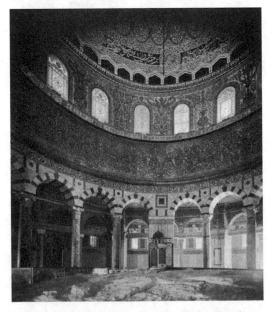

FIG. 10-03 Interior of the Dome of the Rock, Jerusalem, 687–692.

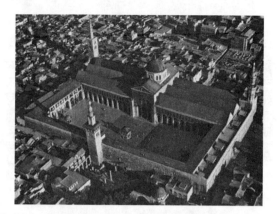

FIG. 10-04 Aerial view (looking southwest) of the Great Mosque, Damascus, Syria, 706–715.

FIG. 10-05 Detail of a mosaic in the courtyard arcade of the Great Mosque, Damascus, Syria, 706–715.

FIG. 10-05A Plan, Umayyad palace, Mshatta, 740–750.

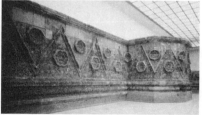

FIG. 10-05B Frieze, Umayyad palace, Mshatta, 740–750.

169

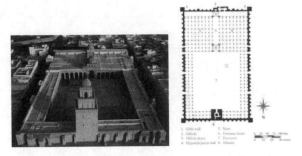

FIG. 10-06 Aerial view *(looking south; left)* and plan *(right)* of the Great Mosque, Kairouan, Tunisia, ca. 836–875.

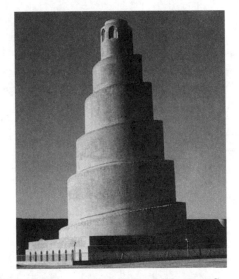

FIG. 10-07 Malwiya Minaret, Great Mosque, Samarra, Iraq, 848–852.

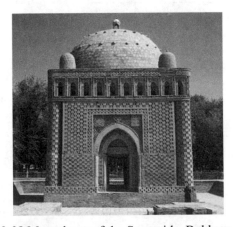

FIG. 10-08 Mausoleum of the Samanids, Bukhara, Uzbekistan, early 10th century.

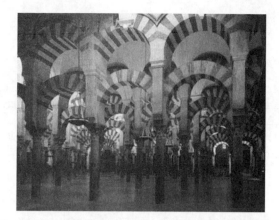

FIG. 10-09 Prayer hall of the Mezqutta (Great Mosque), Cordoba, Spain, 8th to 10th centuries.

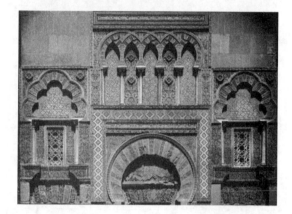

FIG. 10-10 Detail of the upperzones of the east gate of the Mezqutta (Great Mosque), Cordoba, Spain, 961–965.

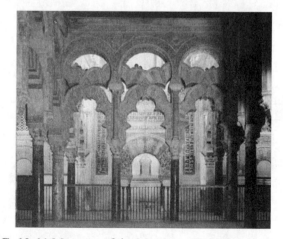

FIG. 10-11 Maqsura of the Mezqutta (great Mosque), Cordoba, Spain, 8th to 10th centuries.

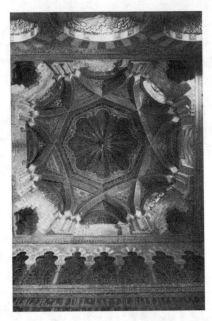

FIG. 10-12 Dome in front of the mihrab of the Mezqutta (Great Mosque), Cordoba, Spain, 961–965.

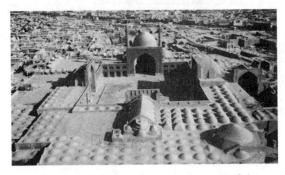

FIG. 10-13 Aerial view (looking southwest) of the Friday Mosque, Isfahan, Iran, 11th to 17th centuries.

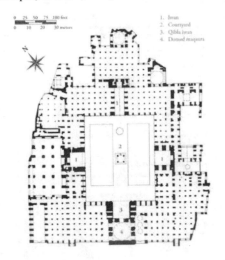

FIG. 10-14 Plan of the Friday Mosque, Isfahan, Iran, 11th to 17th centuries.

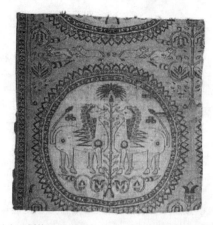

FIG. 10-14A Silk textile from Zandana, eight century.

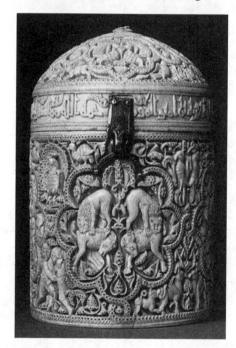

FIG. 10-15 Pyxis of al-Mughira, from Medina al-Zahra, near Córdoba, Spain, 968. Ivory, 5 7/8″ high. Lourvre, Paris.

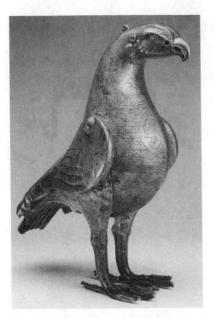

FIG. 10-16 SULAYMAN, Ewer in the form of a bird, 796. Brass with silver and copper inlay, 1′ 3″ high. Hermitage, Saint Petersburg.

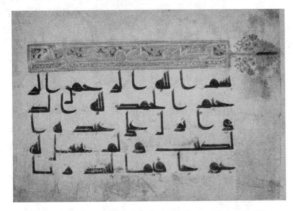

FIG. 10-17 Koran page with beginning of surah 18, 9th or early 10th century. Ink and gold on vellum, 7 1/4″ × 10 1/4.″ Chester Beatty Library and Oriental Art Gallery, Dublin.

FIG. 10-17A Blue Koran, from Kairouan, 9th to mid 10th century.

FIG. 10-18 Dish with Arabic proverb, from Nishapur, Iran, 10th century. Painted and glazed earthenware, 1′ 2 1/2″ diameter. Musee du Louvre.

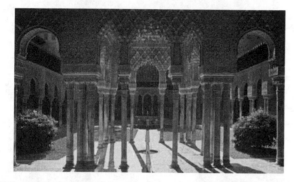

FIG. 10-19 Court of the Lions (looking east), Palace of the Lions, Alhambrra, Granade, Spain, 1354–1391.

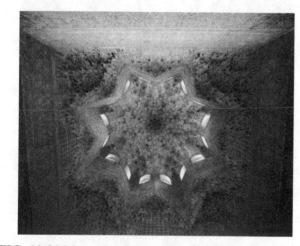

FIG. 10-20 Muqarnas dome, Hall of the Abencerrajes, Palace of the Lions, Alhambra, Granada, Spain, 1354–1391.

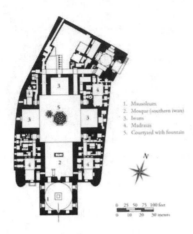

FIG. 10-21 Plan of the madrasa-mosque-mausoleum complex of Sultan Hasan, Cairo, Egypt, begun 1356.

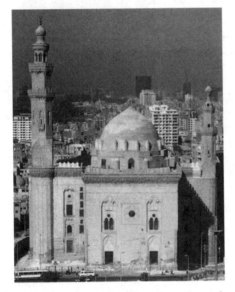

FIG. 10-22 Madrasa-mosque-mausoleum complex of Sultan Hasan (looking northwest with the mausoleum in the foreground), Cairo, Egypt, begun 1356.

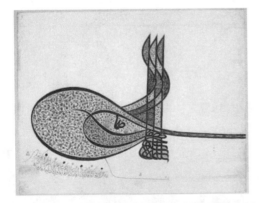

FIG. 10-22A Tughra of Suleyman the Magnificent, ca. 1555–1560.

176

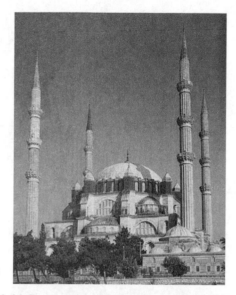

FIG. 10-23 SINAN, Mosque of Selim II, Edirne, Turkey, 1568–1575.

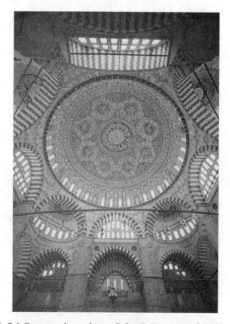

FIG. 10-24 SINAN, interior of the Mosque of Selim II, Edirne, Turkey, 1568–1575.

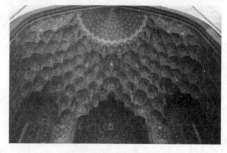

FIG. 10-25 Winter prayer hall of the Imam (shah) Mosque, Isfahan, Iran 1611–1638.

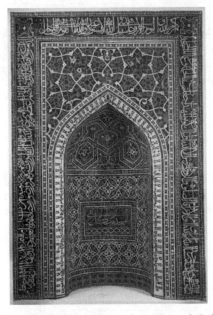

FIG. 10-26 Mihrab from the Madrasa Imami, Isfahan, Iran, ca. 1354. Glazed mosaic tilework, 11′ 3″ × 7′ 6″. Metropolitan Museum of Art, New York.

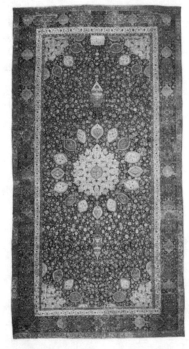

FIG. 10-27 MAQSUD OF KASHAN, carpet from the funerary mosque of Shaykh Safi al-Din, Ardabil, Iran, 1540. Knotted pile of wool and silk, 34′ 6″ × 17′ 7″. Victoria & Albert Museum, London.

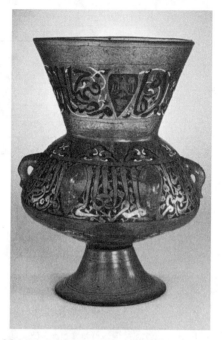

FIG. 10-28 Mosque lamp of Sayf al-Din Tuquztimur, from Egypt, 1340. Glass with enamel decoration, 1′ 1″ high. British Museum, London.

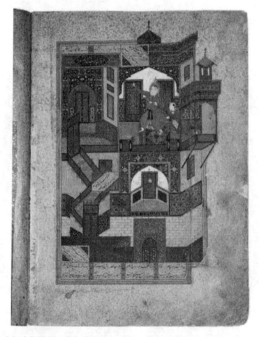

FIG. 10-29 Bihzad, Seduction of Yusuf, folio 52 verso of the Bustan of Sultan Husayn Mayqara, from Herat, Afghanistan, 1488. Ink and color on paper, 11 7/8″ × 8 5/8 ″ National Library, Cairo.

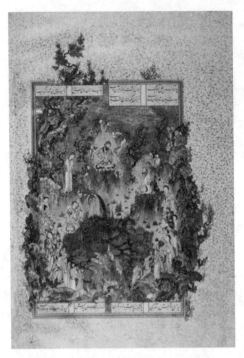

FIG. 10-30 Sultan-Muhammad, Court of Gayumars, folio 20 verso of the Shahnama of Shah Tahmasp, from Tabriz, Iran, ca. 1525–1535. Ink, watercolor, and gold on paper, 1′1″ × 9″. Prince Sadruddin Aga Khan Collection, Geneva.

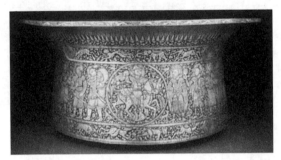

FIG. 10-31 MUHAMMAD IBN AL-ZAYN, basin *(Baptistère de Saint Louis),* from Egypt, ca. 1300. Brass, inlaid with gold and silver, 8 3/4″ high. Musee du Louvre, Paris.

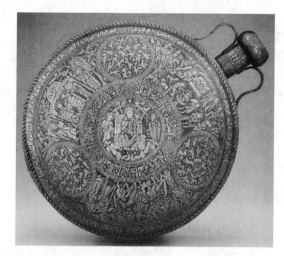

FIG. 10-32 Canteen with episodes from the life of
Christ, from Syria, ca. 1240–1250. Brass, inlaid
with silver, 1′ 2 1/2″ high. Freer Gallery of Art,
Washington, D.C.

Chapter 11

Early Medieval Europe

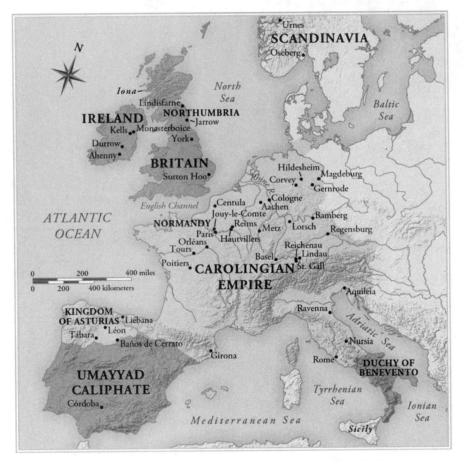

MAP 11-1 The Carolingian Empire at the death of Charlemagne in 814.

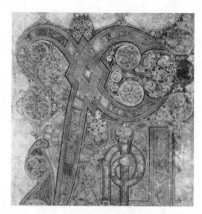

FIG. 11-01 Chi-rho-lota (XPI) page, folio 34 recto of the Book of Kells, probably from Iona, Scotland, late eighth or early ninth century. Tempera on vellum, 1′1″ × 9 1/2″. Trinity College Library, Dublin.

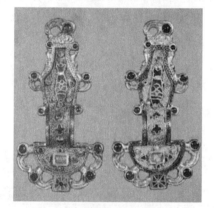

FIG. 11-02 Pair of Merovingian looped fibulae, from Jouy-le-Comte, France, mid-sixth century. Silver gilt worked on filigree, with inlays of garnets and other stones, 4″ high. Musée d'Archéologie nationale, Saint-Germain-en-Laye.

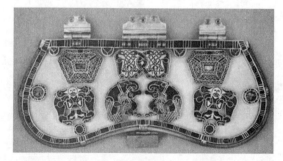

FIG. 11-03 Purse cover, from the Sutton Hoo ship burial in Suffolk, England ca. 625. Gold glass, and cloisonné garnets, 7 1/2″ long. British Museum, London. (gift of Mrs. E. M. Pretty.

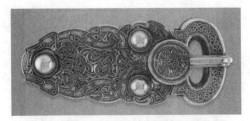

FIG. 11-03A Belt buckle, Sutton Hoo, ca. 625.

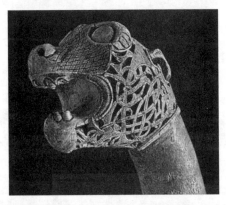

FIG. 11-04 Animal-head post, from the Viking ship burial, Oseberg, Norway, ca. 825. Wood, head 5″ high. Viking Ship Museum, University of Oslo, Bygdoy.

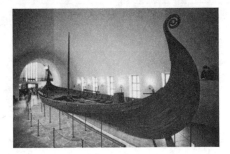

FIG. 11-04A Viking ship burial, Oseberg, ca. 815–820.

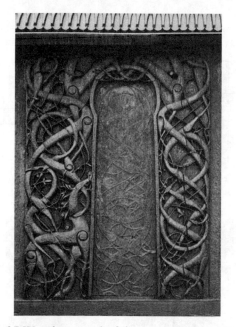

FIG. 11-05 Wooden portal of the stave church at Urnes, Norway, ca. 1050–1070.

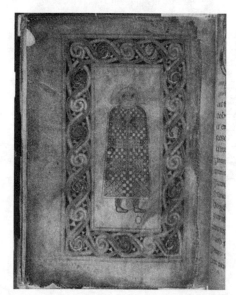

FIG. 11-06 Man (symbol of Saint Matthew), folio 21 verso of the *Book of Durrow,* possibly from Iona, Scotland, ca. 660–680. Ink and tempera on parchment, 9 5/8″ × 6 1/8″. Trinity College Library, Dublin.

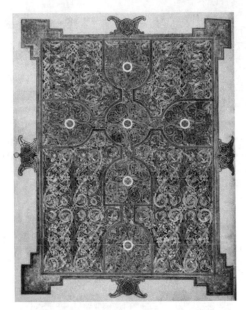

FIG. 11-07 Cross-inscribed carpet page, folio 26 verso of the Lindisfarne Gospels, from Northumbria, England, ca. 698–721. Tempera on vellum, 1′1 1/2″ × 9 1/4″. British Library, London.

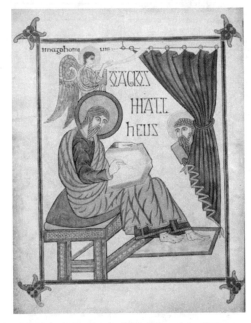

FIG. 11-08 Saint Matthew, folio 25 verso of the *Lindisfarne Gospels,* from Northumbria, England ca. 698–721. Tempera on vellum, 1′ 1/2″ × 9 1/4″. British Library, London.

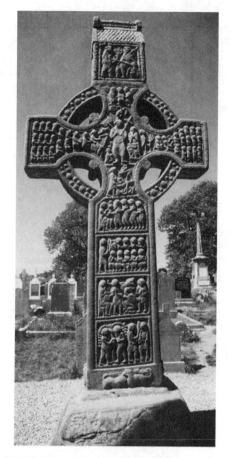

FIG. 11-09 *High Cross of Muiredach* (east face), Monasterboice, Ireland, 923. Sandstone, 18′ high.

FIG. 11-09A South Cross, Ahenny, late eighth century.

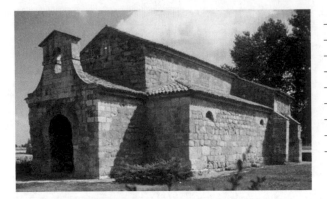

FIG. 11-10 San Juan Bautist (looking northeast), Baños de
Cerrato, Spain, 661.

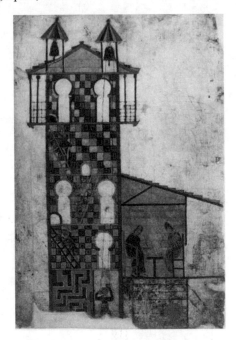

FIG. 11-11 EMETERIUS, the tower and scriptorium
of San Salvador de Tábara, colophon (folio 168) of the
Commentary on the Apocalypse by Beatus, from Tábara,
Spain, 970. Tempera on parchment, 1′ 2 1/8″ × 10″.
Archivo Histórico Nacional, Madrid.

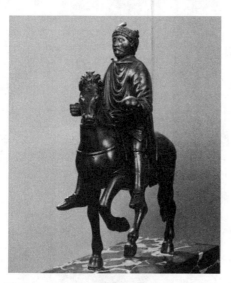

FIG. 11-12 Equestrian portrait of Charlemagne or Charles the Bald, from Metz, France, ninth century. Bronze, originally gilt, 9 1/2″ high. Musee du Louvre, Paris.

FIG. 11-12A Christ enthroned, folio 3 recto of the Godescalc Lectionary, 781–783.

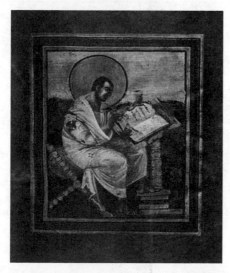

FIG. 11-13 Saint Matthew, folio 15 recto of the *Coronation Gospels (Gospel Book of Charlemagne),* from Aachen, Germany, ca. 800–810. Ink and tempera on vellum, 1′ 3/4″ × 10″. Schatzkammer, Kunsthistorisches Museum, Vienna.

FIG. 11-14 Saint Matthew, folio 18 verso of the *Ebbo Gospels (Gospel Book of Archbiship Ebbo of Reims),* from Hautvillers France, ca. 816–835. Ink and tempera on vellum, 10 1/4″ × 8 3/4″. Bibliothèque Municipale, Épernay.

FIG. 11-15 Psalm 44, detail of folio 25 recto of the *Utrecht Psalter,* from Hautvillers France, ca. 820–835. Ink on vellum, full page, 1′ 1″ × 9 7/8″; detail, 4 1/2″ high. University Library, Utrecht.

FIG. 11-15A Psalm 23, Utrech Psalter, ca. 820–836.

FIG. 11-16 Crucifixion, front cover of the *Lindau Gospels,* from Saint Gall, Switzerland, ca. 870. Gold, precious stones, and pearls, 1′ 1 3/8″ × 10 3/8″. Pierpont Morgan Library, New York.

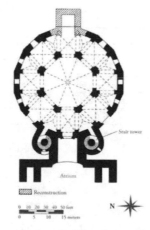

FIG. 11-17 Restored plan (left) and west facade (right) of the Palatine Chapel of Charlemagne, Aachen, germany, 792–805.

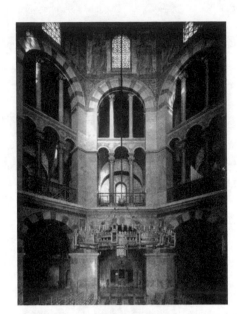

FIG. 11-18 Interior of the Palatine Chapel of Charlemagne (looking east), Aachen, Germany, 792–805.

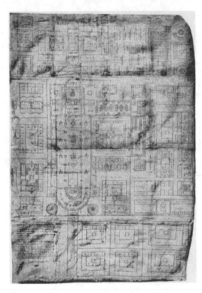

FIG. 11-19 Schematic plan for a monastery from Saint Gall, Switzerland, ca. 819. Red ink on parchment, 2′ 4″ × 3′ 8 1/8″. Stiftsbibliothek, Saint Gall.

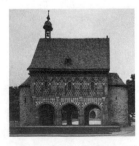

FIG. 11-19A Torhalle, Lorsch, Germany, late eighth or ninth century.

FIG. 11-19B Saint-Riquier, Centula, 790–799.

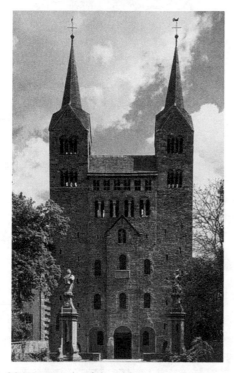

FIG. 11-20 Westwork of the abbey church, Corvey, Germany, 873–885.

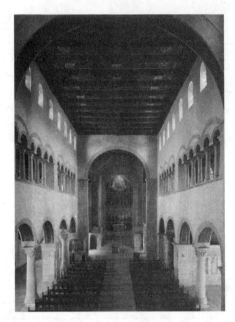

FIG. 11-21 Nave of the church of Saint Cyriakus (looking east), Gernrode, Germany, 961–973.

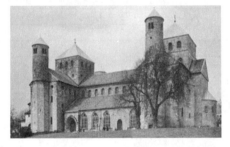

FIG. 11-22 Saint Michael's, Hildesheim, Germany (looking east), 1001–1031.

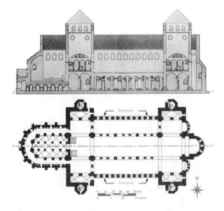

FIG. 11-23 Longitudinal section *(top)* and plan *(bottom)* of the abbey church of Saint Michael's, Hildesheim, Germany, 1001–1031.

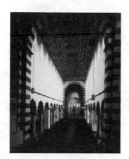

FIG. 11-23A Nave of Saint Michael's, Hildesheim, 1001–1031.

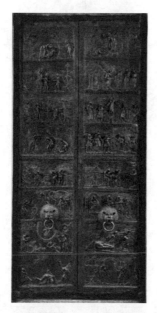

FIG. 11-24 Doors with relief panels (Genesis, left door; life of Christ, right door), commissioned by Bishop Bernward for Saint Micheael's, Hildesheim, Germany, 1015. Bronze, 16′ 6″ high. Dom-Museum, Hildesheim.

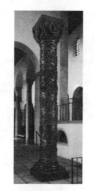

FIG. 11-24A Column, Saint Michael's, Hildesheim, ca. 1015–1022.

FIG. 11-25 God accusing Adam and Eve, detail of the left door of Saint Michael's, Hildesheim, Germany, 1015. Bronze, 1′10 1/4″ high. Dom-Museum, Hildesheim.

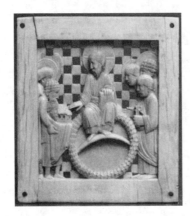

FIG. 11-26 Otto I presenting Magdeburg Cathedral to Christ, from Magdeburg Cathedral, Magdeburg, Germany, 962–968. Ivory, 5″ × 4 1/2″. Metropolitan Museum of Art, New York (gift of George Blumenthal, 1941).

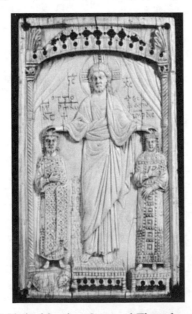

FIG. 11-27 Christ blessing Otto and Theophanu, 972–973. Ivory, 7 1/8″ × 4″. Musee National du Moyen Age, Paris (was Fig. 16-28A below)

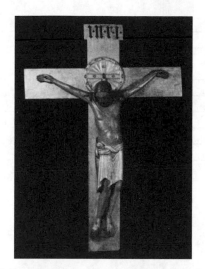

FIG. 11-28 Crucifix commissioned by Archbishop Gero for Cologne Cathedral, Cologne, Germany, ca. 970. Painted wood, height of figure 6′ 2″. Cathedral, Cologne.

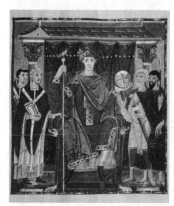

FIG. 11-29 Otto III enthroned, folio 24 recto of the Gospel Book of Otto III, from Reichenau, germany, 997–1000. Tempera on vellum, 1′1″ × 9 3/8″. Bayerische Staatsbibliotek, Munich.

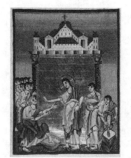

FIG. 11-29A Jesus and Peter, Gospel Book of Otto III, 997–1000.

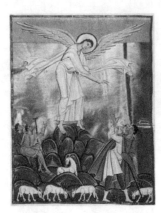

FIG. 11-30 Annunciation to the Shepherds, folio in the Lectionary of Heny II, from Reichenau, Germany, 1002–1014. tempera on vellum, 1'5" × 1'1". Bayerische Staatsbibliothek, Munich.

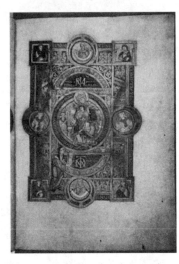

FIG. 11-31 Abbess uta dedicating her codex to the Virgin, folio 2 recto of the Uta Codex, from Regensburg, Germany, ca. 1025. tempera on parchment, 9 5/8" × 5 3/8". Bayerische Staatsbibliothek, Munich.

Chapter 12

Romanesque Europe

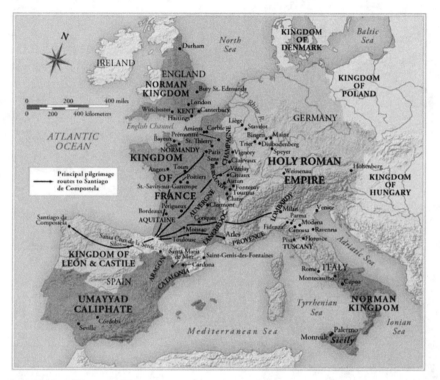

MAP 12-1 Western Europe around 1100.

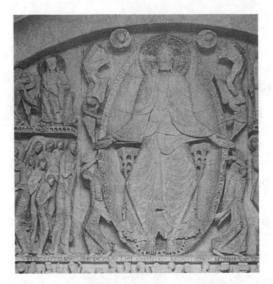

FIG. 12-01 Cislebertus, Last Judgment, west tympanum of Saint-Lazare, Autun, France, ca. 1120–1135. Marble 21' wide at base.

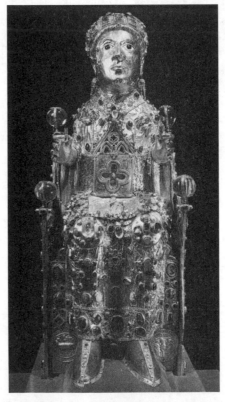

FIG. 12-02 Reliquary statute of Sainte-Foy (Saint Faith), late 10th to early 11th century with later additions. Gold, silver gilt, jewels, and cameos over a wooden core, 2'9 1/2" high. Treasure, Sainte-Foy, Conques.

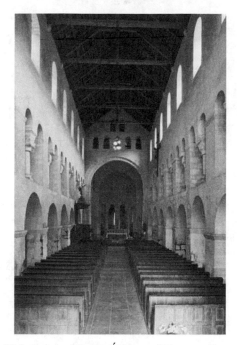

FIG. 12-03 Interior of Saint-Étienne, Vignory, France, 1050–1057.

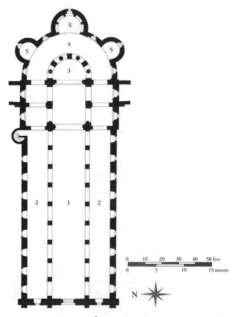

FIG. 12-04 Plan of Saint-Étienne, Vignory, France, 1050–1057. (1) nave, (2) aisles, (3) choir, (4) ambulatory, (5) radiating chapels.

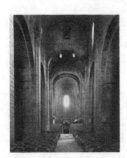

FIG. 12-04A Saint Vicenc, Cardona, ca. 1029–1040.

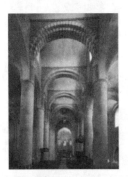

FIG. 12-04B Saint-Philibert, tournus, ca. 1060.

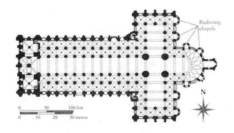

FIG. 12-05 Aerial view of Saint-Sernin (looking northwest), Toulouse, France, ca. 1070–1120.

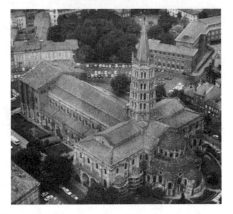

FIG. 12-06 Plan of Saint-Sernin, Toulouse, France, ca. 1070–1120 (after Kenneth John Conant).

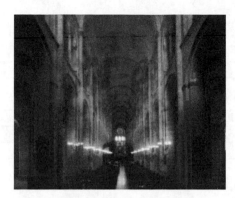

FIG. 12-07 Interior of Saint-Sernin, Toulouse (looking east), France, ca. 1070–1120.

FIG. 12-07A Sainte-Foy, Conques, mid 11th to early 12th century.

FIG. 12-07B Saint James, Santiago de Compostela, ca. 1075–1120.

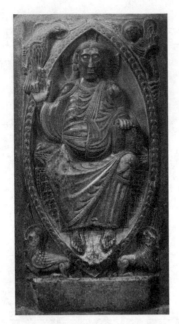

FIG. 12-08 Bernardus Gelduinus, Christ in Majesty, relief in the ambulatory of Saint-Sernin, Toulouse, France, ca. 1096. Marble, 4′ 2″ high.

FIG. 12-08A Saint- Genis-des-Fontaines, 1019–1020.

FIG. 12-08B Santo Domingo. Silos, ca. 1090–1100.

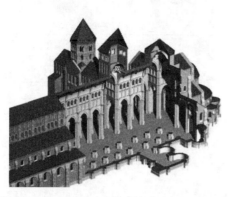

FIG. 12-09 Restored view of the third abbey church (Cluny III), Cluny France, 1088–1130 (John Burge).

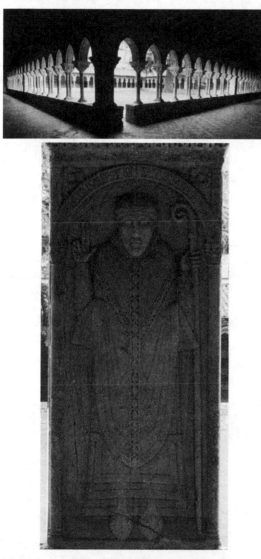

FIG. 12-10 General view of the cloister *(top* looking southeast)* and detail of the pier with the relief of Abbot Durandus *(bottom),* Saint-Pierre, Moissac, France, ca. 1100–1115. Relief: limestone, 6′ high.

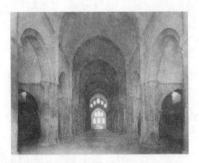

FIG. 12-10A Notre-Dame, Fontenay, 1139–1147.

FIG. 12-11 South portal of Saint-Pierre, Moissac, France, ca. 1115–1135. Top: general view. Bottom: detail of tympanum with Second Coming of Christ.

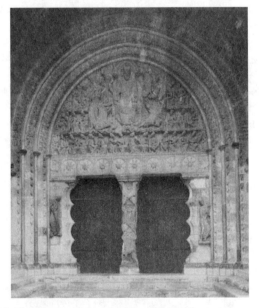

FIG. 12-11A Notre-Dame-la-Grande, Poitiers, ca. 1130–1150.

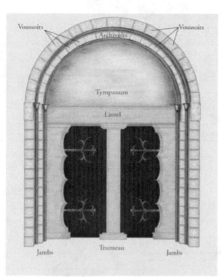

FIG. 12-12 The Romanesque church portal (John Burge).

FIG. 12-13 Old Testament prophet (Jeremiah or Isiah?), right side of the trumeau of the south portal of Saint-Pierre, Mosaic, France, ca. 1115–1130.

FIG. 12-13A GISLEBERTUS, Suicide of Judas, historiated capital from the nave of Saint-Lazare, Autun, France, ca. 1120–1135.

FIG. 12-13B GISLEBERTUS, Eve, detail of the lintel of the north portal of Saint-Lazare, Autun, France, ca. 1120–1135.

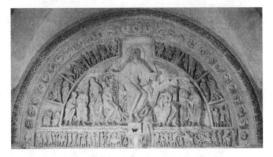

FIG. 12-14 Pentecost and Mission of the Apostles, tympanum of the center portal of the narthex of La Madeleine, Vézelay, France, 1120–1132.

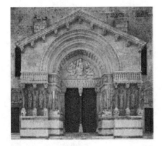

FIG. 12-14A Saint-Trophîme, Arles, France, mid-12th century.

FIG. 12-15 Initial L and Saint Matthew, folio 10 recto
of the Codex Colbertinus, from Moissac, France, ca. 1100.
Tempera on vellum, 7 1/2″ × 4″. Bibliothèque Nationale,
Paris.

FIG. 12-15A Corbie Gosples, ca. 1120.

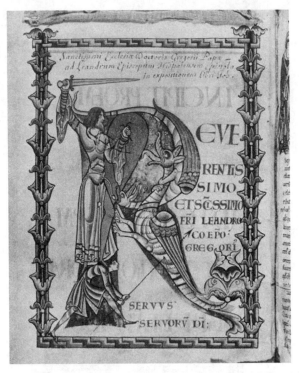

FIG. 12-16 Initial *R* with knight fighting dragons, folio 4 verso of the *Moralia in Job,* from Cîteaux, France, ca. 1115–1125. Ink and tempera on vellum, 1′ 1 3/4″ × 9 1/4″. Bibliothèque Municipale, Dijon.

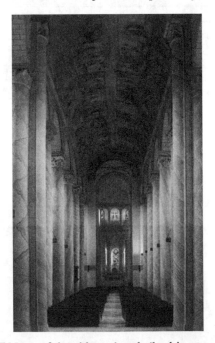

FIG. 12-17 Nave of the abbey church (looking east) of Saint-Savin, Saint-Savin-sur-Gartempe, France, ca. 1100.

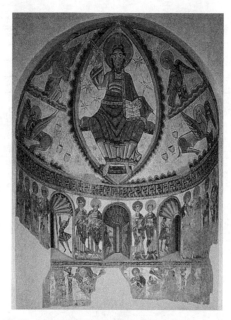

FIG. 12-18 Christ in Majesty, apse, Santa María de Mur, near Lérida, Spain, mid-12th century. Fresco, 24′ high. Museum of Fine Arts, Boston.

FIG. 12-19 Virgin and Child *(Morgan Madonna),* from Auvergne, France, second half of 12th century. Painted wood, 2′ 7″ high. Metropolitan Museum of Art. New York (gift of J. Pierpont Morgan, 1916).

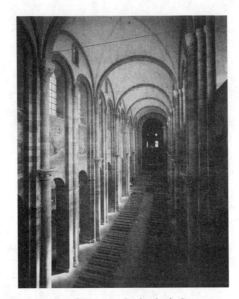

FIG. 12-20 Interior of Speyer Cathedral, Speyer, Germany, (looking east begun 1030; nave vaults, ca. 1082–1105.

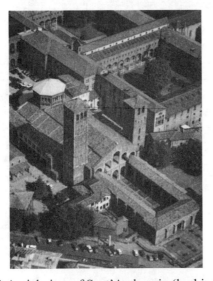

FIG. 12-21 Aerial view of Sant'Ambrogio (looking southeast), Milan, Italy, late 11th to early 12th century.

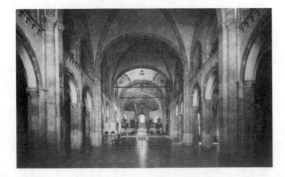

FIG. 12-22 Interior of Sant'Ambrogio (looking east), Milan, Italy, late 11th to early 12th century.

212

FIG. 12-23 Hildegard receives her visions, detail of a facsimile of a lost folio in the Rupertsberger *Scivias* by Hildegard of Bingen, from Trier or Bingen, Germany, ca. 1150–1179. Abbey of St. Hildegard Rüdesheim/Eibingen.

FIG. 12-23A Rufillus, Initial R, ca. 1170–1200.

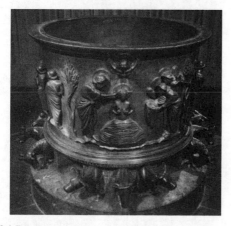

FIG. 12-24 RAINER OF HUY, baptism of Christ, baptismal font from Notre-Dame-des-Fonts, Liège, Belgium, 1118. Bronze, 2′ 1′ high. Saint-Barthélémy, Liège.

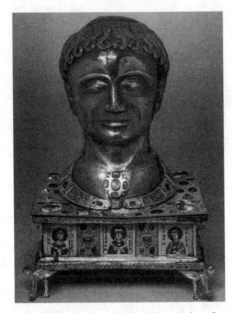

FIG. 12-25 Head reliquary of Saint Alexander, from Stavelot Abbey, Belgium, 1145. Silver repoussé (partly gilt), gilt bronze, gems, pearls, and enamel, 1′ 5 1/2″ high. Musées Royaux d'Art et d'Histoire, Brussels.

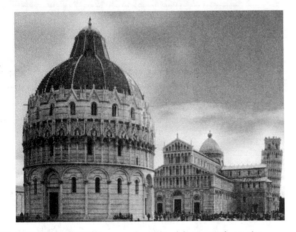

FIG. 12-26 Cathedral complex (looking northeast), Pisa, Italy; cathedral begun 1063; baptistery begun 1153; campanile begun 1174.

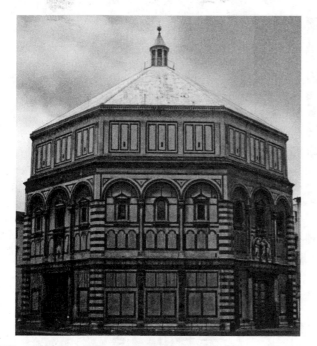

FIG. 12-27 Baptistery of San Giovanni, looking northwest)
Florence, Italy, dedicated 1059.

FIG. 12-27A San Miniato, Florence, ca. 1062–1090.

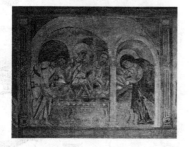

FIG. 12-27B Sant'Angelo in Formis, near Capula,
ca. 1085.

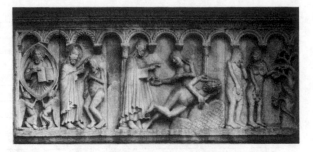

FIG. 12-28 WILIGELMO, creation and temptation of Adam and Eve, detail of the frieze on the west facade, Modena Cathedral, Modena, Italy, ca. 1110. Marble, 3′ high.

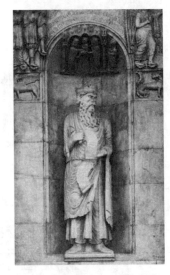

FIG. 12-29 BENEDETTO ANTELAMI, King David, statue in a niche on the west facade of Fidenza Cathedral, Fidenza, Italy, ca. 1180–1190.

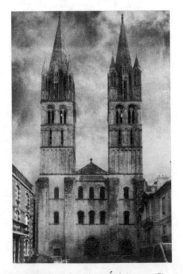

FIG. 12-30 West facade of Saint-Étienne, Caen, France, begun 1067.

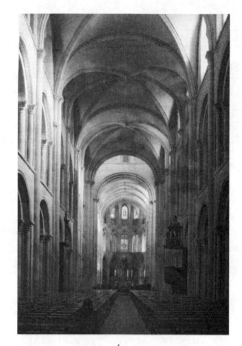

FIG. 12-31 Interior of Saint-Étienne, (looking east) Caen, France, vaulted ca. 1115–1120.

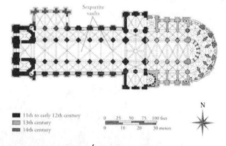

FIG. 12-32 Plan of Saint-Étienne, Caen, France.

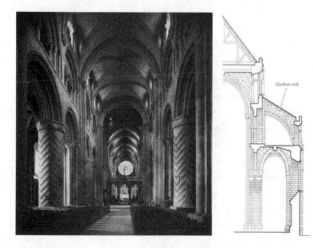

FIG. 12-33 Interior *(left looking east)* and lateral section *(right)* of Durham Cathedral, England begun ca. 1093.

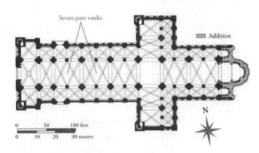

FIG. 12-34 Plan of Durham Cathedral, England (after Kenneth John Conant).

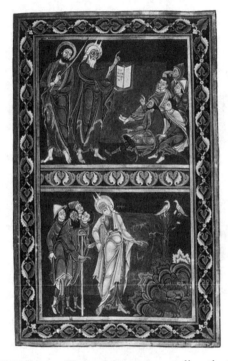

FIG. 12-35 MASTER HUGO, Moses expounding the Law, folio 94 recto of the *Bury Bible,* from Bury Saint Edmunds, England ca. 1135. Ink and tempera on vellum, 1′ 8″ × 1′ 2″. Corpus Christi College, Cambridge.

FIG. 12-35A Winchester Psalter, ca. 1145–1155.

218

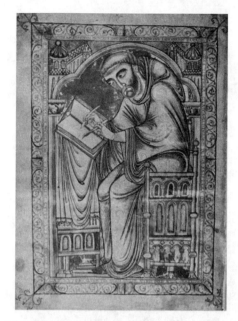

FIG. 12-36 EADWINE THE SCRIBE, Eadwine the Scribe at work, folio 283 verso of the *Eadwine Psalter,* ca. 1160–1170. Ink and tempera on vellum. Trinity College, Cambridge.

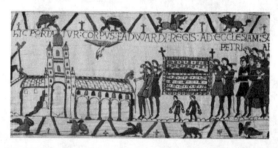

FIG. 12-37 Funeral procession to Westminster Abbey, detail of the Bayeux Tapestry, from Bayeux Cathedral, Bayeux, France, ca. 1070–1080. Embroidered wool on linen, 1′ 8″ high (entire length of fabric 229′ 8″). Centre Guillaume le Conquerant, Bayeux.

Chapter 13

Gothic Europe

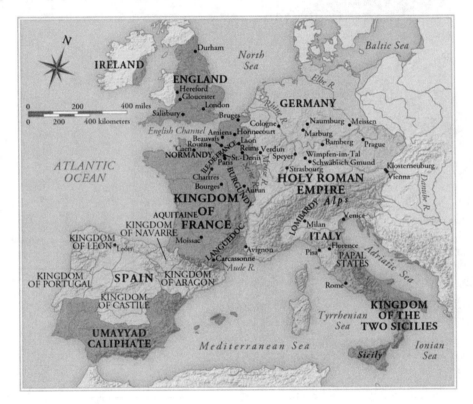

MAP 13-1 Europe around 1200.

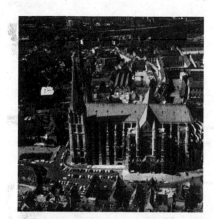

FIG. 13-01 aerial view of Chartres Cathedral
(looking north), Chartres, France, as rebuilt after 1194.

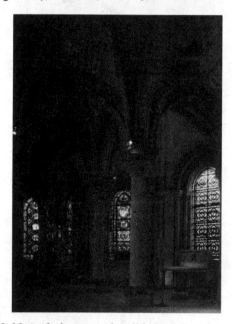

FIG. 13-02 Ambulatory and radidating chapels
(looking northeast), abbey church, Saint-Denis,
France, 1140–1144.

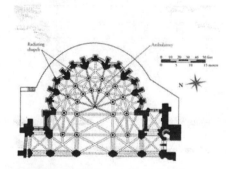

FIG. 13-03 Plan of the east end abbey church,
Saint-Denis, France, 1140–1144
(after Sumner Crosby).

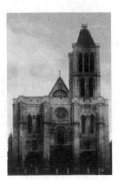

FIG. 13-03A West facade Saint-Denis, France, 1135–1140.

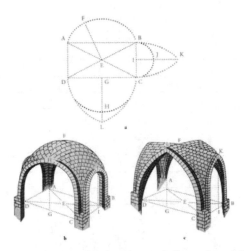

FIG. 13-04 Diagram (a) drawings of rib vaults with semicircular (b) and pointed (c) arches.

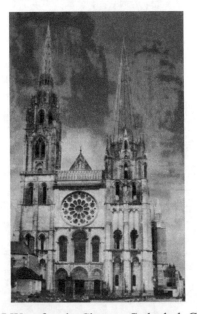

FIG. 13-05 West facade, Chartres Cathedral, Chartres, France, ca. 1145–1155.

222

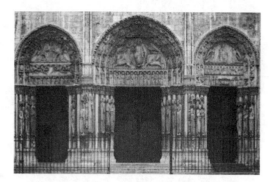

FIG. 13-06 Royal Portal, west facade, Chartres Cathedral, Chartres, France, ca. 1145–1155.

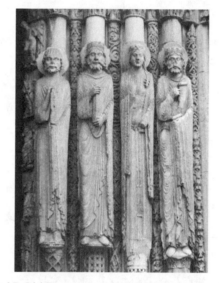

FIG. 13-07 Old Testament kings and queen, jamb statues, right of the central doorway of Royal Portal, Chartres Cathedral, Chartres, France, ca. 1145–1155.

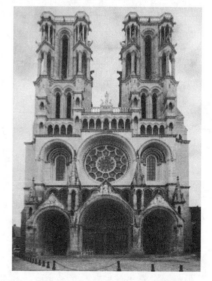

FIG. 13-08 West facade of Laon Cathedral, Laon, France, begun ca. 1190.

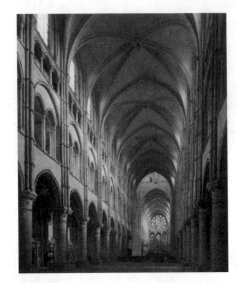

FIG. 13-09 Interior of Laon Cathedral (looking northeast), Laon, France, begun ca. 1190.

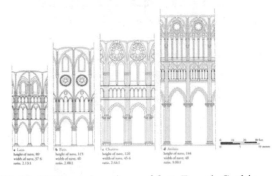

FIG. 13-10 Nave elevations of four French Gothic cathedrals at the same scale (after Louis Grodecki).

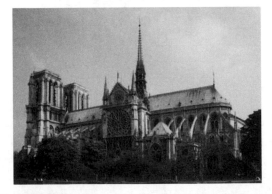

FIG. 13-11 Notre-Dame (looking north), Paris, France, begun 1163; nave and flying buttresses, ca. 1180–1200; remodeled after 1225.

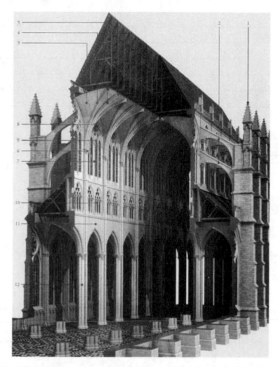

FIG. 13-12 Cutaway view of a typical french Gothic cathedral (John Burge).

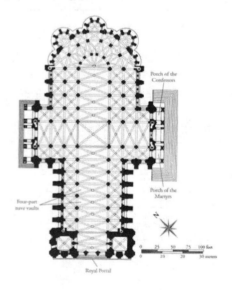

FIG. 13-13 Plan of Chartres Cathedral, Chartres, France, as rebuilt after 1194 (after Paul Frankl).

225

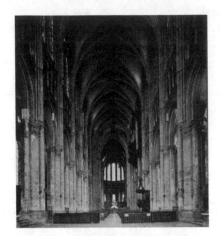

FIG. 13-14 Interior of Chartres Cathedral (looking east), Chartres, France, begun 1194. (page 470)

FIG. 13-15 Stonemasons and sculptors, detail of a stained-glass window in the northernmost radiating chapel in the ambulatory, Chartres Cathedral, Chartres, France, ca. 1200–1220.

FIG. 13-16 Virgin and Child and angels (Notre Dame de la Belle Verriere), detail of a window in the choir of Chartres Cathedral, Chartres, France, ca. 1170, with 13th century side panels. Stained glass, 12′9″ high.

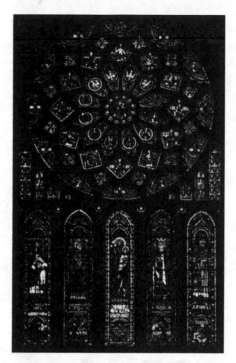

FIG. 13-17 Rose window and lancets, north transept, Charttres Cathedral, Chartres, France, ca. 1220. Stained glass, rose window 43′ in diameter.

FIG. 13-18 Saint Theodore, jamb statue, left portal, Porch of the Martyrs, south transept, Chartres Cathedral, Chartres, France, ca. 1230.

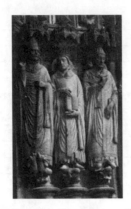

FIG. 13-18A Porch of the Confessors, Chartres, ca. 1220–1230.

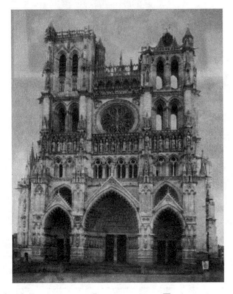

FIG. 13-19 ROBERT DE LUZARCHES, THOMAS DE CORMONT, and RENAUD DE CORMONT, west facade of Amiens Cathedral, Amiens, France, begun 1220.

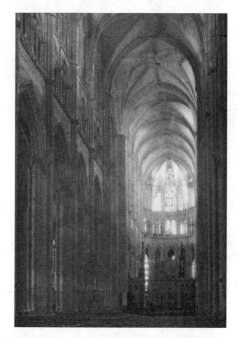

FIG. 13-20 Robert De Luzarches, Thomade De Cormont, and Renaud De Cormont, interior of Amiens Cathedral (looking east), Amiens, France, begun 1220.

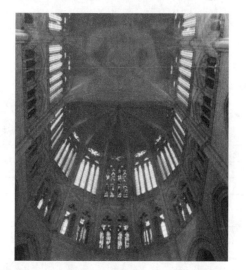

FIG. 13-21 Robert De Luzarches, Thomas de Cormont, and Renaud de Cormont, vaults, clerestory, and triforium of the choir of Amiens Cathedral, Amiens, France, begun 1220.

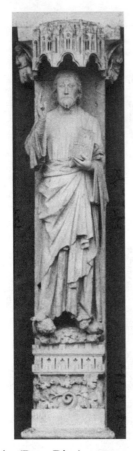

FIG. 13-22 Christ (Beau Dieu), trumeau statue of the central doorway of the west facade, Amiens Chathdral, Amiens, France, ca. 1220–1235.

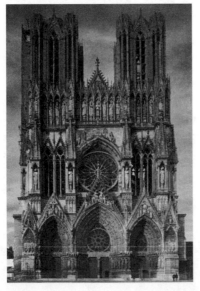

FIG. 13-23 Gaucher de Reims and Bernard de Sorssons, west facade of Reims Cathedral, Reims, France, ca. 1225–1290.

FIG. 13-23A Interior of Reims Cathedral, begun 1211.

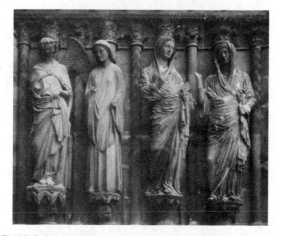

FIG. 13-24 Annunciation and Visitation, jamb statues on the right side of the central doorway of the west facade, Reims Cathedral, Reims, France, ca. 1230–1255.

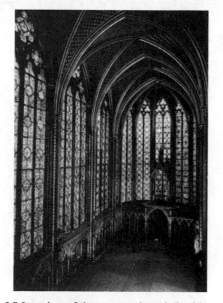

FIG. 13-25 Interior of the upper chapel (looking northeast), Sainte-Chapelle, Paris, France, 1243–1248.

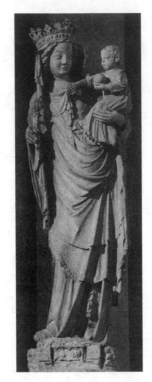

FIG. 13-26 Virgin and Child *(Virgin of Paris),*
Notre-Dame, Paris, France, early 14th century.

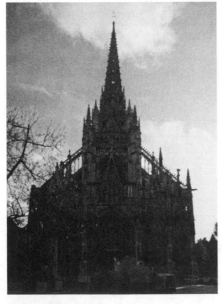

FIG. 13-27 West facade of Saint-Maclou, Rouen,
France, ca. 1500–1514.

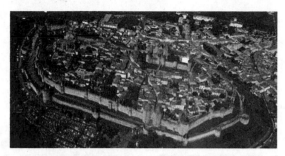

FIG. 13-28 Aerial view of the fortified town of
Carcassonne (looking west), France. Bastions and
towers, 12th–13th centuries, restored by EUGÈNE
VIOLLET-LE-DUC in the 19th century.

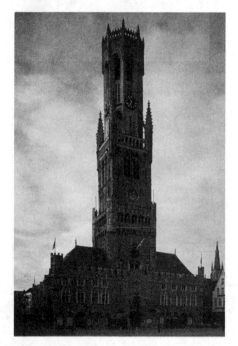

FIG. 13-29 Hall of the cloth guild Bruges, Belgium,
begun 1230.

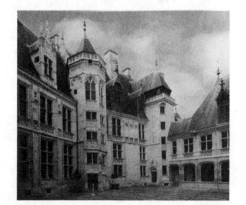

FIG. 13-30 House of Jacques Coeur, Bourges, France,
1443–1451.

FIG. 13-31 VILLARD DE HONNECOURT, figures based on geometric shapes, folio 18 verso of a sketchbook, from Paris, France, ca. 1220–1235. Ink on vellum, 9 1/4″ × 6″. Bibliothèque Nationale, Paris.

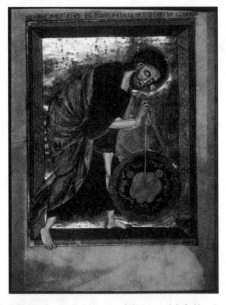

FIG. 13-32 God as architect of the world folio 1 verso of a moralized Bible, from Paris, France, ca. 1220–1230. Ink, tempera, and gold leaf on vellum, 1′ 1 1/2″ × 8 1/4″. Österreichische Nationalbibliothek, Vienna.

FIG. 13-33 Blanche of Castile, Louis IX, and two monks, dedication page (folio 8 recto) of a moralized Bible, from Paris, France, 1226–1234. Ink, tempera, and gold leaf on vellum, 1′ 3″ × 10 1/2″. Pierpont Morgan Library, New York.

FIG. 13-34 Abraham and the three angels, folio 7 verso of the *Psalter of Saint Louis,* from Paris, France, 1253–1270. Ink, tempera, and gold leaf on vellum, 5″ × 3 1/2″. Bibliothèque Nationale, Paris.

FIG. 13-35 MASTER HONORÉ, David anointed by Samuel and battle of David and Goliath, folio 7 verso of the *Breviary of Philippe le Bel,* from Paris, France, 1296. Ink and tempera on vellum, 7 7/8″ × 4 7/8″. Bibliothèque Nationale, Paris.

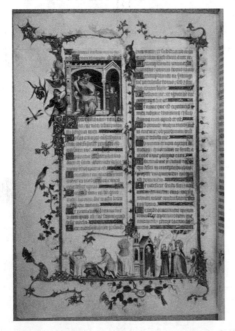

FIG. 13-36 JEAN PUCELLE, David before Saul, folio 24 verso of the *Belleville Breviary,* from Paris, France, ca. 1325. Ink and tempera on vellum, 9 1/2″ × 6 3/4″. Bibliothèque Nationale, Paris.

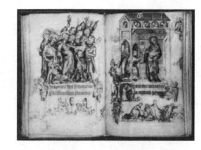

FIG. 13-36A Puchlle, Hours of Jeanna d'Eveux, ca. 1325–1328.

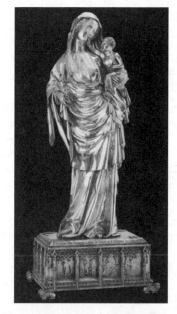

FIG. 13-37 *Virgin of Jeanne d'Evreux,* from the abbey church of Saint-Denis, France, 1339. Silver gilt and enamel, 2′ 3 1/2″ high. Musee du Louvre, Paris.

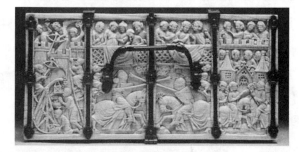

FIG. 13-38 The Castle of Love and knights jousting, lid of a jewelry casket, from Paris, France, ca. 1330–1350. Ivory and iron, 4 1/2″ × 9 3/4″. Walters Art Museum, Baltimore.

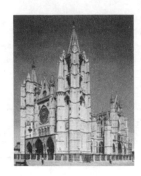

FIG. 13-38A Santa Maria, Leon, begun 1254.

FIG. 13-38B Mappamundi of Henry III, ca. 1277–1289.

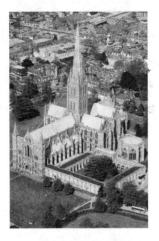

FIG. 13-39 Aerial view of Salisbury Cathedral, Salisbury, England, 1220–1258; west facade completed 1265; spire ca. 1320–1330.

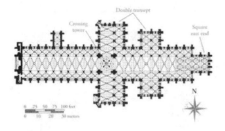

FIG. 13-40 Plan of Salisbury Cathedral, Salisbury, England, 1220–1258.

238

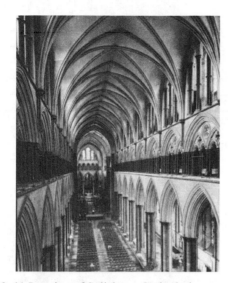

FIG. 13-41 Interior of Salisbury Cathedral (looking east), Salisbury, England, 1220–1258.

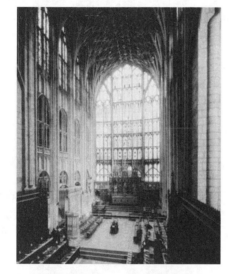

FIG. 13-42 Choir of Gloucester Cathedral (looking east), Gloucester, England, 1332–1357.

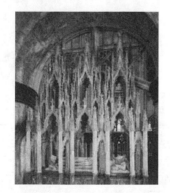

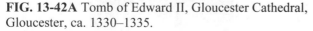

FIG. 13-42A Tomb of Edward II, Gloucester Cathedral, Gloucester, ca. 1330–1335.

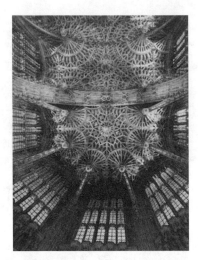

FIG. 13-43 ROBERT and WILLIAM VERTUE, fan vaults of the chapel of Henry VII, Westminster Abbey, London, England 1503–1519.

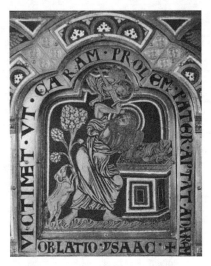

FIG. 13-44 Nicholas of Verdun, Sacrifice of Isaac, detail of the Klosterneuburg Altar, from the abbey church at Klosterneuburg, Austria, 1181. Gilded copper and enamel, 5 1/2″ high. Stiftsmuseum, Klosterneuburg.

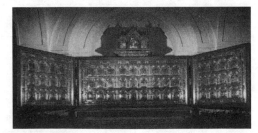

FIG. 13-44A Klosterneuburg Altar, refashioned alter 1330.

240

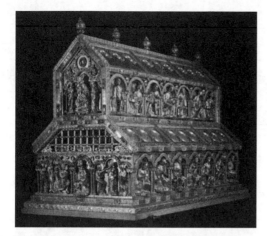

FIG. 13-45 Nicholas of Verdun, Shrine of the three Kings, from Cologn Cathedral, Cologne, Germany, begun ca. 1190. Silver, bronze, enamel, and gemstondes, 5′8″ × 6′ × 3″8″. Dom Schatzkammer, Cologne.

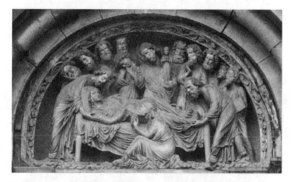

FIG. 13-46 Death of the Virgin, tympanum of the left doorway of the south transept, Strasbourg, France, ca. 1230.

FIG. 13-47 Naumburg Master, Crucifiction, west choir screen of Naumburg Cathedral, Naumburg, Germany, ca. 1249–1255, Painted limestone statues, life size.

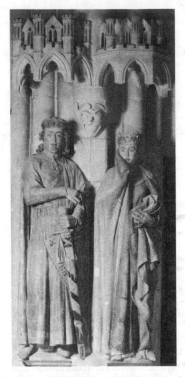

FIG. 13-48 Naumberg Master, Ekkahard and Uta, statues in the west choir, Naumburg Cathedral, Naumburg, Germany, ca. 1249–1255. Painted limestone, Ekkehard 6′ 2″ high.

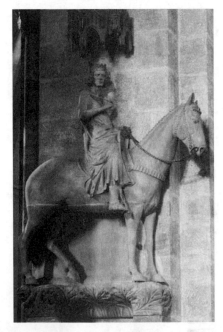

FIG. 13-49 Equestrian portrait *(Bamberg Rider),* statue in the east choir, Bamberg Cathedral, Germany, ca. 1235–1240. Sandstone, 7′ 9″ high.

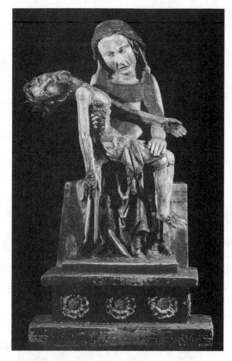

FIG. 13-50 Rottgen Pieta, from the Rhineland, Germany, ca. 1300–1325. Painted wood 2′ 10 1/2″ high. Rheinisches Landemuseum, Bonn.

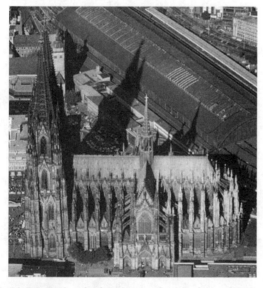

FIG. 13-51 Gerhard of Cologne, aerial view of Cologne Cathedral (looking north), Cologne, Germany begun 1248: nave, facade, and towers completed 1880.

243

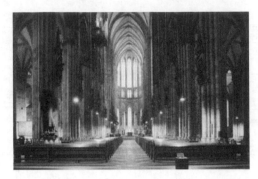

FIG. 13-52 Gerhard of Cologne, interior of Cologn Cathedral (looking east), Cologne Germany. Choir completed 1322.

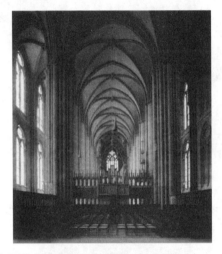

FIG. 13-53 Interior of Saint Elizabeth (looking west), Marburg, Germany, 1235–1283.

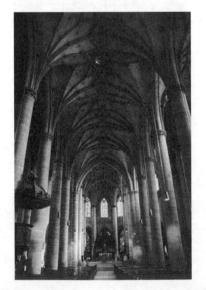

FIG. 13-54 Peter Parler, interior (looking east), of Helligkreuzkirche (Church of the Holy Cross), Schwaibsch Gmund, Germany, begun 1351.

Chapter 14

Late Medieval Italy

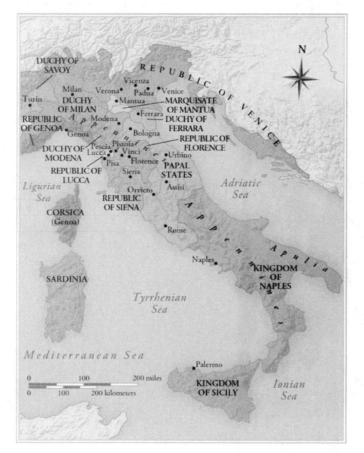

MAP 14-1 Italy around 1400.

FIG. 14-01 GIOTTO DI BONDONE, Arena Chapel (Cappella Scrovegni; interior looking west), Padua, Italy, 1305–1306.

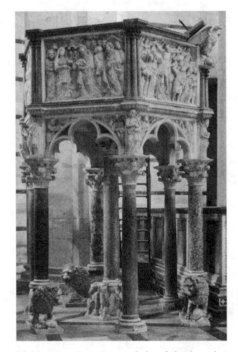

FIG. 14-02 NICOLA PISANO, pulpit of the baptistery, Pisa, Italy, 1259–1260. Marble, 15′ high.

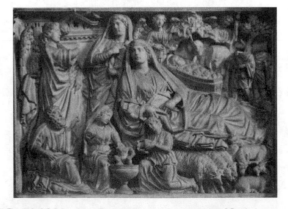

FIG. 14-03 NICOLA PISANO, *Annunciation, Nativity, and Adoration of the Shepherds,* relief panel on the baptistery pulpit, Pisa, Italy, 1259–1260. Marble 2′ 10″ × 3′ 9″.

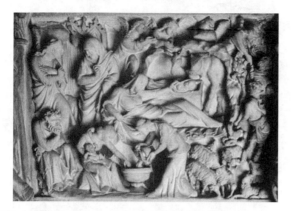

FIG. 14-04 GIOVANNI PISANO, *Annunciation, Nativity, and Adoration of the Shepherds,* relief panel on the pulpit of Sant' Andrea, Pistoia, Italy, 1297–1301. Marble, 2′ 10″ × 3′ 4″.

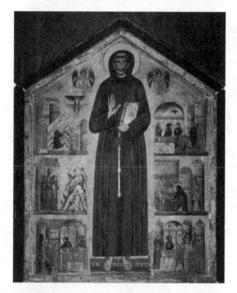

FIG. 14-05 BONAVENTURA BERLINGHIERI, the *Saint Francis Altarpiece,* San Francesco, Pescia, Italy, 1235. Tempera on wood, 5′ × 3′ × 6″.

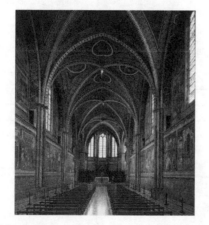

FIG. 14-05A San Francesco, Assisi, 1228–1253.

FIG. 14-05B Sr. Frences Master, Preaching to the Birds, CE. 1290–1300.

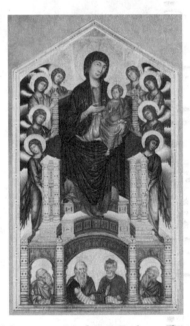

FIG. 14-06 CIMABUE, *Madonna Enthroned with Angels and Prophets,* from Santa Trinità, Florence, Italy, ca 1280–1290. Tempera and gold leaf on wood, 12′ 7″ × 7′ 4″. Galleria degli Uffizi, Florence.

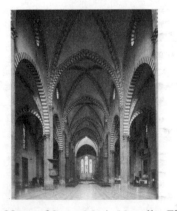

FIG. 14-06A Nave of Santa Maria Novella, Florence, begun ca. 1246.

FIG. 14-06B Cavallini, Last Judgment, ca. 1290–1295.

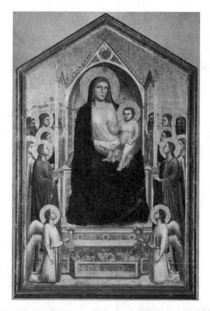

FIG. 14-07 GIOTTO DI BONDONE, *Madonna Enthroned,* from the Church of Ognissanti, Florence, Italy, ca. 1310. Tempera and gold leaf on wood, 10′ 8″ × 6′ 8″. Galleria degli Uffizi, Florence.

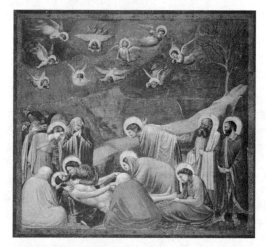

FIG. 14-08 GIOTTO DI BONDONE, *Lamentation,* Arena Chapel (Cappela Scrovegni), Padua, Italy, ca. 1305. Fresco, 6′ 6 3/4″ × 6′ 3/4″.

FIG. 14-08A Grotto, Entry into Jerusalem, ca. 1305.

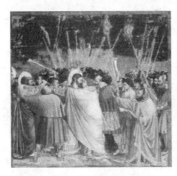

FIG. 14-08B Grotto, Betrayal of Jesus, ca. 1305.

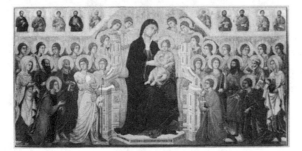

FIG. 14-09 DUCCIO DI BUONINSEGNA, *Virgin and Child Enthroned with Saints,* principal panel of the *Maestà* altarpiece, from Siena Cathedral, Siena, Italy, 1308–1311. Tempera and gold leaf on wood 7′ × 13′ (center panel). Museo dell'Opera del Duomo, Siena.

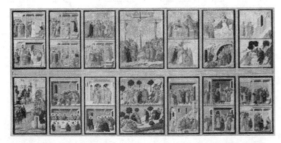

FIG. 14-10 DUCCIO DI BUONINSEGNA, Life of Jesus, 14 panels from the back of the Maestà altarpiece, from Siena Cathedral, Siena, Italy, 1308–1311. Tempera and gold leaf on wood 7′ × 13′. Museo dell' Opera del Duomo, Siena.

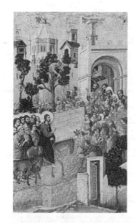

FIG. 14-10A Duccio, Entry into Jerusalem, 1306–1311.

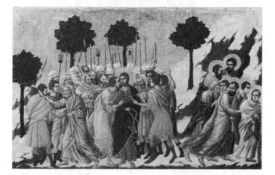

FIG. 14-11 Duccio di Buoninsegna, *Betrayal of Jesus,* detail from the back of the *Maestà* altarpiece, from Siena Cathedral, Siena, Italy, 1309–1311. Tempera and gold leaf on wood detail 1′ 10 1/2″ × 3′ 4″. Museo dell'Opera del Duomo, Siena.

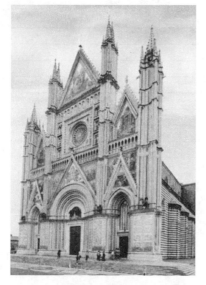

FIG. 14-12 Lorenzo Maitani, Orvieto Cathedral (looking northeast), Orvieto, Italy, begun 1310.

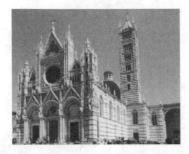

FIG. 14-12A Sienna Cathedral, begun ca. 1226.

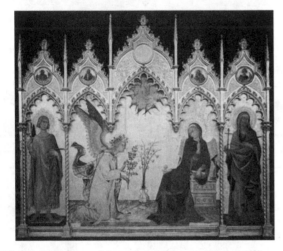

FIG. 14-13 SIMONE MARTINI and LIPPO MEMMI(?), *Annunciation* altarpiece, from Siena Cathedral, 1333 (frame reconstructed in the 19th century). Tempera and gold leaf on wood center panel 10′ 1″ × 8′ 8 3/4″. Galleria degli Uffizi, Florence.

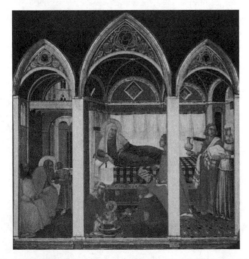

FIG. 14-14 PIETRO LORENZETTI, *Birth of the Virgin,* from the altar of Saint Savinus, Siena Cathedral, Siena, Italy, 1342. Tempera on wood, 6′ 1′ × 5′ 11″. Museo dell'Opera del Duomo, Siena.

252

FIG. 14-15 Aerial view of the Campo (looking southeast) with the Palazzo Pubblico, Siena, Italy, 1288–1309.

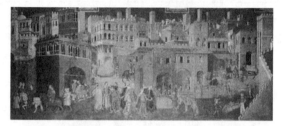

FIG. 14-16 AMBROGIO LORENZETTI, *Peaceful City,* detail *from Effects of Good Government in the City and the Country,* east wal, Sala della Pace, Palazzo Pubblico, Siena, Italy, 1338–1339. Fresco.

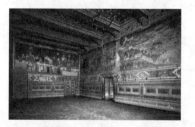

FIG. 14-16A Sala della Pace, Siena, 1338–1339.

FIG. 14-17 AMBROGIO LORENZETTI, *Peaceful Country,* detail from *Effects of Good Government in the City and in the Country,* east wall, Sala della Pace (Fig.-16A), Sala della Pace, Palazzo Pubblico, Siena, Italy, 1338–1339. Fresco.

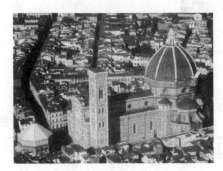

FIG. 14-18 Arnolfo Di Cambio and others, aerial view of Santa Maria del Fiore (and the Baptistery of San Giovanni; looking northeast) Florence, Italy, begun 1296. Campanile designed by Giotto di Bondone, 1334.

FIG. 14-18A Nave, Florence Cathedral, begun 1296.

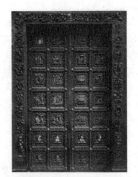

FIG. 14-18B Palazzo della Signoria, Florence, 1299–1310.

FIG. 14-19 ANDREA PISANO, south doors of the Baptistery, of San San Giovanni (Fig. 12-27) Florence, Italy, 1330–1336. Gilded bronze, doors 16′ × 9′ 2″; individual panels 1′ 7 1/4″ × 1′ 5″. (The door frames date to the mid-15th century.)

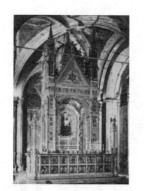

FIG. 14-19A Orcagna or San Michele tabernacle 1355–1359.

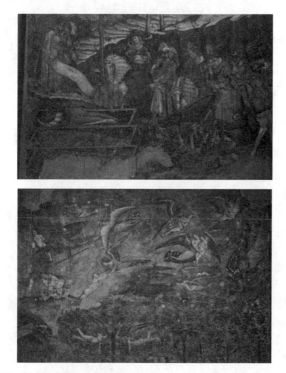

FIG. 14-20 FRANCESCO TRAINI or BUONAMICO BUFFALMACCO, two details of *Triumph of Death,* 1330s. Full fresco, 18′ 6″ × 49′ 2″. Camposanto, Pisa.

FIG. 14-21 Doge's Palace, Venice, Italy, begun ca. 1340–1345; expanded and remodeled 1424–38.

255

Chapter 15

South and Southeast Asia before 1200

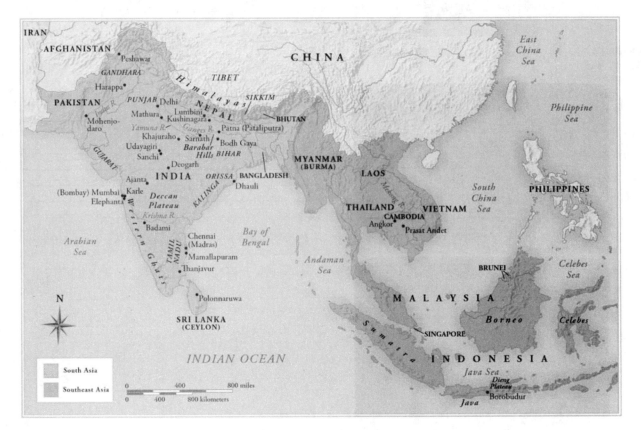

MAP 15-1 South and Southeast Asian sites before 1200.

FIG. 15-01 The life and death of the Buddha, frieze from Gandhara, Pakistan, second century ce. Schist, 2′2 3/8″ × 9′ 6 1/8″. Freer Gallery of Art, Washington, D.C.

FIG. 15-02 Great Bath (looking northeast), Mohenjo-daro, Pakistan, ca. 2600–1900 BCE.

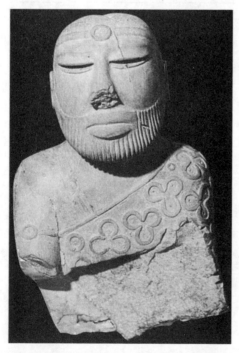

FIG. 15-03 Robed male figure, from Mohenjo-daro, Pakistan, ca. 2000–1900 BCE. Steatite, 6 7/8″ high. National Museum of Pakistan, Karachi.

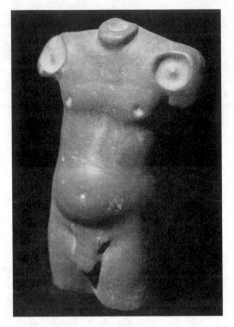

FIG. 15-04 Nude male torso, from Harappa, Pakistan, ca. 2000–1900 BCE. Red sandstone, 3 3/4″ high. National Museum, New Delhi.

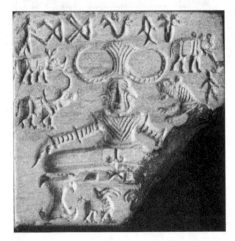

FIG. 15-05 Seal with seated figure in yogic posture, from Mohenjo-daro, Pakistan, ca. 2300–1750 BCE. Steatite coated with alkali and baked 1 3/8″ × 1 3/8″. National Museum, New Delhi.

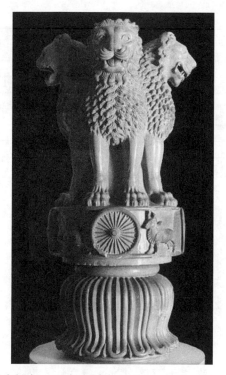

FIG. 15-06 Lion capital of the column set up by erected by Ashoka at Sarnath, India, ca. 250 BCE. Polished sandstone, 7′ high. Archaeological Museum, Sarnath.

FIG. 15-06A Lion pillar, Lauriya Nandangarh, India, ca. 245 BCE.

FIG. 15-06B Yakshi with fly whisk, Didarganj, mid-third century BCE.

259

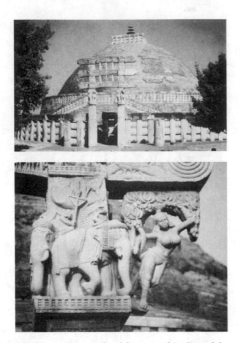

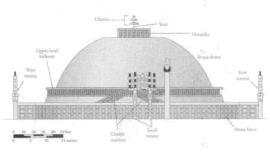

FIG. 15-07 Great Stupa (looking north), Sanchi, India, third century BCE to first century CE. Bottom: Elephants and yakshi, detail of the east torana, mid-first century BCE to early first century CE. Sandstone, 5′ high.

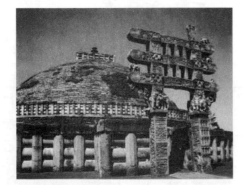

FIG. 15-08 Diagram of the Great Stupa, Sanshi, India, Third century BCE to first century CE.

FIG. 15-08A East torana, Great Stupa, Sanchi, ca. 50 BCE–50-CE.

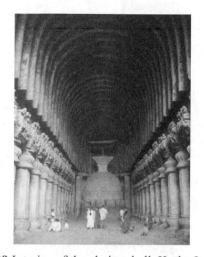

FIG. 15-09 Interior of the chaitya hall, Karle, India, ca. 50–100 CE.

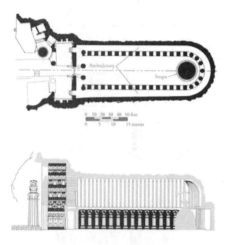

FIG. 15-10 Plan *(top)* and section *(bottom)* of the chaitya hall (FIG. 6–1), Karle, India, ca. 50–100 CE.

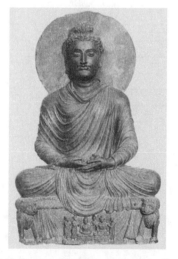

FIG. 15-11 Meditating Buddha, from Gandhara, Pakistan, second century CE. Gray schist, 3′ 7 1/2″ high. National Museums of Scotland Edinburgh.

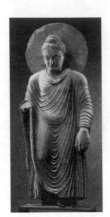

FIG. 15-11A Standing Buddha, Gandhara, second to third century CE.

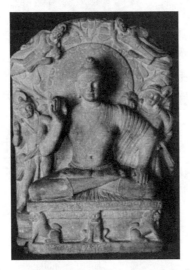

FIG. 15-12 Buddha seated on lion throne, from Mathura, India, second century CE. Red sandstone, 2′ 3 1/2″ high. Archaeological Museum, Muttra.

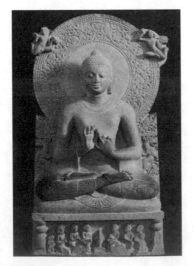

FIG. 15-13 Seated Buddha preaching first sermon, from Sarnath, India, second half of fifth century. Tan sandstone, 5′ 3″ high. Archaeological Museum, Sarnath.

262

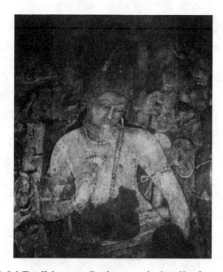

FIG. 15-14 Bodhisattva Padmapani, detail of a wall painting in cave 1, Ajanta, India, second half of fifth century.

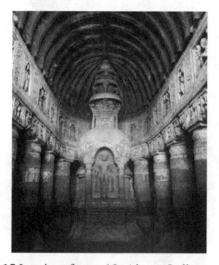

FIG. 15-15 Interior of cave 19, Ajanta, India, second half of fifth century.

FIG. 15-16 Boar avatar of Vishnu rescuing the earth, cave 5, Udayagiri, India, early fifth century. Relief 13′ × 22′; Vishnu 12′ 8″ high.

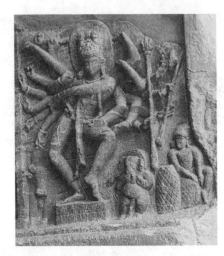

FIG. 15-17 Dancing Shiva, rock-cut relief in cave temple, Badami, India, late sixth century.

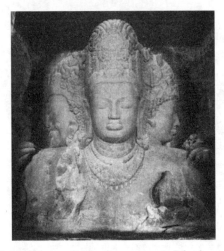

FIG. 15-18 Shiva as Mahadeva, cave 1, Elephanta, India, ca. 550–575. Basalt, Shiva 17′ 10″ high.

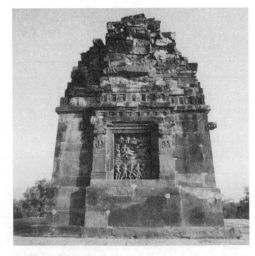

FIG. 15-19 Vishnu Temple (looking north), Deogarh, India, early sixth century.

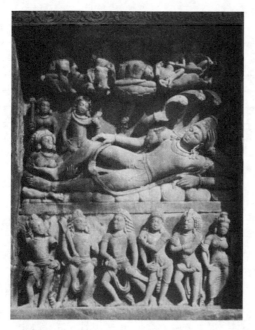

FIG. 15-20 Vishnu asleep on the serpent Ananta, relief panel on the south facade of the Vishnu Temple, Deogarh, India, early sixth century.

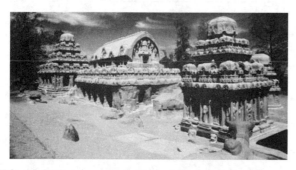

FIG. 15-21 Rock-cut rathas, (looking southwest) Mamallapuram, India, second half of seventh century. From *left to right:* Dharmaraja, Bhima, Arjuna, and Draupadi rathas.

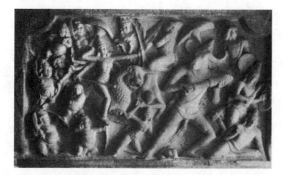

FIG. 15-22 Durga slaying the buffalo demon Manisha, rock-cut relief in the Mahishasuramardini cave temple, Mamallapuram, India, seventh century CE. Granite, 9′ high.

265

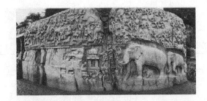

FIG. 15-22A Descent of the Ganges, Mamallapuram, ca. 500–650.

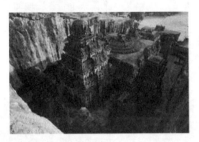

FIG. 15-22B Kailasanatha Temple, Ellora, second half of eight century.

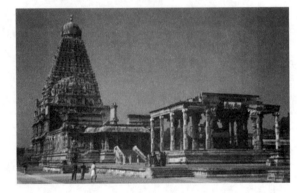

FIG. 15-23 Rajarajeshvara Temple, Thanjavur, India, ca. 1010.

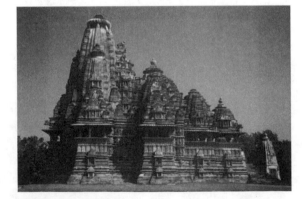

FIG. 15-24 Vishvanatha Temple (looking north), Khajuraho, India, ca. 1000.

FIG. 15-25 Plan of the Vishvanatha Temple, Khajuraho, India, ca. 1000.

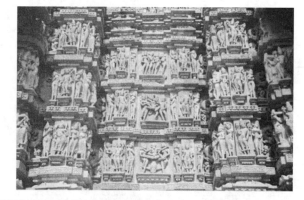

FIG. 15-26 Mithuna reliefs, detail of the north side of the Vishvanatha Temple, Khajuraho, India, ca. 1000.

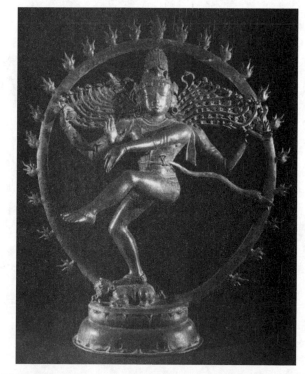

FIG. 15-27 Shiva as Nataraja, from Tamil Nadu, India, ca. 1000. Bronze. British Museum, London.

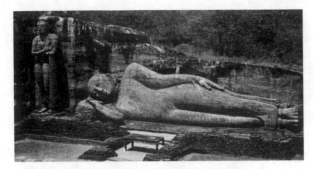

FIG. 15-28 Death of the Buddha (Parinirvana), Gal Vihara, near Polonnaruwa, Sri Lanka, 11th to 12th century. Granulite, Buddha 10′ × 46′.

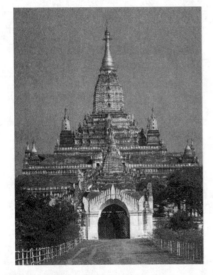

FIG. 15-28A Ananda Temple, Bagan, Myanmar, begun 1091.

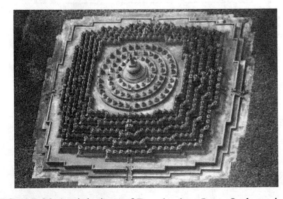

FIG. 15-29 Aerial view of Borobudur, Java, Indonesia, ca. 800.

FIG. 15-29A Bodhisattva Maitreya, from Prakhon Chai, Thailand, eighth to ninth century.

FIG. 15-30 Harihara, from Prasat Andet, Cambodia, early seventh century. Stone, 6′ 3″ high. National Museum, Phnom Penh.

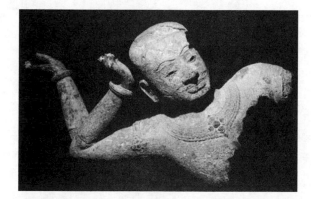

FIG. 15-31 Vishnu lying on the cosmic ocean, from the Mebon temple on an island in the western baray, Angkor, Cambodia, 11th century. Bronze, 8′ long.

269

FIG. 15-32 Aerial view of Angkor Wat, Angkor, Cambodia, first half of 12th century.

FIG. 15-33 King Suryavarman II holding court, detail of a stone relief, lowest gallery, south side, Angkor Wat, Angkor, Cambodia, first half of 12th century.

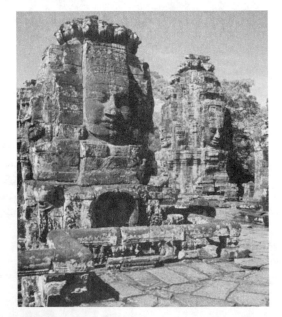

FIG. 15-34 Towers of the Bayon, Angkor Thom, Cambodia, ca. 1200.

Chapter 16

China and Korea to 1279

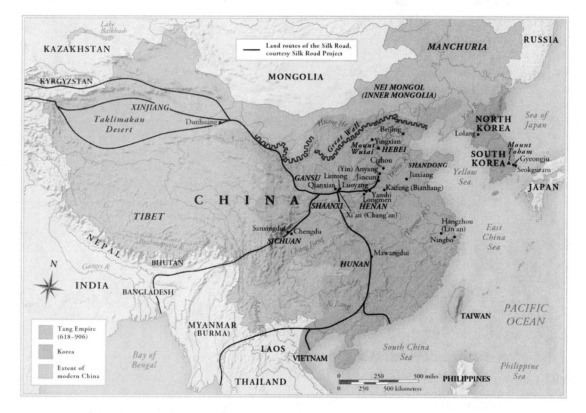

MAP 16-1 China during the Tang dynasty.

FIG. 16-01 Funeral banner, from tomb 1 (tomb of the marquise of Dai), Mawangdui, China, Han dynasty, ca. 168 BCE. Painted silk, 6′ 8 3/4″ × 3′ 1/4″. Hunan Provincial Museum, Changsha.

FIG. 16-02 Yanshao Culture vases, from Gansu Province, China, mid-third millennium BCE.

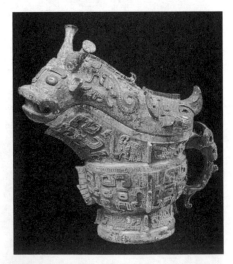

FIG. 16-03 Guang, probably from Anyang, China, Shang dynasty, 12th or 11th century BCE. Bronze, 6 1/2″ high. Asian Art Museum of San Francisco, San Francisco (Avery Brundage Collection).

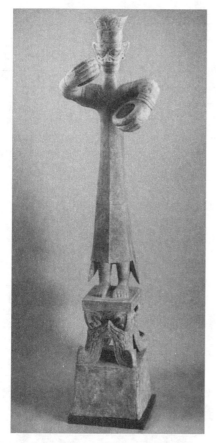

FIG. 16-04 Standing male figure, from pit 2, Sanxingdui, China, ca.1200–1050 BCE. Bronze, 8′ 5″ high, including base. Museum, Sanxingdui.

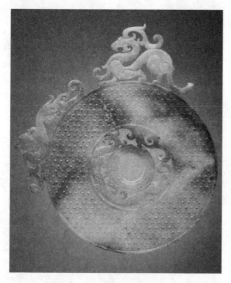

FIG. 16-05 Bi disk with dragons, from Jincun(?), near Luoyang, China, Eastern Zhou dynasty, fourth to third century BCE. Nephrite, 6 1/2″ in diameter. Nelson-Atkins Museum of Art, Kansas City.

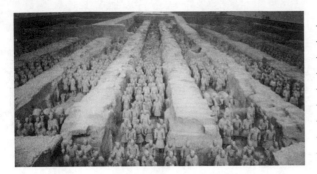

FIG. 16-06 Army of the First Emperor of Qin in pits next to his burial mound Lintong, China, Qin dynasty, ca. 210 BCE. Painted terracotta, average figure 5′ 10 7/8″ high.

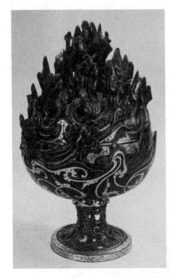

FIG. 16-06A Incense burner of Prince Liu Sheng, ca. 113 BCE.

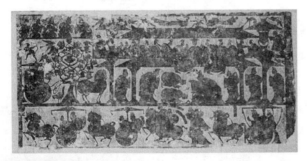

FIG. 16-07 The archer Yi(?) and a reception in a mansion, Wu family shrine, Jiaxiang, China, Han dynasty, 147–168 CE. Rubbing of a stone relief, 3′ × 5′.

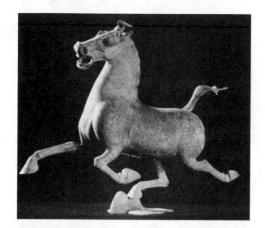

FIG. 16-08 Flying horse, from the tomb of Governor-General Zhang, Wuwei, China, Han dynasty, late second century CE. Bronze, 1′ 1 1/2″ high. Gansu Provincial Museum, Lanzhou.

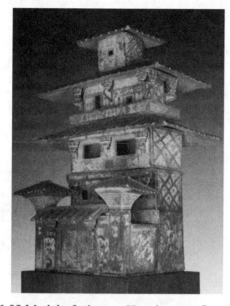

FIG. 16-09 Model of a house, Han dynasty, first century CE. Painted earthenware, 4′ 4″ high. Nelson-Atkins Museum of Art, Kansas City.

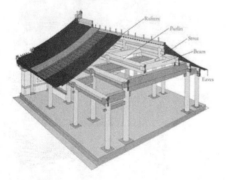

FIG. 16-10 Chinese raised-beam construction (after L. Lui).

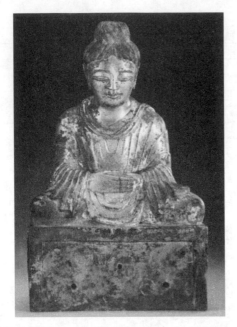

FIG. 16-11 Shakyamuni Buddha, from Hebei Province, Later Zhao dynasty, Period of Disunity, 338. Gilded bronze, 1′ 3 1/2″ high. Asian Art Museum of San Francisco, San Francisco (Avery Brundage Collection).

FIG. 16-12 Attributed to GU KAIZHI, *Lady Feng and the Bear,* detail of *Admonitions of the Instructress to the Court Ladies,* Period of Disunity, late fourth century. Handscroll, ink and colors on silk, 9 3/4″ × 11′ 4 1/2″. British Museum, London.

FIG. 16-13 Shakyamuni and Prabhutaratna, from Hebei Province, Northern Wei dynasty, 518. Gilded bronze, 10 1/4″ high. Musée Guimet, Paris.

FIG. 16-13A Seated Buddha Cave 20, Yungang, ca. 460–470 CE.

FIG. 16-13B Sui altarpiece with Amitabha and attendants, 593.

277

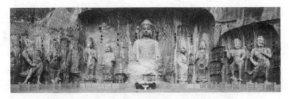

FIG. 16-14 Vairocana Buddha, disciples, and bodhisattvas, Fengxian Temple, Longmen Caves, Luoyang, China, Tang dynasty, completed 676. Limestone, Buddha 44′ high.

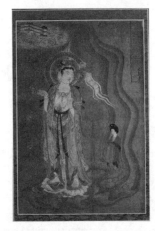

FIG. 16-14A Bodhisattva Guanyin Dunhuang, late 9th or early 10th century.

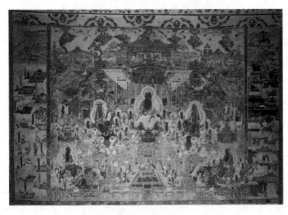

FIG. 16-15 *Paradise of Amitabha,* cave 172, Dunhuang, China, Tang dynasty, mid-eighth century. Wall painting 10′ high.

FIG. 16-15A Foguang Si, Mount Wutai, ca. 857.

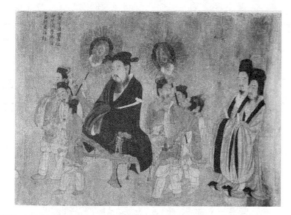

FIG. 16-16 Attributed to YAN LIBEN, *Emperor Xuan and Attendants,* detail of *The Thirteen Emperors,* Tang dynasty, ca. 650. Handscroll, ink and colors on silk, detail 1′ 8 1/4″ × 1′ 5 1/2″; entire scroll 17′ 5″ long. Museum of Fine Arts, Boston.

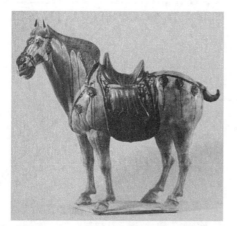

FIG. 16-17 Palace ladies, detail of a wall painting, tomb of Princess Yongtai, Qianxian, China, Tang dynasty, 706. Detail 5′ 10″ high.

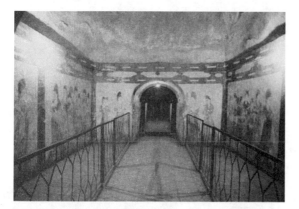

FIG. 16-18 Neighing horse, Tang dynasty, eighth to ninth century. Glazed earthenware, 1′ 8″ high. Victoria & Albert Museum, London.

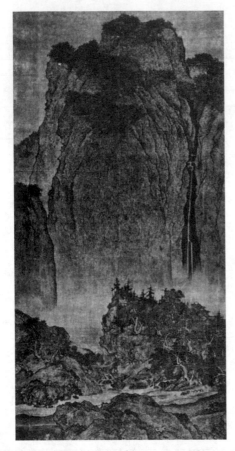

FIG. 16-19 FAN KUAN, *Travelers among Mountains and Streams*, Northern Song period, early 11th century. Hanging scroll, ink and colors on silk 6′ 7 1/4″ × 3′ 4 1/4″; National Palace Museum, Taibei.

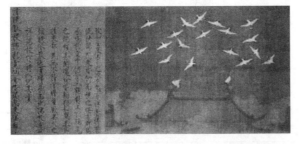

FIG. 16-20 Attributed to HUIZONG, *Auspicious Cranes*, Northern Song period 1112. Section of a handscroll, ink and colors on silk, 1′ 8 1/8″ × 4′ 6 3/8″. Liaoning Provincial Museum, Shenyang.

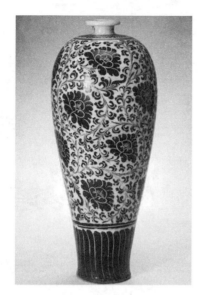

FIG. 16-21 Meiping vase, from Xiuwi, China, Northern Song period 12th century. Stoneware, Cizhou type, with sgraffito decoration, 1 7 1/2″ high. Asian Art Museum of San Francisco, San Francisco (Avery Brundage Collection).

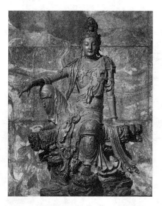

FIG. 16-21A Bodhisattva Guanyin seated on Potalaka, 11th or early 12th century.

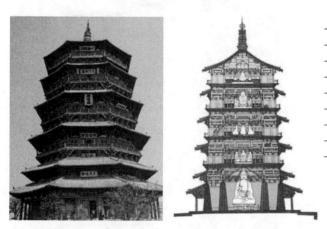

FIG. 16-22 View *(left)* and cross-section *(right; after L. Liu)* of Foguang Si Pagoda, Yingxian, China, Liao dynasty, 1056.

281

FIG. 16-23 MA YUAN, *On a Mountain Path in Spring,*
Southern Song period early 13th century. Album leaf, ink
and colors on silk, 10 3/4″ × 17″. National Palace
Museum, Taibei.

FIG. 16-23A XIA GUI, Twelve Views from A Thatched
Hut, ca. 1200–1225.

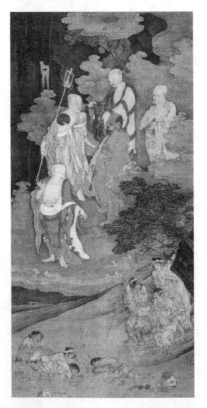

FIG. 16-24 ZHOU JICHANG, *Lohans Giving Alms to
Beggars,* Southern Song period ca. 1178. Hanging scroll,
ink and colors on silk, 3′ 7 7/8″ × 1′ 8 7/8″. Museum of
Fine Arts, Boston.

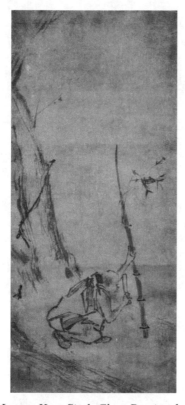

FIG. 16-25 LIANG KAI, *Sixth Chan Patriarch Chopping Bamboo,* Southern Song period early 13th century. Hanging scroll, ink on paper, 2′ 5 1/4″ high. Tokyo National Museum, Tokyo.

FIG. 16-26 Crown, from north mound of the Cheonmachong (tomb 98), Hwangnamdong, near Kyongju, Korea, Three Kingdoms period fifth to sixth century. Gold and jade, 10 3/4″ high. Kyongju National Museum, Kyongju.

283

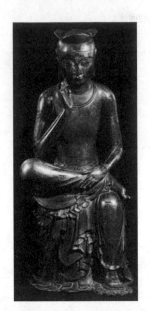

FIG. 16-27 Meditating Bodhisatva Maitreya, Three Kingdoms period, early seventh century CE. Guilt bronze, 2′ 11 7/8″ high. National Museum of Korea, Seoul.

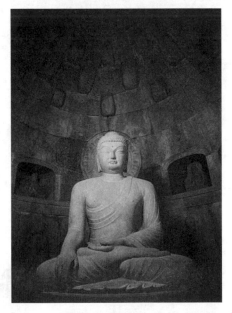

FIG. 16-28 Shakyamuni Buddha, in the rotunda of the cave temple, Seokguram Korea, Unified Silla Kingdom, 751–774. Granite, 11′ high.

FIG. 16-29 Maebyeong vase, Goryeo dynasty, 12th century. Porcellaneous stoneware with incised decoration under celadon glaze, 1′4″ tall. Philadelphia Museum of Art, Philadelphia (purchased with the Fiske Kimball Fund and the Marie Kimball Fund, 1974).

Chapter 17

Japan Before 1333

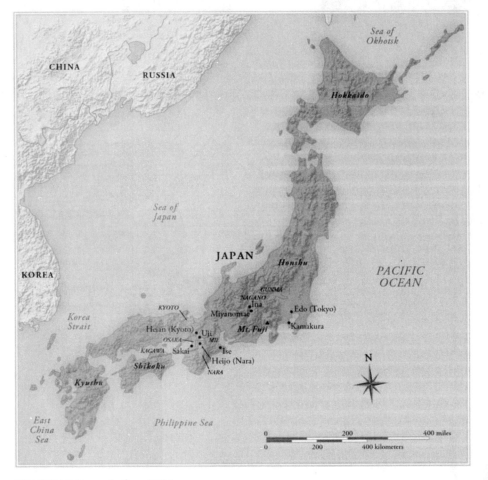

MAP 17-1 Japan before 1333.

286

FIG. 17-01 Aerial view of the Horyuji temple complex (looking northwest), Nara Prefecture, Japan period, ca. 680.

FIG. 17-02 Vessel, from Miyanomae, Nagano Prefecture, Japan, Middle Jomon period 2500–1500 BCE. Earthenware, 1′11 2/3″ high. Tokyo National Museum, Tokyo.

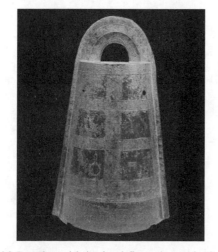

FIG. 17-03 Dotaku with incised figural motifs, from Kagawa Prefecture, Japan, late Yayoi period 100–300 CE. Bronze, 1′ 4 7/8″ high. Tokyo National Museum, Tokyo.

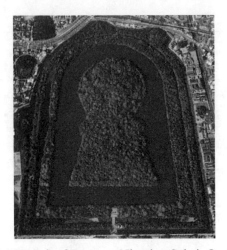

FIG. 17-04 Tomb of Emperor Nintoku, Sakai, Osaka Prefecture, Japan, Kofun period, late fourth to early fifth century.

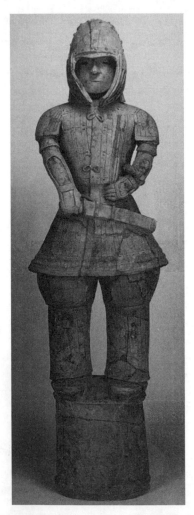

FIG. 17-05 Haniwa warrior, from Gunma Prefecture, Japan, Kofun period, fifth to mid-sixth century. Low-fired clay, 4′ 3 1/4″ high. Tokyo National Museum, Tokyo.

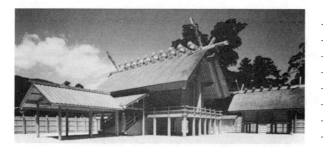

FIG. 17-06 Main hall (looking northwest) of the Ise Jingu, Mie Prefecture, Japan, Kofun period or later; rebuilt in 1993.

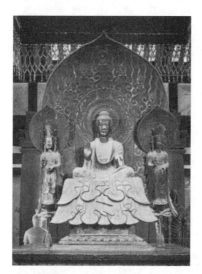

FIG. 17-07 TORI BUSSHI, Shaka triad, kondo, Horyuji, Nara Prefecture, Japan, Asuka period, 623. Bronze, central figure 2′ 10″ high.

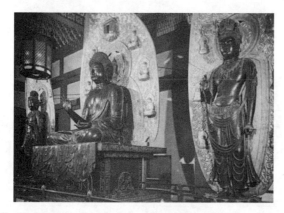

FIG. 17-08 Yakushi triad, kondo, Yakushiji, Nara Prefecture, Japan, Nara period, late seventh or early eighth century. Bronze, central figure 8′ 4″ high, including base and mandorla.

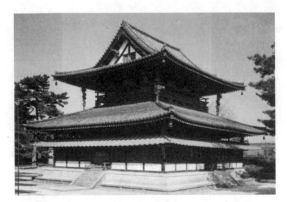

FIG. 17-09 Kondo (looking southeast), Horyuji, Nara Prefecture, Japan, Nara period, ca. 680.

FIG. 17-10 Amida triad, photograph before fire damage of the mural formerly in the kondo, Horyuji, Nara Prefecture, Japan, Nara period ca. 710. Ink and colors, 10′ 3″ × 8′ 6″. Horyuji Treasure House, Nara

FIG. 17-11 Daibutsuden, (looking north),Todaiji, Nara, Japan, Nara period 743; rebuilt ca. 1700.

FIG. 17-12 Taizokai (Womb World) mandara, Kyoogokokuji (Toji), Kyoto, Japan, Heian period second half of ninth century. Hanging scroll, color on silk, 6′ × 5′ 5/8″.

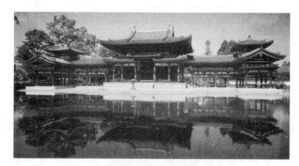

FIG. 17-13 Phoenix Hall, (looking west), Byodoin, Uji, Kyoto Prefecture, Japan, Heian period 1053.

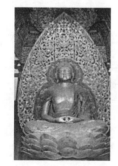

FIG. 17-13A Jocho, Seated Amida, Phoenix Hall, Uji, 1053.

FIG. 17-13B Fujiwara No Sadanobu, Ishiyama-gire, early
12th century.

FIG. 17-14 *Genji Visits Murasaki,* from the Minori
chapter, *Tale of Genji,* Heian period first half of 12th
century. Handscroll, ink and color on paper, 8 5/8″ high.
Goto Art Museum, Tokyo.

FIG. 17-15 The flying storehouse, from *Legends of Mount
Shigi,* Heian period, late 12th century. Handscroll, ink and
colors on paper, 1′ 1/2″ high. Chogosonshiji, Nara.

FIG. 17-16 Portrait statue of the priest Shunjobo Chogen, Todaiji, Nara, Japan, Kamakura period ca 1206. Painted cypress wood statue 2′ 8 3/8″ high;

FIG. 17-17 KOSHO, *Portrait statue of the priest Kuya preaching,* Kamakura period, early 13th century. Painted wood with inlaid eyes, 3′ 10 1/4″ high. Rokuharamitsuji, Kyoto.

FIG. 17-17A Unkei, Agyo, Todaiji, 1203.

FIG. 17-18 *Night Attack on the Sanjo Palace,* from *Events of the Heiji Period,* Kamakura period, 13th century. Handscroll, ink and colors on paper, 1′ 4 1/4″ high; complete scroll 22′ 10″ long. Museum of Fine Arts, Boston (Fenollosa-Weld Collection).

FIG. 17-19 *Amida Descending over the Mountains,* Kamakura period, 13th century. Hanging scroll, ink and colors on silk, 4′ 3 1/8″ × 3′ 10 ½.

Chapter 18

Native Arts of the Americas Before 1300

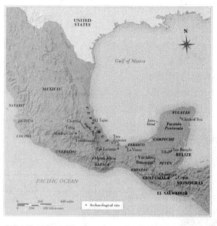

MAP 18-1 Early sites in Mesoamerica.

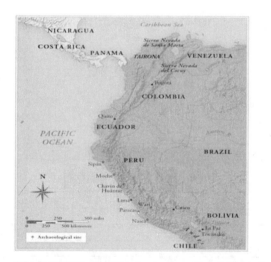

MAP 18-2 Early sites in Andean South America.

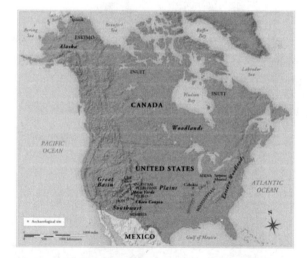

MAP 18-3 Early Native American sites in North America.

FIG. 18-01 Aerial view (looking southwest) of the Maya city of Chichen Itza, Mexico, centered on the Castillo, ca. 800–900 CE.

FIG. 18-02 Colossal head, La Venta, Mexico, Olmec, ca. 900–400 BCE. Basalt, 9′ 4″ high. Museo-Parque La Venta, Villahermosa.

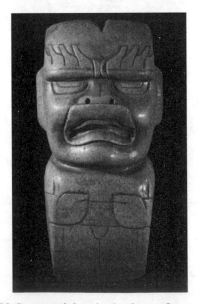

FIG. 18-03 Ceremonial ax in the form of a were-jaguar, from la Venta, Mexico, Olmec, ca. 900–400 BCE. Jadeite, 11 1/2″ high. British Museum, London.

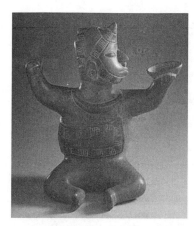

FIG. 18-04 Seated figure with drinking cup, from Colima, Mexico, ca. 200 BCE–500 CE. Clay with orange and red slip, 1′ 1″ high. Los Angeles County Museum of Art (Proctor Stafford Collection, purchased with funds provided by Mr. and Mrs. Allan C. Balch).

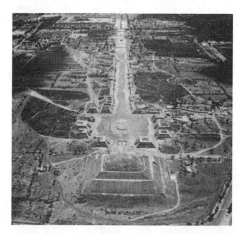

FIG. 18-05 Aerial view of Teotihuacan (looking south), Mexico. Pyramid of the Moon *(foreground),* Pyramid of the Sun *(top left),* and the Citadel *(background),* all connected by the Avenue of the Dead; main structures ca. 50–250 CE.

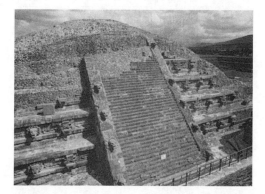

FIG. 18-06 Partial view of the Temple of Quetzalcoatl, (looking southeast), the Citadel Teotihuacan, Mexico, third century CE.

297

FIG. 18-07 Goddess, wall painting from the Tetitla apartment complex at Teotihuacan, Mexico, 650–750 CE. Pigments over clay and plaster.

FIG. 18-07A Bloodletting mural, Teotihuacan, ca. 600–700 CE.

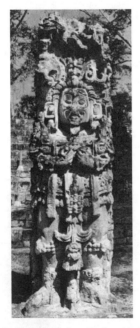

FIG. 18-08 Stele D portraying Ruler 13 (Waxaklajuun-Ub'aah-K'awiil), Great Plaza, Copan, Honduras, Maya, 736 CE. Stone, 11' 9" high.

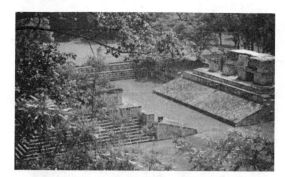

FIG. 18-09 Ball court (looking northeast), Maya, Middle Plaza, Copán, Honduras, 738 CE.

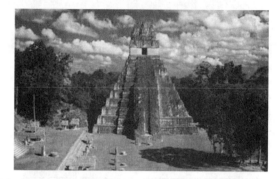

FIG. 18-10 Temple 1 (Temple of the Giant Jaguar), Maya, Tikal, Guatemala, ca. 732 CE.

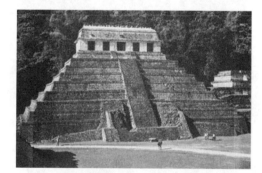

FIG. 18-10A Temple of the INscription, Palenque, ca. 675–690 CE.

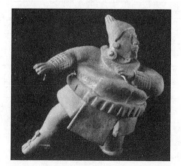

FIG. 18-11 Ball player, Maya, from Jaina Island, Mexico, 700–900 CE. Painted clay, 6 1/4″ high. Museo Nacional de Antropología, Mexico City.

299

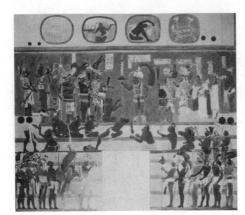

FIG. 18-12 Presentation of captives to Lord Chan Muwan, room 2 or structure 1, Bonampak, Mexico, Maya, Mexico, ca. 790 CE. Mural, 17′ × 15′; watercolor copy by Antonio Tejeda. Peabody Museum, Harvard University, Cambridge.

FIG. 18-13 Enthroned Maya lord and attendents, cylinder vaze, probably from Altemira, Mexico, Maya, ca. 672–830 CE. Polychrome ceramic, 8″ high. Dumbarton Oaks Research Library and Collections, Washington, D.C.

FIG. 18-14 Shield Jaguar and Lady Xoc, lintel 24 of temple 23, Yaxchilan, Mexico, maya, ca. 725 CE. Limestone, 3′7″ × 2′ 2 1/2″. British Museum, London.

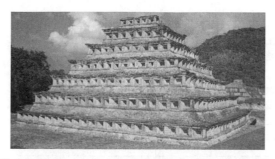

FIG. 18-15 Pyramid of the Niches (looking northeast), El Tajin, Mexico, Classic Veracruz, sixth century CE.

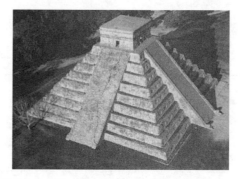

FIG. 18-16 Aerial view of the Castillo (looking southwest), Chichen Itza, Mexico, Maya. ca. 800–900 CE.

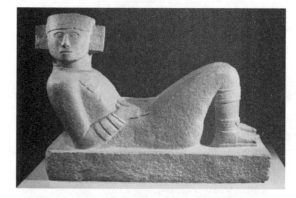

FIG. 18-17 Chacmool, Maya, from the Platform of the Eagles, Chichén Itzá, Mexico, Maya ca. 800–900 CE. Stone, 4′10 1/2′′′ high. Museo Nacional de Antropología, Mexico City.

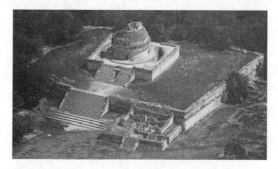

FIG. 18-18 Aerial view of the Caracol (looking south), Chichen Itze, Mexico, Maya, ca. 800–900 CE.

301

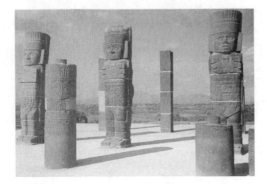

FIG. 18-19 Colossal atlantids, pyramid B, Tula, Mexico, Toltec, ca. 900–1180 CE. Stone, each 16′ high.

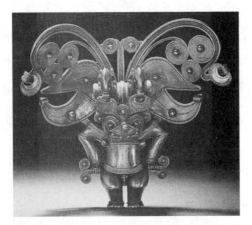

FIG. 18-20 Pendant in the form of a bat-faced man, from northeastern Columbia, Tairona, after 1000 CE. Gold 5 1/4″ high. Metropolitan Museum of Art, New York (Jan Mitchell and Sons Collection).

FIG. 18-21 *Raimondi Stele,* from the main temple, Chavín de Huántar, Peru, ca 800–200 BCE. green diorite, 6′ high. Instituto Nacional de Cultura, Lima.

FIG. 18-22 Embroidered funerary mantle, Paracas, from the southern coast of Peru Paracas, first century CE. Plain-weave camelid fiber with stem-stitch embroidery of camelid wool, 4′ 7 7/8″ × 7′ 10 7/8″. Museum of Fine Arts, Boston (William A. Paine Fund).

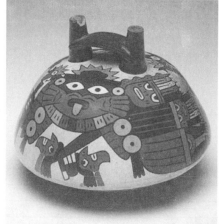

FIG. 18-23 Bridge-spouted vessel with flying figures, from Nasca River valley, Peru, Nasca ca. 50-200 CE. Painted ceramic, 5 1/2″ high. Art Institute of Chicago, Chicago (Kate S. Buckingham Endowment).

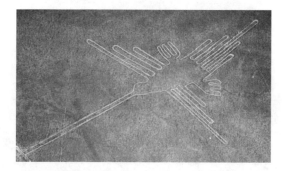

FIG. 18-24 Hummingbird, Nasca, Nasca plain, Peru, ca. 500 CE. Dark layer of pebbles scraped aside to reveal lighter clay and calcite beneath.

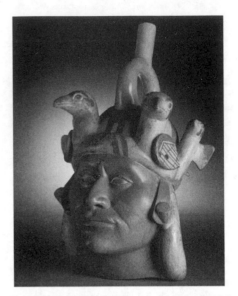

FIG. 18-25 Vessel in the shape of a portrait head, from the northern coast of Peru, Moche fifth to sixth century, CE. Painted clay, 1′ 1/2″ high. Museo Arqueológico Rafael Larco Herrera, Lima.

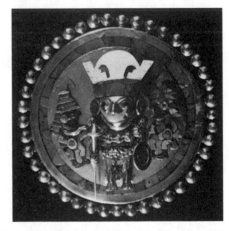

FIG. 18-26 Ear ornament, From Sipan, peru, Moche. Bruning Archaeological Museum, Lambayeque.

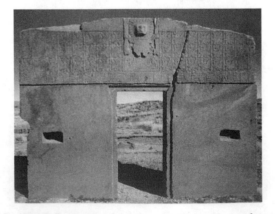

FIG. 18-27 Gateway of the Sun, Bolivia, Tiwanaku ca. 375–700 CE. Stone, 9′ 10″ high.

FIG. 18-28 *Lima Tapestry* (tunic), from Peru, Wari, ca. 500–800 CE. 3′ 3 3/8″ × 2′ 11 3/8″. Museo Nacional de Antropoligía Arqueología e Historia del Perú, Lima.

FIG. 18-29 Burial mask, from Point Hope, Alaska, Ipiutak ca 100 CE. Ivory, greatest width 9 1/2″. American Museum of Natural History, New York.

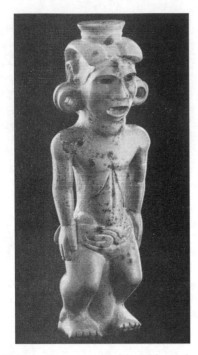

FIG. 18-30 Pipe, from a mound in Ohio, Adena, ca 500–1 BCE. Stone, 8″ high. Ohio Historical Society, Columbus.

FIG. 18-30A Monk's Mound, Cahokia, ca. 2050–1200.

FIG. 18-31 Serpent Mound Ohio, Missippian. ca. 1070 CE. 1,200′ long, 20′ wide, 5′ high.

306

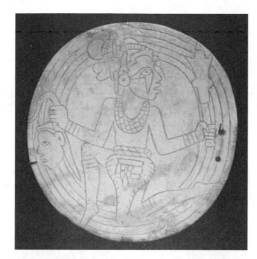

FIG. 18-32 Incised gorget with running warrior, from Sumner County, Tennesse, Mississippian, ca. 1250–1300 CE. Shell, 4″ wide. National Museum of the American Indian, Smithsonian Institution, Washington, D.C.

FIG. 18-33 Bowl with two cranes and geometric forms, from New Mexico, Mimbres, ca. 1250 CE. Ceramic, Painted, 1′ 1/2″ diameter. Art Institute of Chicago, Chicago (Hugh L. and Mary T. Adams Fund).

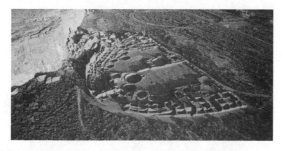

FIG. 18-33A Pueblo Benito, Chaco Canyon, ca. 850–1050.

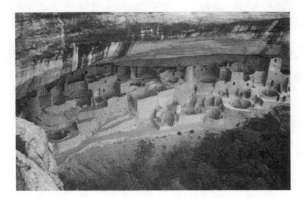

FIG. 18-34 Cliff Palace, Mesa Verde National Park, Colorado, Ancestral Puebloan, ca. 1150–1300 CE.

Chapter 19

Africa Before 1800

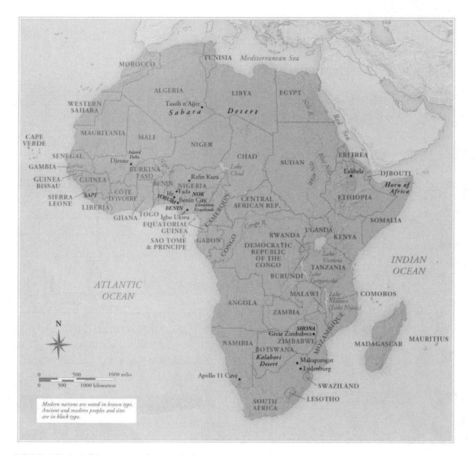

MAP 19-1 African peoples and sites.

FIG. 19-01 Alter to the Hand (ikegobo), from Benin, Nigeria, ca. 1735–1750. Brass, 1′ 5 1/2″ British Museum, London (gift of Sir William Ingram).

FIG. 19-02 Running horned woman, rock painting, from Tassili n'Ajjer, Algeria, ca. 6000–4000 BCE.

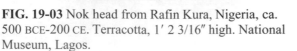

FIG. 19-03 Nok head from Rafin Kura, Nigeria, ca. 500 BCE-200 CE. Terracotta, 1′ 2 3/16″ high. National Museum, Lagos.

FIG. 19-04 Head, from Lydenburg, South Africa, ca. 500 CE. Terracotta, 1′ 2 15/16″ high. IZIKO Museums of Cape Town, Cape Town.

FIG. 19-4A Roped water basin, Igbo Ukwu, 9th to 10th centuries CE.

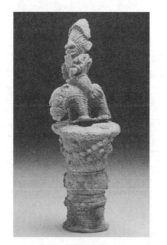

FIG. 19-05 Equestrian figure on fly-whisk hilt, from Igbo Ukwu, Nigeria, 9th to 10th century CE. Copper-alloy bronze, figure 6 3/16″ high. National Museum, Lagos.

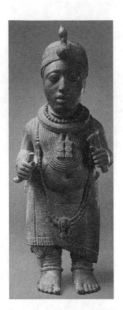

FIG. 19-06 King, from Ita Yemoo (Ife), Nigeria, 11th to 12th century. Zinc-brass, 1′ 6 1/2″ high. Museum of Ife Antiquities, Ife.

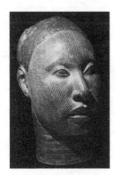

FIG. 19-06A Head of a king, Ile-Ife, 12th to 13th centuries.

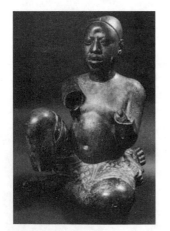

FIG. 19-07 Seated man, from Tada, Nigeria, 13th to 14th century. Copper, 1′ 9 1/8″ high. National Museum, Lagos.

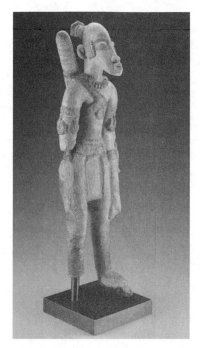

FIG. 19-08 Archer, from Djenne, Mali, 13th to 15th century. Terracotta, 2′ 3/8″ high. National Museum ofAfrican Art, Washington, D.C.

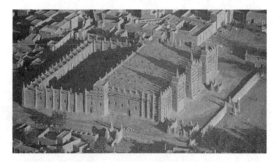

FIG. 19-09 Aerial view of the Great Mosque (looking northwest), Djenne, Mali, begun 13th century, rebuilt 1906–1907.

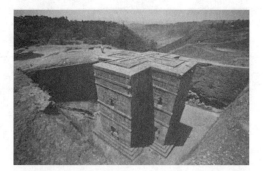

FIG. 19-10 Beta Giorghis (Church of Saint George), Lalibela, Ethiopia, ca. 1220.

313

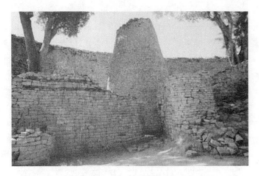

FIG. 19-11 Walls and tower, Great Enclosure, Great Zimbabwe, Zimbabwe, 14th century.

FIG. 19-12 Monolith with bird and crocodile, from Great Zimbabwe, Zimbabwe, 15th century. Soap-stone, bird image 1′ 2 1/2″ high. Great Zimbabwe Site Museum, Great Zimbabwe.

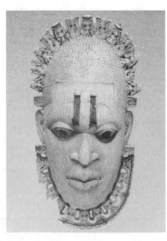

FIG. 19-13 Waist pendant of a Queen Mother, from Benin, Nigeria, ca. 1520. Ivory and iron, 9 3/8″ high. Metropolitan Museum of Art, New York (Michael C. Rockefeller Memorial Collection, gift of Nelson A. Rockefeller, 1972).

314

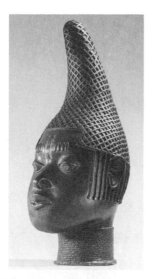

FIG. 19-13A Head of a queen mother, Benin, ca. 1520–1550.

FIG. 19-14 MASTER OF THE SYMBOLIC EXECUTION, saltcellar, Sapi-Portuguese, from Sierra Leone, ca. 1490–1540. Ivory, 1′ 4 7/8″ high. Museo Nazionale Preistorico e Etnografico Luigi Pigorini, Rome.

315